Nigel Spivey
was born in Cheshunt in 1958.
Educated at Emmanuel College, Cambridge, he went on to
become a scholar at the British School of Rome in 1983–4.
In 1988 he organized the exhibition "The Micali Painter and
his World" at the Villa Giulia Museum in Rome. A lecturer
in Classics at the University of Cambridge and a Fellow of
Emmanuel College, he is the author of *Understanding Greek
Sculpture*, also published by Thames and Hudson, and the
co-author of *Etruscan Italy* and
Looking at Greek Vases.

WORLD OF ART

This famous series
provides the widest available
range of illustrated books on art in all its aspects.
If you would like to receive a complete list
of titles in print please write to:
THAMES AND HUDSON
30 Bloomsbury Street, London WC1B 3QP
In the United States please write to:
THAMES AND HUDSON INC.
500 Fifth Avenue, New York, New York 10110

Printed in Slovenia

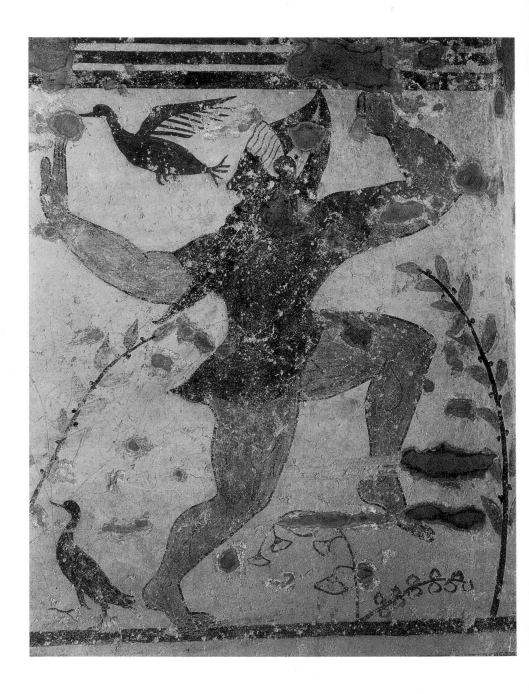

Nigel Spivey

ETRUSCAN ART

186 illustrations, 37 in color

Thames and Hudson

Per Mauro Cristofani, "il miglior fabbro"

Frontispiece Detail from the Tomb of the Augurs, Tarquinia, *c.* 510 BC, showing Phersu.

© 1997 Thames and Hudson Ltd, London

First published in the United States of America in 1997 by Thames and Hudson Inc., 500 Fifth Avenue, New York, New York 10110

Library of Congress Catalog Card Number 97-60250
ISBN 0-500-20304-0

Printed and bound in Slovenia

Contents

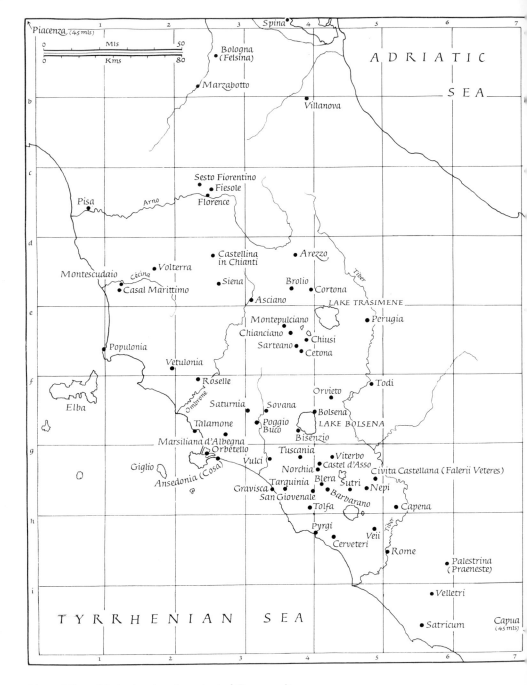

Map of Central Italy showing the principal Etruscan sites.

Etruria and the Limits of Demystification

To mention the Etruscans at an ordinary social gathering is to court two predictable enquiries. The first will be: 'Do we know where they came from?' The second: 'Can anyone understand their language?'

The scholar's rejoinder to both questions is a truthful affirmative. Etruscan specialists (to whom we shall refer in future as Etruscologists) are by and large agreed that the roots of Etruscan culture were indigenous; ancient theories of the foundation of Etruria by immigrants from the East are now usually discounted. We believe that the inhabitants of Central Italy in the Bronze Age – roughly the period of 3000–1000 BC – should be considered the ethnic ancestors of those who during the Iron Age (conventionally dated from 1000–1 BC) occupied the territory which the Romans called 'Etruria'.

These people spoke their own language: Etruscan. A little before 700 BC, using Greek letters, they established a system for writing down this language. Compared with the other languages of the world, and of Europe in particular, Etruscan is certainly unusual. It does not belong to the family of languages known as Indo-European whose diverse members include Greek, Latin, Gaelic and Sanskrit. Nonetheless, it is perfectly possible to understand the meaning of most surviving Etruscan texts. Glossaries of Etruscan words are not enormous because no substantial examples of Etruscan literature have come down to us. We are left with inscriptions rather than books, and though the number of these inscriptions runs into many thousands, most of them are formulaic and repetitive in nature. As evidence of a language, they are tantalizing, because it is clear that the Etruscans must once have enjoyed an extensive literature – poems, plays, folk-tales, hymns and religious manuals – which was either obliterated by Roman conquest or else simply failed to survive the process of medieval transmission. But unlike, say, the Linear A script of the prehistoric Minoans, the Etruscan language is not beyond decipherment. Its widely-supposed enigmatic status can

therefore be denied. And so it is that the professional Etruscologist can claim to have relieved the Etruscans of their two traditionally 'mysterious' aspects.

But perhaps only at a superficial level. For it has to be admitted that while substantial progress has been made in Etruscan studies over the last few decades, we remain a long way short of properly understanding this florid but relatively short-lived civilization. The generally offhand and incidental references to the Etruscans from Greek and Roman writers do very little to illuminate the internal events of Etruscan history. This means that the archaeologist will uncover a layer of destruction at an Etruscan site and will rarely be in a position to connect it with any particular historical narrative. Then the ancient disappearance of Etruscan literature relentlessly exposes gaps in our modern knowledge of the Etruscans. Faced with what might seem to be a straightforward question, such as: 'How would an Etruscan have defined a city?', we can only struggle for a plausible answer. Because no Etruscan account survives on this matter, nor on other elementary components of Etruscan society, politics, law and administration, we are often left searching for a code with which to make sense of the material and structural relics of Etruscan culture.

This presents a serious problem for the understanding of Etruscan art. Here is an example of how the problem arises. Many depictions of athletics exist in Etruscan art: scenes of chariot-racing, jumping, boxing, throwing the discus and the javelin. We can associate these images with finds of athletic gadgets in Etruscan tombs, such as the flesh-toning scrapers known as strigils. But where did these athletes meet in Etruria, and under what institutional auspices? In the con-temporary context of Greece, the iconography of athletics can be directly related to documented sporting festivals, to well-known locations such as Olympia and Delphi, and even to recorded lists of winners. But no stadium has yet been excavated in Etruria. Although it is true that some Etruscan graves contain prize vases from Greek contests, it seems doubtful that Etruria sent athletes to compete at sites such as Olympia, where meetings excluded those whose native language was not Greek (which is all that the Greek word *barbaroi*, 'barbarians', technically means). So what are we looking at when we see pictures of athletes in Etruscan art? Is it the reflection of an elusive reality or pretentious fantasy? Or indeed some combination of the two?

This is a recurrent dilemma. What we shall find as we pick our way through the generous remains of Etruscan art – for whatever else

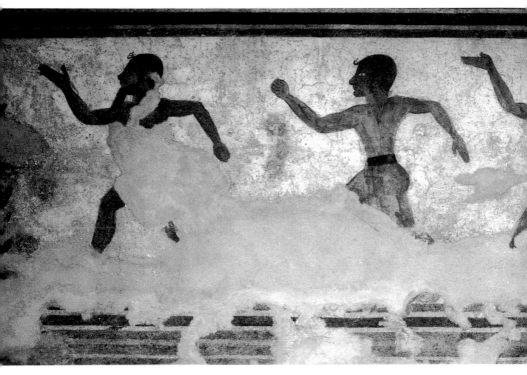

1 Detail from the Tomb of the Olympic Games, Tarquinia, *c.* 510 BC, showing athletes.

it was, Etruscan society was one in which the artist had plenty to do – is that the iconography repeatedly creates expectations which cannot be satisfied, or raises questions which cannot be answered. Fraught with such elementary historical uncertainties, and frequently recovered from 'beyond this world' contexts such as necropolises, Etruscan images tend naturally to add to the sheen of popular Etruscan mystique.

Plainly we should try to relate Etruscan art to its social functions. Art for art's sake was neither a tenet of the Egyptians or the Greeks, nor of the Romans or the Celts, and we have no reason to suppose that the Etruscans were exceptional in this regard. But again it is necessary to register that tracing the social history entailed by Etruscan art is hardly going to be a direct or definitive process. Etruscan artists, like all artists, held up mirrors to the world around them.

As long as the historical appearance of Etruria itself remains opaque to us, we shall never be able to gauge quite how much those mirrors distort or tease reality.

This may seem like a depressing overture. From another point of view, it might be seen as liberating – a licence for extravagant speculation. And such extravagant speculation was certainly rife in the past, indulged in by art historians and archaeologists alike, but perhaps most notoriously by the poet and novelist D. H. Lawrence in his *Etruscan Places*. We shall have more to say about Lawrence's fetish for the Etruscans in Chapter Six; here, it is worth quoting a representative passage of his response to his first day of exploring Etruscan painted tombs at Tarquinia.

To the Etruscan, all was alive: the whole universe lived: and the business of man was to live amid it all. He had to draw life into himself, out of the wandering huge vitalities of the world. The cosmos was alive, like a vast creature. The whole thing breathed and stirred. Evaporation went up like breath from the nostrils of a whale, steaming up. The sky received it in its blue bosom, breathed it in and pondered on it and transmuted it, before breathing it out again. Inside the earth were fires like the heat in the red hot liver of a beast. Out of the fissures of the earth came breaths of other breathing, vapours direct from the the living physical underearth, exhalations carrying inspiration. The whole thing was alive, and had a great soul, or anima: and in spite of one great soul, there were myriad roving, lesser souls; every man, every creature and tree and lake and mountain and stream was animate, had its own peculiar consciousness. And has it today.

'And has it today' betrays the author's own romantic leanings. No Etruscan poetry or doctrine can be quoted to support any of the metaphysics which Lawrence extracts from the tomb paintings. Lawrence, disenchanted with the modern industrial world, foists upon Etruscan imagery the wishful significance of his own intuitions. He sees what he wants to see in Etruscan art – even figures in the paintings who must be slaves are reckoned to be doing their chores 'joyfully'. Inspired as it may be, this is an extreme example of excessive speculation in trying to comprehend Etruscan art. As far as possible we shall aim to proceed with more restraint.

But too much restraint is a risk in itself. One of Lawrence's shots at what he perceived as the wearyingly arid scholarly appraisal of Etruscan art has found plenty of targets. 'Most people despise everything B.C. that isn't Greek', writes Lawrence ironically, 'for the good reason that it ought to be Greek if it isn't.'

One target is undoubtedly the patrician standpoint of perhaps the greatest (and certainly the most articulate) absolutist in art history, Bernard Berenson. Though Berenson lived for many years near Florence in what was once Etruscan country, he had no time for Etruscan art, bracketing the Etruscans with the Phoenicians as 'paste and scissors craftsmen', operating to 'a ruffian brutality of intention'. He declares, of such barbarian work:

It is improbable that in any of these regions, art, as distinct from artifacts, has been discovered which was not of Greek origin. . . . We can thus take it for granted that when a work of high order in the Greek mode appeared anywhere in the ancient world it was done by a Greek. . . . It has been the case at all times and in all places that the farther away from the generating centers of art, the more incompetent, the more distorted, and the more 'original' the product. They [the Etruscans] manifestly had nothing to contribute except the originality of incompetence, and behind that, the resistance of crude craft habits.

This is not the place to debate the pertinence of such value judgments in art history. But we can justifiably deplore the demeaning of interaction between one ancient culture and another, since this model of infallible Greek superiority owes more to anecdotes of modern Western colonialism than to the archaeological record. It is an easy and deceptive paradigm, which has lured too many scholars into treating Etruscan images as bastard or 'banalized' versions of aesthetically preferable Greek prototypes. Fortunately, we are now able to replace such crass over-simplification with a more subtle analysis.

ART, ETHNICITY AND THE MYTH OF THE SPONTANEOUS

One reason why it is nonsense to condemn Etruscan art for failing to meet the standard of Greek art is that a good deal of what we call 'Etruscan art' was produced by Greeks. This is evident not only on stylistic grounds: signatures of individual artists also make plain their Greek origins, and, as we shall see in Chapter Three, a Greco-Roman literary tradition tells of Greek artists settling in Etruria as early as the seventh century BC.

The implications of non-Etruscan artists producing Etruscan art will unfold as we go further. For now, it is worth briefly considering what kind of ethnic identity or purity can be fixed upon what seems, archaeologically, to have been a busily cosmopolitan Mediterranean ambience. We have stated that, as a language, Etruscan was an

independent entity, though it is true that it was heavily influenced by Greek. And we know that the territory in which Etruscan speakers prevailed was more or less independent too. Unlike Sicily, South Italy and some other neighbouring areas (such as the island of Corsica and the French Riviera), Etruria was not actually colonized by Greeks or Phoenicians. We know that the Etruscans – to whom the Greeks referred as *Tyrrhenoi* – had their own name for Etruria, which was Rasenna. We cannot do more than guess at what fictive kinships they might have woven and what foundation myths and self-defining epics they might have devised, but will their ethnic identity count nonetheless?

The answer is a qualification: up to a point. One of the best definitions of ethnicity describes it as 'the will to descend'. This allows ethnic awareness as such to be usually retrospective, and equally often inventive. Historians have successfully exposed the tendency of modern communities and nations to conjure up 'traditions' for themselves: it is generally agreed among historians of ancient Rome that the antique stories of Aeneas and Romulus and Remus were programmatically fabricated during the reign of the Emperor Augustus (27 BC–AD 14). There is some strong iconographic evidence to show Etruscans from the late fourth century BC onwards inventing mythical prehistories for themselves, and we may suppose that they were as prone as any other group of people to indulge in tribal chauvinism and periodic xenophobia. But an imagined or projected ethnic purity is chiefly what the student of literature has to contend with. The real fuzziness of borders, identities and mixed-up objects is the archaeologist's preserve.

An apparently promising prescription for ethnic awareness is given by the Greek historian Herodotus, writing (for a Greek audience) in the mid-fifth century BC. He puts these words into an appeal made by an Athenian spokesman during the war between Greeks and Persians: 'Then there is Greekness [*Hellenikon*] – that is, the blood we share, the language we share, our common cult places and sacrifices and our similar customs' (*Histories* 8. 144).

But does this statement truly amount to a declaration of ethnic identity? Greek scientists had no notion of genetics, so 'the blood we share' is purely a sentiment (and one that counted for little in the normally abrasive relationships between individual Greek city-states). The expression 'the language we share' is similarly meaningless, since dialects within the Greek world were strong enough to frustrate mutual comprehension on plenty of occasions, and of course many

Greek words found their way into 'barbarian' tongues such as Etruscan. In fact, as we shall see, it is highly likely that many individual Etruscans had a working knowledge of Greek, either for the purposes of commerce or else for participation in 'high culture', the latter being, effectively, whatever was deemed to define a conspicuously aristocratic lifestyle.

And what may be understood by 'common cult places and sacrifices'? Herodotus himself knew that Etruscans made dedications at the 'pan-Hellenic' site of Delphi (*Histories* I. 166), and archaeology indicates other shrines in the Greek world visited by Etruscans, such as the sanctuary of Hera at Perachora, near Corinth. In Etruria itself, it is clear that Greeks and Etruscans could share a temple and its associated altars: indeed, at the harbour sanctuary of Pyrgi, near Cerveteri, a single cult place served not only Greeks and Etruscans but Phoenicians too, allowing the Greek mother-goddess Hera to be equated with the Etruscan Uni (whence the Latin Juno) and the Phoenician Astarte. In some areas of the Mediterranean it is true that the Greeks were isolated or even garrisoned in their cult activities, as seems to have been the case at their trading post at Naukratis, in the Nile Delta. But in Etruria and elsewhere, ritual observances were more fluid and interchangeable than the Herodotean passage suggests: the situation verged on the genuinely ecumenical.

Lastly, the speaker in Herodotus appeals to 'our similar customs'. What does he mean? Herodotus himself devoted a lifetime to the

2 Aerial view of the sanctuary at Pyrgi. Temple B, above, to which the gold plaques probably relate, is the smaller temple, and older (*c.* 500 BC). Temple A belongs to *c.* 460 BC.

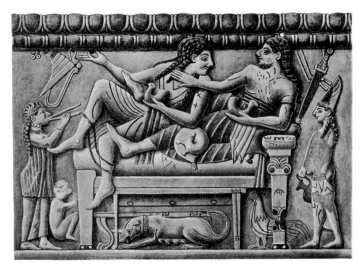

3 Reconstruction of part of a terracotta frieze from Larisa in Asia Minor, mid- to late sixth century BC. The couple on the couch hold drinking horns, and one has an egg or perhaps a delicacy while a flautist entertains them. Below and around the couch stand their pet monkey, dog and cockerel.

4 Detail from the Tomb of the Leopards, Tarquinia, c. 475 BC.

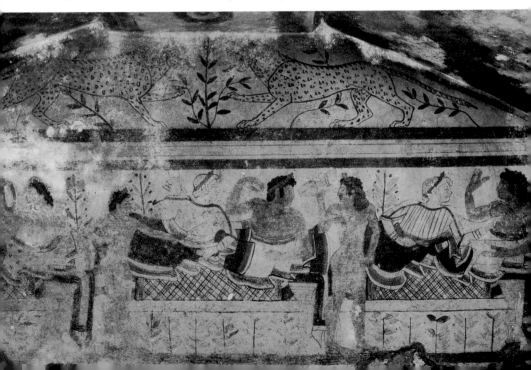

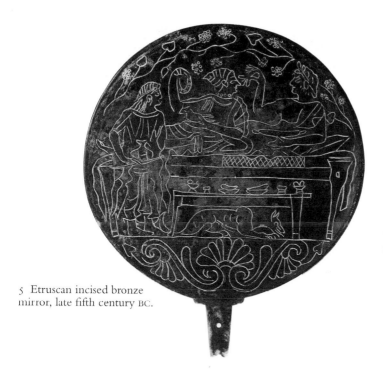

5 Etruscan incised bronze mirror, late fifth century BC.

study and documentation of non-Greek customs, but defines Greek customs only by default. An aggregative list of especially Greek customs is never compiled. However, we know that there were certain social institutions which the Greeks recognized among themselves as a means of establishing common ground. The best-known of these is the symposium, the formal drinking party. 'You who loll on beds inlaid with ivory, and sprawl over your couches . . . you who pluck the strings of the lute . . . you who drink wine by the bowlful, and lard yourselves with the richest of oils . . .' The words are not Homer's, but those of the prophet Amos indicting 'men of mark' in Samaria, reminding us that the Greeks themselves adopted the symposium from the Near East, during the ninth and eighth centuries BC. Now it is true that the Greeks developed their own rules, with local variations, for the conduct of the symposium. It should take place after the consumption of food; the wine should be diluted; wives should not be present, and so on. Some Greeks deplored the

infringement of these rules by non-Greeks. For instance, the Macedonians, notoriously, did not dilute their wine, and the Etruscans, equally notoriously, allowed their womenfolk to drink with the men. But the fact remains that just as the Greeks in Ionia had adopted the symposium from their Eastern neighbours, so, in their turn, they transmitted it onwards. As such, it was hardly an exclusive custom, even allowing for locally proprietorial refinements.

When we contemplate an image of Etruscans at a drinking party, we may hesitate to call it a symposium. We do not have the Etruscan word for such a gathering, and we can understand that if a Greek were invited to an Etruscan party he might be horrified at various *faux pas*, such as a tippling wife or a plate of bread buns. Yet we can recognize that the basic elements of the custom are similar, and the basic function of the custom is the same: to seal a social status, to affirm the existence of a convivial peer-group. In this respect, what matters here is not ethnicity. It is rather the diffusion of a shared aristocratic ideology, which pays scant heed to normal borders and boundaries. So as far as communality is concerned, aristocrats in Phoenician Tyre, Greek Thebes and Etruscan Tarquinia may have had much more in common with each other than with the lesser mortals of Tyre, Thebes and Tarquinia respectively.

Horse ownership; wine drinking; the possession of finely worked weapons and utensils, and of various luxuries; the enjoyment and understanding of epic poetry; the acquisition and practice of the skills of literacy: these are the sorts of defining factors we should be looking for in the search for the identity of art's patrons in Etruria. Throughout this book we may refer to them as 'aristocrats': a retrospective term here used to define a lifestyle rather than any control of oligarchic political power, though surely those Etruscans who commissioned such things as painted tombs considered themselves a peer-group ruling by virtue of being the best (which is what the Greek term *aristokratia* implies). The earliest Etruscan inscriptions, in fact, are mostly found on drinking vessels and metal jewelry, and mostly relate to the protocols of gift exchange. *Mi mulu* . . . 'I was given by . . .'; *Mini muluvanice* . . . 'I am the gift of . . .': the scratched formulae of these 'speaking objects' enunciate the patterns of reciprocal obligation and endowment among Etruscan aristocrats in the early seventh century BC. Their Greek contemporaries, not to mention the heroes of Homer, would have understood such binding arrangements (in Greek the cognate word *doron* means, significantly, both 'gift' and 'bribe').

The logistics of the Mediterranean exchange networks during the first millennium BC will become clearer when we approach the chronological subdivisions imposed by scholarly tradition (it is customary to talk of an 'Orientalizing' phase in the seventh century, when trade with the East seems to have been vigorous; the denominations of successive stages of Greek art, 'Archaic', 'Severe', 'Classical', and 'Hellenistic' are also transferred to Etruria). But it is worth describing here what may be taken as a firm archaeological testament to the nature of cultural interaction experienced by the Etruscans: the Giglio shipwreck.

It was some time around 580 BC that a merchant vessel capsized off the little island of Giglio in the Tuscan archipelago. The ship was probably heading for the Gallic coast, perhaps for Marseilles; it seems that it sank after a stopover in Etruria, for among its cargo were at least 130 Etruscan trade amphorae or storage jars, apparently carrying olives, pitch and wine. A much smaller number of trade amphorae had come from East Greece (including some from the island of Samos) and Phoenicia. Finer decorated vases, predominantly the 6–9 small oil or perfume flasks known as *aryballoi*, mostly of Corinthian style, were on board with some vessels of Laconian origin. An impressively embellished helmet of Corinthian type is also thought 10 to have come from the wreck.

Some metal went down with the boat, including lead and copper ingots, iron bars, a cache of bronze arrowheads and a quantity of lead fishing-net weights. We cannot tell how many other goods perished in this mishap (such as textiles, timber, or sacks of wheat), and we may not be surprised that wine, olives and perfumes were in transit. The ship's captain is presumed to have been an Ionian Greek; Corinth would have been a natural port of call for westward-bound craft from East Greece, hence the stock of Corinthian pottery. But other items recovered from the ship point very clearly to the passage not only of goods, but an ideology: a boxwood writing tablet, for instance, a number of musical pipes made of boxwood or ivory and fragments of a turned wooden couch leg. Possibly these were the personal possessions of the captain and his crew, in which case the ship was a floating advertisement for the aristocratic lifestyle, since it carried not only the 'fuel' of a symposium (the wine), but also a full service of drinking equipment (including a silver jug), the furniture on which to recline while drinking and the instruments for lyrical entertainment during the party. The presence of a writing tablet, and possibly a stylus too, implies that both business transactions and lines

6–10 Finds from the Giglio wreck, including (*right*) a Corinthian helmet (with incised decoration); (*left*) a Laconian *aryballos* (perfume jar); (*centre*) an Ionian drinking cup; and (*bottom*) two Corinthian-made *aryballoi*.

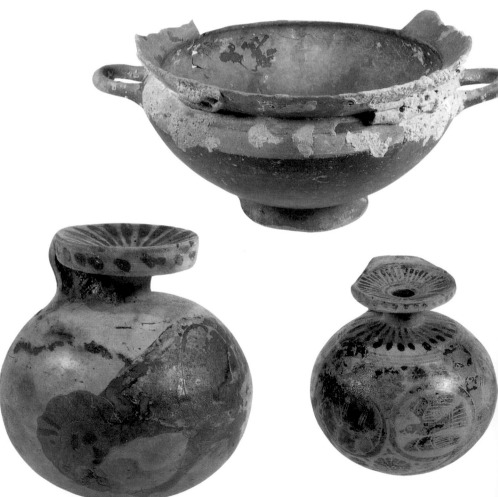

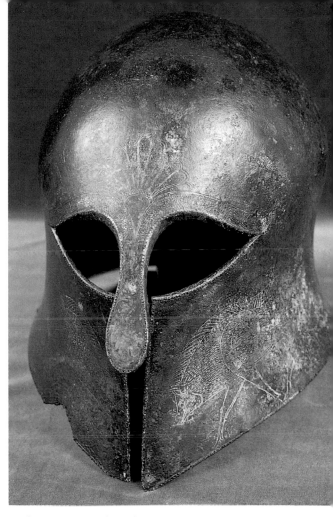

of poetry could be put on record at a time when literacy was very much an élite accomplishment.

The Giglio wreck, then, goes some way to confirming our proposed new model of interaction between Etruscans, Greeks and Phoenicians. And the transcendence of social status over ethnicity in the ancient Mediterranean actually enables us to make much more sense of the role of artists in such a system. We know that Greek artists were itinerant, both within and beyond the Greek-speaking world. The construction of a temple or any other substantial monument required a convocation of artistic expertise. Greek artists (including, for present purposes, not only painters and sculptors, but

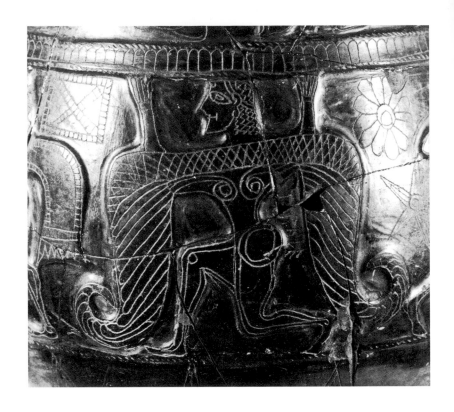

bronze-smiths, carpenters, stonemasons, architects, nail-makers, door-fitters and so on) were widely acknowledged as travelling handymen, open to offers with their ingenuity for hire. They were even lured (or compelled) to venture down the Tigris by the Persian King Darius to assist in the construction of his ambitious capital at Susa towards the end of the sixth century BC. The Persian occupation of East Greece at that time may also have persuaded many artists to move permanently westwards. But it is not necessary to imagine a 'diaspora' of East Greek artists to account for their presence in Etruria. The burgeoning Etruscan aristocracy would have summoned Greek artists quite deliberately, almost as a matter of Mediterranean convention. Though it seems a self-contradiction, we can surmise that Greek artists both shaped and responded to Etruscan ideology.

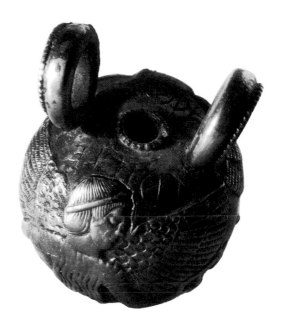

11 (*left*) Detail of bucchero jug, *c.* 650 BC, showing Taitale (the name appears as Taitle). The rest of the vase shows scenes from the story of Jason and the Argonauts.

12 (*right*) Taitle on part of a gold necklace piece, late fifth century BC.

The Etruscans mythologized the beginnings of art in the same way as the Greeks: by reference to the fabulous proto-craftsman, Daedalus. In the story of Daedalus, there is the episode of the making of wings and the flight westwards. As the Etruscans knew this story, Taitale or Taitle (their transliteration of the Greek Daidalos) indeed lost his son Vikare (Ikaros) *en route*; but whereas Greek mythographers have Daedalus settling in Sicily, the Etruscans probably imagined him progressing to Etruria. In fact the very first attestation of Daedalus so far known comes from Etruria rather than Greece. On a relief-decorated jug made of the shiny black Etruscan clay fabric called 'bucchero', found in a mid-seventh-century BC tomb at Cerveteri, we see a winged figure inscribed as Taitale. He will appear again in Etruscan art and eventually pass into Roman mythology as the founding father of craftsmanship and technical dexterity. There is no reason to suppose that the Etruscans saw him as anything less than the universal paragon of artistic enterprise.

In the modern history of ancient art, from the seminal *History of the Art of Antiquity* (1764) by J. J. Winckelmann forwards, there is a dogged faith in the high canonical status of Greek art, especially as embodied in the monuments of the Classical period (the fifth and

fourth centuries BC). When analysed, this often turns out to be a salutation not so much to Greek art as to Athenian art. With Athens as the core centre of excellence, the periphery of relative provincial 'incompetence' can consequently include not only the usual 'barbarian' fringes such as Etruria, Scythia and Celtic Europe, but also areas of the Aegean – Cyprus and Lycia, for example – and parts of the Greek mainland, such as Boeotia. It may well have been the case that some educated Etruscans, like some educated Romans, recognized the central cultural prestige of Athens. By the same token, an Athenian visiting Etruria might have been horrified by some of the images on display: for example, in a temple at Orvieto there was a statue of a nude goddess created in the late sixth century BC, a time when an Athenian would have regarded such divine nudity as indecorous. (The sight of a male nude statue of the *kouros* type, such as the one recovered from the interior Etruscan colony of

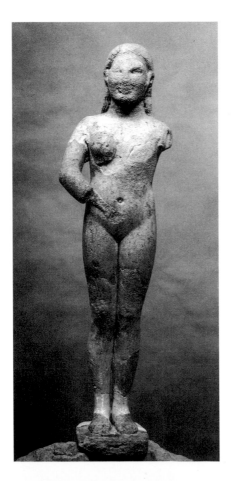

13 Half-life-size statue of Aphrodite from Orvieto, *c.* 520 BC. The image once stood in a sanctuary within the Cannicella necropolis.

14 Black figure amphora probably from Orvieto, late sixth century BC. The vessel is unevenly fired and the incised detail careless. Although the warrior has not yet released the wavy spear, it may be intended to convey movement.

Marzabotto, would on the other hand have been a great comfort to our Athenian visitor.) But to treat Etruscan art as a catalogue of more or less inadequate attempts to keep up with Athens is both a dispiriting and a mistaken exercise.

Examples of sloppy brush strokes, hack carving and misshapen pots are not lacking in Etruscan art, and it is clear that technically substandard work was more indulgently received in Etruria than it would have been in Athens. Certain examples of Etruscan art are either truly inept in their execution or else bizarre in their results. The painter of the Tomb of the Bulls at Tarquinia, for instance, was evidently unpractised in working on the scale demanded by a wall space. And efforts at black figure vase painting in Etruria during the fifth century BC contain clear examples of both negligence and eccentricity. But we should not be deceived into thinking that this amounts to a meditated anti-Classicism on the part of Etruscan artists. The fact is that in some areas of technique (vase painting, marble sculpture) they lagged behind their Athenian counterparts, while in others (filigree gold-work, gem cutting, terracotta sculpture) they surpassed them. We should entirely expect such fluctuations of expertise if we bear in mind the local variations of demand and decorum.

So we cannot join those partisans of Etruscan art who make a virtue of a perceived 'spontaneity' in Etruscan images, those who celebrate its vivacious achievements as cursive, immediate and chanced – 'the mode of the mandolin player' (in the phrase of the great Italian art historian, Bianchi Bandinelli). 'If you love the odd spontaneous forms that are never to be standardized,' writes D. H. Lawrence, 'go to the Etruscans.' Alas, no such forms exist. We should rather celebrate the combined consistency and heterogeneity of those images generated by Daidalos/Taitle and his many followers – artists of the floating Mediterranean world.

The Emergence of Etruscan Culture

OUT OF THE BRONZE AGE

Imagine a plateau. The geological result of volcanic activity probably several million years ago, it is marked off from outlying terrain by cliffs, some of them sheer-sided, others fringed with thickets and undergrowth. Streams or minor rivers flow in the surrounding valleys. Ancient trackways provide approaches at axial points, and natural defences may be supplemented by ditches or earthen embankments.

Up on the mildly undulating surface, covering usually several hectares, huts are grouped here and there. These are one-room hearths, whose structural basis is an oval network of timber poles embedded into the soft sedimentary rock, tufa. Wattle and daub make walls. The roofs are thatched. Where huts are contiguous, open drainage channels run between them. Simple systems of ditches and fences allow animals to be enclosed nearby: pigs, sheep and cattle. The area of the plateau may be sufficiently expansive to accommodate crops too: beans, barley and bread wheat.

The people living here are not numerous – probably no more than one or two hundred individuals at any given time. But even where their dwellings seem to be sub-grouped or nucleated in various areas of a relatively extensive plateau – such as that of the settlement at Veii – they are probably all related in family terms. Subsistence is their main concern. They possess little in the way of metal jewelry or weapons. There is not much obvious social differentiation between them. They speak the unwritten tongue which will become Etruscan. Their ancestors rest in cemeteries beyond but in view of the plateau, in small, unendowed graves, cut as holes or shafts into the tufa.

To visit in the mind's eye an Etruscan site as it was in the late Bronze Age – say 1200 BC, around the supposed time of the Trojan War – is romantically inviting, especially when such a site remains undeveloped today, and the breeze blowing there is pungent with

oregano and wild fennel. There is no question, however, that when compared with well-built Mycenae, or the palatial centres of the Aegean, our pre-Etruscan settlements present a primitive aspect. No kings, no polities; nothing much in terms of hierarchy and ceremony, and few traces of trade, mineral exploitation and accumulated wealth.

The pattern described applies predominantly to southern Etruria, including on the smaller scale such places as San Giovenale and Sorgenti della Nova, and on the larger scale Veii, Tarquinia and Cerveteri. Among the Bronze Age communities on these plateaux there were no specialized craftsmen. The making of pots would have been a household activity. Art in such circumstances is not so much inconceivable as uncalled for. It seems a world apart from frescoed Knossos or Pylos. But the disparity in relative sophistication between the East and West Mediterranean was soon to be resolved. Around 1200–1100 BC, as the great Mycenaean palaces began to crumble – for reasons still disputed among archaeologists – the rustic plateau habitations of Central Italy were accelerating towards proto-urbanism.

15 Reconstruction of an eighth-century BC Villanovan hut.

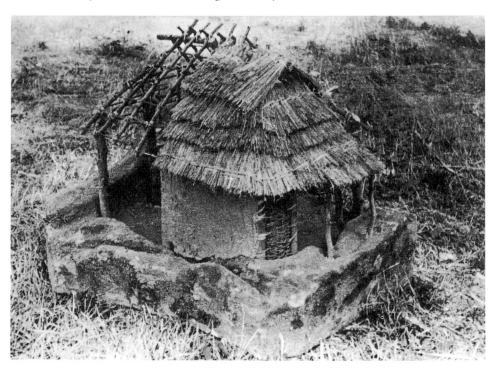

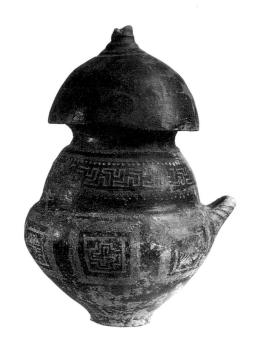

16 Villanovan impasto biconical urn from Narce, early eighth century BC. The lid approximates to a 'bell' helmet. The scratched meander patterns were added before the pot was fired.

Agriculture intensified, metallurgy developed and metal products were diffused, and, alongside increases in population, systems of social ranking evolved.

The process of this change in Central Italy has been most effectively traced at a large site to the east of Rome, Osteria dell'Osa. This site shows that the people who would eventually become the Latins (and thence Romans) shared the same early Iron Age cultural formation as the Etruscans. But mapping the cultural prehistory of the Etruscans is complicated by the fact that they have acquired a different name in archaeological circles. Early Iron Age Etruscans are known as 'Villanovans', after the hamlet of Villanova, near Bologna, where a cemetery with distinctive tomb groups was discovered and published in the mid-nineteenth century. Since then it has become eponymous to subsequent finds of similar assemblages, and hence to an archaeological 'culture'.

These Villanovan graves were cremations. The ashes of the dead had been deposited into urns described as 'biconical' – that is, worked as two large cup-shaped parts. The term 'biconical' generally includes two-storied urns potted all as one piece, and also those where one half is placed as an inverted separate vase on top of the other (as we shall see, some imaginative variations on this theme

were developed). The urns at Villanova were placed in shallow holes with other objects which ranged from further vases (usually identifiable as drinking vessels), to small bronze objects such as pins, fasteners, bracelets, razors and earrings. In turn, these bronze pieces would exhibit particular stylistic characteristics which permit various local and chronological classifications: for example, the fasteners (or fibulae, to use their eventual Latin name) may be shaped as arcs or bows, and have ribbed or 'serpentine' handles and extra loops.

The term 'Villanovan' is really only one of convenience. It denotes a set of objects repeatedly found in association with one another, no more than that. Some of these objects, taken individually, are also common to other prehistoric groupings in Italy, Central Europe and the Mediterranean. But the discovery, again at Bologna, of a typically Villanovan object carrying a relatively long and early (mid-seventh-century BC) Etruscan inscription, has encouraged scholars to uphold the Villanovans as the indigenous forebears of the Etruscans. The distribution of characteristic Villanovan burials closely resembles the area which will become, in historical times, recognizable as Etruscan territory. Their extent covers Tuscany, northern Lazio, parts of Emilia-Romagna and the Marches, and parts too of Campania, notably Pontecagnano near Salerno. At a local level, it is clear, at least from cemetery evidence, that the primary Etruscan cities grew upon sites with Villanovan habitation. And to judge from excavations at Tarquinia and Cerveteri, there was no interruption in continuity between the phases – no equivalent to the 'Dark Age' in Greece during the eleventh to eighth centuries BC. Thus 'Villanovan' can be understood to be merely a way of saying 'early Etruscan'.

Villanovan, with its subdivisions, is usually taken to mean the period around 1000–750 BC. It is perhaps still premature to speak of 'art' in this period, since it is hard to imagine full-time 'artists' operating before the eighth century BC. Yet there are incipient signs of craft specialization in the metalwork and jewelry – fasteners inlaid with glass beads, for example. And while pottery remains essentially a domestic product, produced without the benefit of a wheel, it is by no means plain in either shape or decoration. Take the biconical urns: beyond a vaguely anthropomorphic basis, whereby their twin cones might be seen as presenting a 'belly' and a 'neck', these carry both abstract and figurative designs. To deposit ashes in an earthenware metaphor for the body may reflect a faith (conscious or otherwise) in regeneration: one urn from Tarquinia is given two breast-like protrusions, perhaps to support that faith, or possibly to

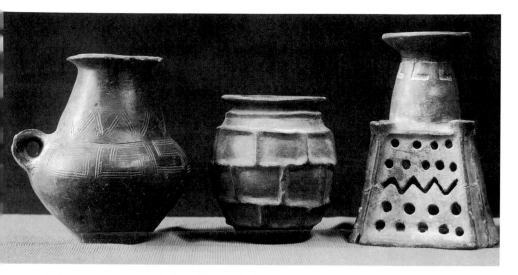

17 Villanovan impasto vessels from Cerveteri, eighth century BC. On the far right is a jug with a built-in brazier, a shape with late Bronze Age precedents, known as a 'milk-boiler'.

define the gender of the deceased. More commonly, however, decoration was impressed or scratched onto the surface of the pot before firing. Often this was in the form of multiple-lined meanders or swastikas – designs rooted in the Neolithic cultures of the Mediterranean and beyond – and sometimes these comb-toothed scratchings take on the likeness of human figures shown sitting down, or even shaking hands.

Where urns are surmounted not by a second cup or bowl, but by clay imitations of helmets, three types exist. The most spectacular (and least practical, as a helmet) is the crested helmet, which features a thin crest rising to a tall spike above the helmet proper. Then there is a bell-shaped type, with a handy knob on top (on a helmet this was not a handle, but a socket for inserting plumes), and a variant of this, which has a cap at the front. Faced with such pseudo-functional shapes, one obvious interpretative temptation is to characterize them as the relics of warriors. This may be valid, but we should be wary of assuming that such indicators of status necessarily denote a male rather than a female memorial. In fact as grave deposits become more generous, the indicators of gender are less stereotypical than they might at first appear. For instance, the little spools and spindle-whorls used for weaving and spinning – customarily defined as

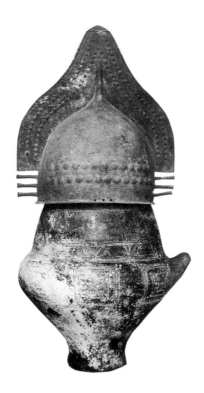

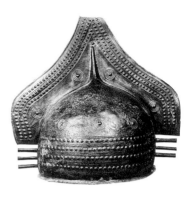

18 (*left*) Villanovan helmet-urn from the Impiccato cemetery, Tarquinia, eighth century BC.

19 (*above*) Bronze Villanovan helmet, eighth century BC.

women's work – may be found in a single grave alongside weapons of war. Did men make clothes? Did women join combat?

It is not merely the onus of modern political correctness that obliges us to pose these questions. Historical documentation claims for Etruscan women far greater social freedom than that enjoyed by their counterparts in other regions of the Mediterranean; we are naturally intrigued to know how the prehistoric origins of these 'matrilineal rights' might have been formed.

The pottery imitations, or 'skeumorphs' as they are called, of metal originals, are useful indices of the skill of Etruscan metal-workers in all periods. (In due time a particular type of Etruscan pottery overtly reflects the embossing and chasing techniques used on metal vessels.) In the case of the helmets, actual metal examples have survived too, from the ninth century BC. To judge from their shape, decoration and thin-walled bronze construction, some of these must have been ceremonial headpieces. They may accordingly argue for the rise of ranking systems among our previously 'egalitarian' plateau communities. Rank demands symbols for its public definition.

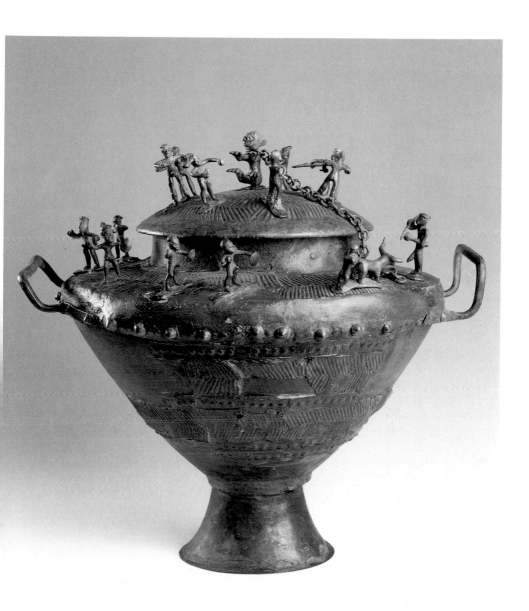

20 Bronze urn from Bisenzio, *c.* 710 BC. The animal chained to the centre of the lid may be a large dog, or a bear. The surrounding figures seem mostly to be dancing, although some may be ploughing.

A few attempts at small-scale metal sculpture have survived from the Villanovan period: most notably, a bronze urn and bronze model cart recovered from an eighth-century BC tomb at Bisenzio, both thronged with stumpy little figures. On the urn lid, they seem to be dancing around a chained beast, perhaps some monster of the underworld. Again, some representation of a ceremony or *rite de passage* may be a plausible explanation here.

HUT-URNS AND HOUSES FOR THE DEAD

The terracotta hut-urn is for many people one of the most engaging items in an Etruscan museum. It is an essential, primal form: a den, a shelter; 'Adam's house in Paradise'; a childhood idyll. Perhaps modern viewers sense an inkling of its original, uncanny function – to provide a comforting booth for the soul. When a hut-urn is decorated outside with a maze, as is a famous example from the Selciatello cemetery at Tarquinia, it will be seen by folklorists as a refuge from confusion, or a marker of the unknown – 'the undiscovered country, from whose bourn no traveller returns'.

As a concept, the hut-urn is not unique to Etruria. But if any single artefact could be said to embody the predominant surviving *raison d'être* of Etruscan art and architecture generally, then the hut-urn would be a strong candidate. It is patently a miniature simulacrum of the sort of dwelling actually in use at the time, with its oval or circular form, and its ridged and gabled sloping roof with smoke openings and closable door (though most urns have detachable lids too). Windows may be suggested by exterior decoration. The apex of the roof may feature projected 'horns'. Inside the hut would be placed the cremated remains of the deceased.

The process of cremation does not normally reduce the entire body to ashes, and in some cases the bone remains within a hut-urn are sufficient for a tentative analysis of their gender. At Osteria dell'Osa, such analyses reveal a pattern of male usage of hut-urns, and concomitant associations of weapons – swords, spears or razors – deposited with the urns. The excavator of Osteria, Bietti Sestieri, accordingly proposes that hut-urns there were reserved for the burial of young male 'heads of houses'. Whether this was the custom elsewhere is not clear. At Tarquinia, finds of hut-urns are infrequent; those found are generally accompanied by conspicuously generous assemblages of grave goods, which would suggest that some sort of élite was honoured in this fashion.

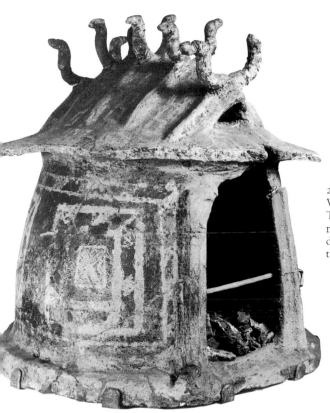

21 Villanovan hut-urn from Vetulonia, eighth century BC. The 'horns' on the roof probably reflect actual akroteria on domestic or sacred buildings of the period.

22 Villanovan hut-urn from southern Etruria, eighth century BC.

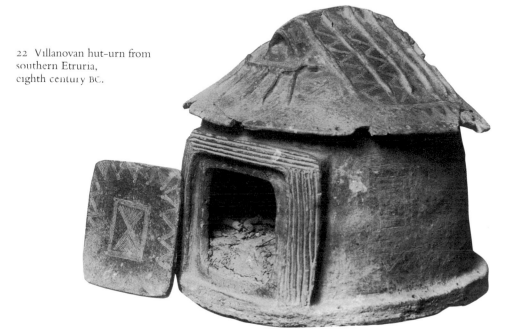

Whatever specific social status was entailed by a hut-urn, its basic significance demands our sympathy. It presents, in miniature, a posthumous domicile: a permanent resting place created in the image of a transitory habitat. This is a reflexive concept which will become a hallmark of Etruscan culture. It amounts to more than the honorific furnishing of an afterlife with familiar objects or daily gee-gaws – the prize cup, the stout weapon, the perfume jar or the delicate brazen tweezers – and is instead an act of scrupulous imitation. The society of the living recreates itself as the community of the dead.

To describe this process as 'scrupulous' does not mean that circumstances of burial faithfully reflect conditions among the living. Plainly not all hut dwellers were buried in a hut-urn. But we can see that the aspirations of a blessed afterlife were framed in an essentially non-fantastical spirit. The deceased members of an Etruscan settlement formed satellite communities that were linked to the living not only by topographical proximity, but also by physical resemblance. The Etruscan dead were not hived into dovecotes, nor subdued beneath cenotaphs; they had houses. In due time the dead had not only their own streets, but their own town planning too. This is why the best term for an Etruscan cemetery is not cemetery at all, or graveyard, but 'necropolis' which means, literally, 'city of the dead'.

It is in the necropolises of Etruscan cities that we can best see the development of Etruscan domestic and urban architecture. The thatched roof of the hut will give way to tiles. The single room of the hut will become a chamber with multiple rooms. And the reflexive logic will begin to work on a parallel scale. That is, although the dead may still be cremated and their remains stored neatly in a jar, they will occupy a tomb-house equivalent in size to their accommodation while they were alive. In fact, it appears that the houses of the dead were more solidly constructed than the Etruscans' living quarters. Carved wholly or partly into the tufa stone, these were desirable residences intended to last not merely a lifetime, but for all eternity.

To the Romans, centuries later, this aspect of Etruscan culture would appear grotesque and on a par with the wasteful vanity (as the Romans perceived it) of Egyptian pyramid building. Why expend so much time and effort for the benefit of shades? Why take so many valuables out of circulation by depositing them in sepulchres? We can only speculate, though, on how an Etruscan might have defended funerary expenditure. Some clues are later provided by tomb iconography. In the meantime, it is sufficient to

notice that the key concept of providing the soul with a familiar space was established in the Villanovan period. It was not an imported ideology.

ETRUSCAN POTTERY: IMPASTO AND BUCCHERO

Before we turn to the successive waves of external artistic influence upon Etruria, it seems appropriate at this point to define the indigenous styles of pottery. Pottery was a minor art in the ancient world, but it has a greater significance now because of its capacity to survive. Other artefacts decay, or are more prone to raids. Thus pottery gains a disproportionate archaeological value. But it was also once the most ubiquitous connection between life and art in Etruria, even if (at a guess) eighty per cent of vessels in daily use carried little or no decoration as such.

The blanket term for homemade, coarse or simply utilitarian Etruscan ware is 'impasto'. This term denotes a type of clay which contains chips ('inclusions') of mica or stone. It fires, often unevenly, to a range of colours: brown, black, orange, red, ochre and various shades in between and besides. Storage jars, cooking pots and braziers were all made of impasto, as were hut-urns and biconical urns. In northern Etruria especially, potters experimented with figurative complexes similar to those achieved in metalwork. On one such, a biconical urn from Montescudaio, near Volterra, two figures on the 23 lid of the vessel seem to be preparing or enjoying a tray of hearty loaves or cakes, with a big wine bowl nearby. Below, a solitary figure perches on the handle of the body of the vase. Is he the deceased, and are the figures above his bereaved family, staging a funerary meal? The scene should quite possibly be read in that way, though of course the details are too indeterminate to permit any precise interpretation. Similarly, the helmeted and combative rider we see serving as the handle of a 'duck-shaped' flask (askos), found in a 24 Villanovan tomb at Bologna, remains a simplified and abstracted form of ornament. The groups of intertwined figures, found on urns from Chiusi in the north and from Pontecagnano down in Campania, are also difficult to identify: the embracing motif may suggest a form of sacred union, or some kind of 'last farewell'.

Impasto was steadily purified over the centuries of its production. But its role in domestic and funerary pottery was supplanted during the seventh century BC by the more distinctive shiny black or grey wheel-turned ware known as 'bucchero'.

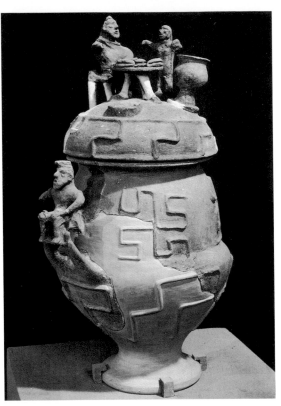

23 (*left*) Figured biconical urn from Montescudaio, *c.* 650 BC.

24 (*below*) Impasto *askos* from the Benacci cemetery, Bologna, late eighth century BC. The vessel probably served as a sort of drinking horn. The warrior wears the characteristic Villanovan crested helmet, and has a round shield slung over his shoulders.

25 Inscribed bucchero cup from Vetulonia, early sixth century BC.

Bucchero is such a distinctively Etruscan product, in fact, that it is taken sometimes rashly – to be a sign of Etruscan presence wherever it is found; it occurs in many sites around the Mediterranean basin, from the Iberian peninsula to the Levantine coast. It evolved out of impasto (hence the intermediate 'buccheroid impasto'), by a technical process still not fully understood, which evidently involved the oxidization of clay during the firing process. Production appears to begin at Cerveteri around 675 BC, spreading quickly to Veii and Tarquinia. Curiously, it is more sensitively formed at the outset than in its 'developed' state: so in the usual categorization of the pottery, bucchero starts as 'fine' (*sottile*: 675–625 BC), is then 'transitional' (*transizionale*: 625–575 BC) and ultimately 'heavy' (*pesante*: from 575 to the early fifth century BC). Fine bucchero is mostly associated with southern Etruria, and heavy with northern centres such as Chiusi.

37

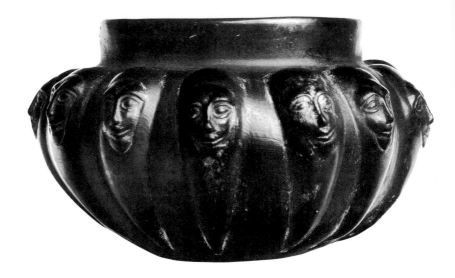

26 Bucchero bowl with anthropoid relief decoration, mid–sixth century BC.

Bucchero is pottery pretending to be metalware. Not deceptively pretending, of course – although there are examples of bucchero vases once covered with a very thin layer of gold or silver leaf – but certainly aiming to give the exterior appearance of metal vessels (which would have been much more precious). From the earliest examples, it looks as though the initial intention was to glaze and fire bucchero to a fine metallic sheen. If modes of decoration more commonly found in metalwork than pottery, such as plastic appliqués or carinated (ridged) surfaces and rims, are added and the sharp lines of beaten bronze replicated, the result can be almost convincing.

Whether engraved or added in relief, whether geometric or figurative, bucchero employs plenty of ornament. In the course of its production, bucchero assimilates motifs and sequences of motifs from the East; it had no choice, since these usually came engraved upon metal vessels which the bucchero potter could not ignore. The morphological range of bucchero vases in turn exerted an influence upon the potters of late sixth-century BC Athens, who copied bucchero shapes, painted them in full Greek style and then sent them back to Etruria. Bucchero could also be pressed into the manufacture of

figurines and votive models. But perhaps it presents its most satisfying effect in its simple, 'classic' lines, such as the two-handled drinking cup known (in Greek) as a *kantharos*, or the trefoil-lipped wine jug (*oinochoe*).

This brings us to a point of summary. In tomb assemblages belonging to the seventh century BC, entire 'services' of bucchero vases have been found. To see the full range of glossy pourers, plates and drinking cups is to be struck by a testament of some formal luxury, if not in terms of strict value (for bucchero, as we have noted, is only feigning to be precious), then at least in terms of function. These chalices and ewers do not belong to a religious sacrament, but rather to the symposium, that social institution briefly mentioned in the Introduction. From at least 750 BC onwards, the symposium or drinking party was establishing itself around the Mediterranean. Whatever the material changes during the Villanovan period in Etruria – most likely a compound of mutually dependent factors such as population growth and increased agricultural efficiency – there was an élite in place by the early seventh century, ready to participate. And not only in drinking, but also in other displays of status, including the purchase and patronage of art.

Etruria and the Orient

FROM GILGAMESH TO THE ETRUSCAN LION

He was wise. He saw mysteries and he knew secrets. He brought us the tale of the days before the Flood. He journeyed far, he was wearied and sorely belaboured. On his return he engraved his story on a stone.

So concludes the epic of Gilgamesh, set down on various tablets in the Assyrian and Sumerian world. In both place (Gilgamesh semi-mythically ruled the city of Uruk, far along the Euphrates) and time (the earliest version of the epic belongs to the third millennium BC) the epic of Gilgamesh may seem remote from Etruria in the so-called 'Orientalizing' period, which conventionally runs from around 750 BC to the middle or end of the sixth century. But it is the proper starting point for anyone trying to understand the Orientalizing phenomenon in Etruscan art.

It is not inconceivable that some weather-beaten version of the Gilgamesh story eventually arrived in Etruria. Bucchero pottery, a possible sign of Etruscan presence, has been recovered from at least one site on the Syrian coast (Ras el-Bassit), and we know that there were Hittite translations of the epic in this area. However, it is not necessary to propose an actual transmission of the tale in order to measure its iconographical impact. It is the footloose image of Gilgamesh which counts, as a paradigm of personal or regal heroism. His great combat is with the monster of the cedar forests, Humbaba, who had teeth like dragon's fangs and the strength of a crushing torrent. His quest is for everlasting youth. Goddesses seduce him, and he kills lions at close quarters.

Although he was renowned for killing other animals too, his lion-slaying earned him an art-historical reputation. The 'Gilgamesh motif' denotes the figure of a warrior hieratically flanked by a pair of rampant lions ('tamed', or even dangling upside down from his hands). By the time this motif had diffused itself into Assyrian royal iconography, or been appropriated by other heroes or deities (such as the Greek Artemis, 'mistress of the animals'), the specific resonance

27 Etruscan gold fibula with granulated decoration of stalking lions, seventh century BC. Fibulae served as both brooches and fasteners.

of the name and deeds of Gilgamesh may have comprehensively faded. However, it is no accident that the image of mastery over lions appeals wherever autocracy requires a symbol or heraldic device. As a testament of personal power it was already a formulaic association by the eighth century BC in most parts of the Mediterranean.

And this despite no first-hand acquaintance with the beast. A substantial scholarly monograph entitled *The Etruscan Lion* by William Llewelyn Brown concludes with the perhaps over-tentative conjecture that 'lions were [not] often, if ever, to be seen in ancient Etruria'. Etruscan artists, as the author points out, committed too many errors of representation, such as giving a lioness a set of multiple dugs or teats that would not occur naturally. Since lions have never been part of the indigenous fauna of Italy, only their importation for special religious or circus-style purposes may ever have given an artist the opportunity for direct observation. But what we are dealing with in the Orientalizing phase of Etruscan art is not merely an aesthetic vogue for the exotic. The civilizations of the Near East and Egypt had nurtured technically innovative artists, especially in

41

28 (*left*) Miniature ivory sphinx from Murlo, late seventh century BC.

29 (*below*) Etruscan bronze cauldron with lion-head *protomes* from the Regolini-Galassi Tomb, Cerveteri, *c.* 650 BC. The vessel would have stood on a tripod, and was used for ceremonies of burning, libation or anointment.

metal engraving and relief work. Their figurative repertoires generically evoked a kingly or aristocratic 'good life': heroic duels, hunting, feasting, music and dancing. Samples of their work, when brought to the shores of Etruria, must have seemed exotically enchanting (for example, an ostrich egg covered with miniature incised decoration). But more importantly, such items of oriental provenance responded to a need: the requirement of a consolidating élite to set itself apart with distinct personal ornaments, weapons, socializing equipment and other markers of status.

27

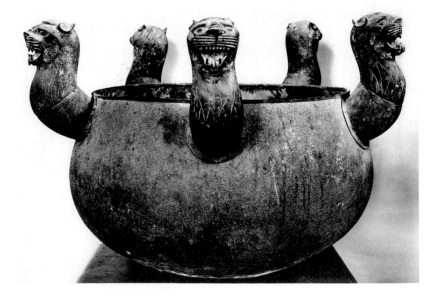

The Greeks of Homer's time, the eighth century BC, had a word for these prestige objects: *keimelia*, which implies those things which are to be treasured when plundered or presented, but not cashed in. In a pre-monetary age, the phrase 'cashed in' may seem peculiar. The point is that such *keimelia* circulated widely in geographical terms, but narrowly in a social sense. They were the means, along with feasting, by which aristocracies in the Asian Near East and the Aegean formed networks of friendship and reciprocal obligation. The extension of such networks westwards to include the Etruscans was ultimately what brought about the Orientalizing phase in Etruscan art. Our next task is to identify the agents of transmission – those who, in the interests of connecting élites, brought so many silent lions to Etruria.

THE PHOENICIANS AND ETRURIA

From an Etruscan perspective, of course, the 'Orient' could include Greece. But archaeologists have traditionally disputed the categorical identity of those who brought Oriental *objets d'art* to Etruria during the eighth and seventh centuries. The excavation of what appears to be the earliest Greek trading post in the West, at Pithekoussai on the little island of Ischia in the Gulf of Naples, has encouraged those supportive of the Greeks, and, more particularly, Greeks from Euboea who were believed to have opened direct links with the port of Al Mina on the Syrian coast in the ninth century BC. Others, however, prefer to promote the Phoenicians, arguing that periodic bouts of anti-Semitism have warped the course of scholarship in this area. There is probably no absolute answer regarding the ethnic allegiance of the 'Orientalizers' of Etruria: here we shall focus primarily upon the Phoenicians, reserving discussion of Greek activity for the next chapter. It may be noted that even at the supposedly 'Euboean' site of Pithekoussai, a large quantity of objects has been recovered whose provenance of origin more readily implies Phoenician mediation than Greek, but again, opinions on original provenance are not fixed (for example, there is disagreement about whether the figured sealstones belonging to the so-called Lyre-Player Group were made in Cilicia, or north Syria, or Rhodes). And the disintegration of Phoenicia itself during the eighth century (under Assyrian conquest) does not facilitate the establishment of precise provenances.

Chronologically, however, there can be little doubt about who first skirted Etruscan waters. An inscribed Phoenician temple dedication

stone from Nora in Sardinia has been known since 1773, and is unanimously dated to the late ninth century BC. And in the eighth-century world of Odysseus, it is not the Euboeans but the Phoenicians who are caricatures of ruthless itinerant mercantilism. Their interests lie solely in identifying demand and organizing supply. Homer, pandering to an aristocratic disdain for trade, accords them only scorn. But beyond this stereotype, and beyond apparently isolated inscriptions such as that from Nora, what do we know of these Phoenicians?

Ancient Phoenicia was roughly equivalent to modern Lebanon, though in English 'the Levant' tends to imply a more extensive area of the eastern Mediterranean seaboard. The Biblical denomination 'Canaanites' is probably close to the Phoenicians' own term for themselves. With a famously 'cedar-rich' hinterland, their principal city was the promontory of Tyre, one of whose kings, Hiram I, seems to have established a protectorate over the western parts of Cyprus during the tenth century BC. Further westerly expansion by the Phoenicians was marked by their settlement at Carthage (in modern Tunisia) in 814 BC. Those Phoenicians based at Carthage are usually referred to as 'Punic'; their strength was ultimately sufficient to launch an invasion attempt on Rome, under the command of Hannibal, at the end of the third century BC.

But their earlier contacts with Italy were more peaceful. Indeed, notoriously so. When Aristotle was composing his *Politics*, around the middle of the fourth century BC, and considering the nature and extent of independence of states bound together by economic treaties, he referred his Greek audience to the example of the Carthaginians and the Etruscans. 'These peoples', he notes, 'have agreements about imports and exports; treaties to ensure rightful conduct of trade; and written pacts of alliance for mutual defence.' But, as he goes on to point out, they did not interfere in each other's internal affairs. The purpose of their bilateral agreements was to further reciprocal benefit from commerce; non-aggression treaties were a natural part of that end (*Politics* 1280 a–b).

Aristotle's choice of the Etruscans and Carthaginians as exemplary exponents of cordial interaction in the Mediterranean is a valuable minor historical allusion to a pair of 'barbarian' powers acting with the political sophistication usually associated with the Greek city-states. And it was significantly buttressed in 1964 when excavators at Pyrgi, the port of Cerveteri, unearthed a set of gold plaques inscribed with a joint Etrusco-Phoenician announcement relating to

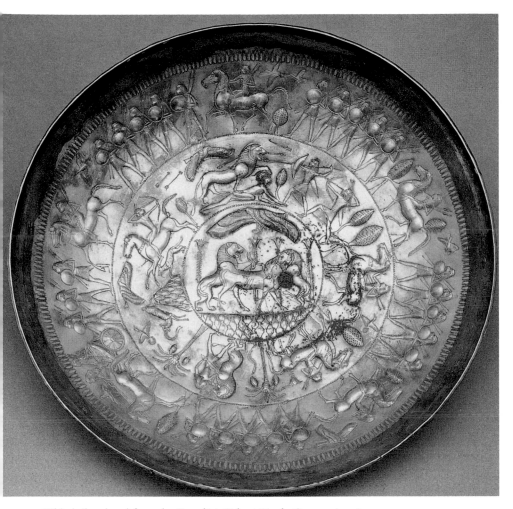

30 Gilded silver bowl from the Regolini-Galassi Tomb, Cerveteri, *c.* 650 BC.

one of the early fifth-century BC temples at the site. Further discussion of Pyrgi follows in Chapter Four. But neither Aristotle nor the Pyrgi plaques can assist us with the beginnings of entente between Phoenicians and Etruscans. This is a process only delicately reconstructed on the archaeological basis of the 'diffusion' of Oriental objects in Etruria, linked with the early history of Phoenician colonies in Sicily and Sardinia.

Perhaps a general clue is to be had from Aristotle, however. He implies that politically mature agreements, such as those pacts (*symbola*) made by Etruria and Carthage, develop from relationships established in an earlier period, when it was not a state which controlled the lives of its citizens, but aristocracies which undertook to provide security for the lower orders of society. Homer may have despised Phoenician traders, but when he describes the large silver bowl offered by Achilles as a prize in the games held at the funeral of his friend Patroclus, he specifically identifies it as Phoenician craftsmanship. 'The loveliest thing in the world', it was a typical *keimelion* 'shipped across the misty seas by Phoenician merchants' (*Iliad* 23, 740–5). And it has its own colourful history of exchange, ransom and seizure even before it is won at the funeral games by Odysseus.

When we contemplate any of the showy objects of Phoenician handiwork recovered from a seventh-century Etruscan tomb, such as the gilded silver bowls from the Regolini-Galassi Tomb at Cerveteri, we can only imagine such histories. What bright-cheeked girl brought these as her dowry? Who wrestled brawnily for their award? Still, this is where our recourse to theories of gift exchange allows us to comprehend at least the patterns of distribution evident here. Probably manufactured in Phoenician Cyprus, similar examples of such bowls have been recovered from 'princely' tombs in various parts of Italy: at Cerveteri and Vulci in Etruria, at Palestrina (Praeneste) in Lazio and at Pontecagnano in Campania. Close relatives of these bowls, executed in bronze, have also been found in Vetulonia, in northern Etruria, and Francavilla Marittima, down in Calabria.

Had their owners studied these bowls as a corpus, their imagery would have presented the following formulaic nature. Concentric registers display figures hunting deer and other animals (including lions); there may also be files of waterfowl or horses, perhaps evoking the hunting or cavalier ambience. Scenes of warriors stepping out on foot are complemented by figures – apparently a king and his entourage – driving chariots. Combat with a monster takes place, as do scenes of sacrifice and worship. A central tondo motif recalls the standard image of pharaoh triumphant; Egyptian hieroglyphs may also be scattered around.

While some components of this imagery – the hieroglyphs, for a start – may have puzzled an Etruscan viewer, the overall effect comfortingly meets the expectations of a kingly lifestyle. And the distribution of these bowls surely attests to their intrinsic promiscuity.

They circulated not only among an Etruscan élite, but also served to lubricate relations between Etruscan aristocrats and their Latin or 'Italic' counterparts.

AN ORIENTALIZING PARADIGM:
THE REGOLINI-GALASSI TOMB

Several individual tombs or tomb complexes in Etruria bid to be considered paradigmatic of the Orientalizing phenomenon. Among the various candidates we might mention the Bocchoris Tomb at Tarquinia (*c.* 670 BC). This contained a Phoenician faience vase decorated in pseudo-Egyptian style which bears the cartouche of the pharaoh Bocchoris (who reigned *c.* 720 BC); in the same tomb assemblage was a necklace of numerous Egyptian-style faience figurines. The Tomb of the Warrior (Tomba del Duce) at Vetulonia is a group of several burials which mixes military relics (shield, helmet, horse-bits and the remains of a chariot) with delicate Phoenician and Greek drinking vessels. And the later, sixth-century BC Polledrara Tomb, or Tomb of Isis, at Vulci, seems to have stored a number of engraved ostrich eggs, as well as some enigmatic female statuettes, one of them speculatively labelled as the Egyptian goddess Isis.

31 Bronze figure of a woman holding a horned bird from the Tomb of Isis, Vulci, mid-sixth century BC.

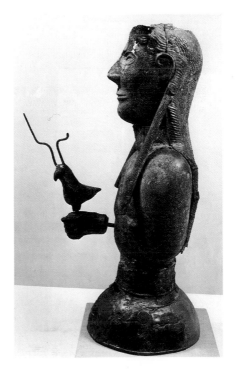

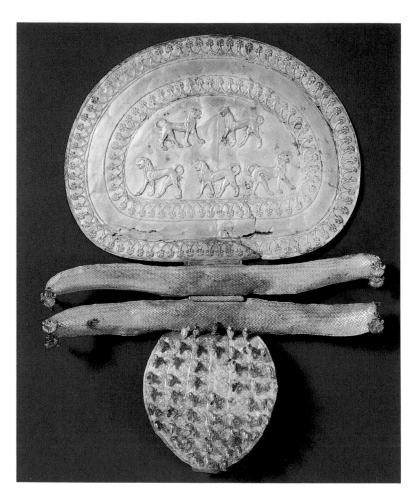

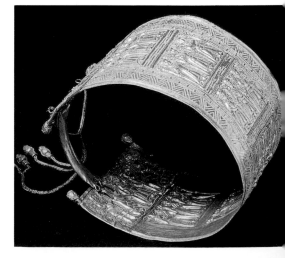

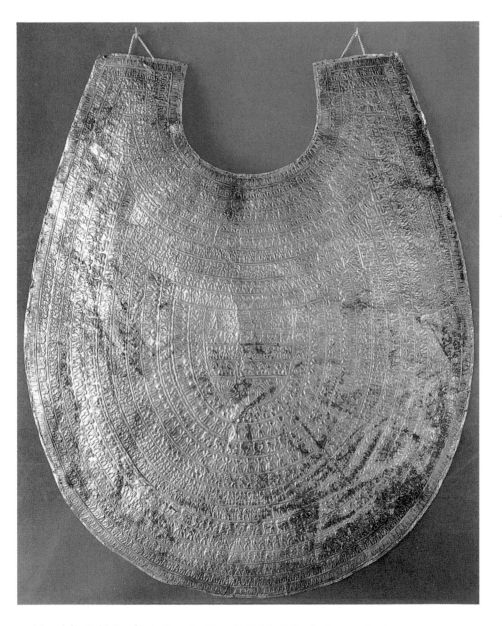

32 (*above left*) Gold disc fibula from the Regolini-Galassi Tomb, Cerveteri, *c.* 650 BC.

33, 34 (*left*) Gold bracelet, and detail showing dancing ladies, from the Regolini-Galassi Tomb, Cerveteri, *c.* 650 BC.

35 (*above*) Gold pectoral from the Regolini-Galassi Tomb, Cerveteri, *c.* 650 BC. Though the gold may have been backed with leather, the pectoral is too thin to have served any purpose in actual combat: its function is purely ceremonial.

Excavated in the nineteenth century, none of these is very satisfactorily documented. The best, relatively, is the Regolini-Galassi Tomb at Cerveteri, whose contents have long been displayed as the nucleus of the Vatican's Etruscan collection. Hacked out of the Sorbo necropolis – the oldest of several cemeteries surrounding the city of Cerveteri – in 1836, this was by no means a subtle excavation: the tomb contained so much metal that its pottery seems to have been largely discarded, and much of the grave furniture was damaged by an inept attempt to enter by the roof of the tomb, which caused it to collapse. Nevertheless, the generous relics associated with the three burials inside the tomb (entered by a gabled passageway or *dromos*) still create a grand impression.

One burial was a cremation, with an ash-urn placed in a niche; another was the inhumation of a woman in the central area of the tomb; the third was the inhumation of a 'warrior' in an ante-room. Bearing in mind our earlier caveat about assuming too much by way of gender stereotypes in grave depositions, we shall here avoid attempts to assign objects to 'woman' or 'warrior' on the grounds of supposed likelihood of possession (it is, for instance, not clear from the excavation record to which assemblage the remains of a 'killed' war chariot pertain). But there is no doubt that the woman, seemingly named Larthia to judge from several inscribed objects (though Larthia has also been read as the genitive form of a man's name), was accorded the richest honours.

She (or he) was decked with jewels and other splendours. Since she was probably laid to rest in her finest vestments, the golden fasteners found in her area may be taken to have adorned her inhumed body. On one large disc fibula, five lions stride. Two bracelets, similarly worked in granulated gold, show registers of dancing ladies. Ivory perfume or make-up jars (*pyxides*) feature winged beasts and the 'Gilgamesh motif'. But perhaps the most splendid item is the laminated gold pectoral or breastplate, tricked out with numerous registers of tiny patterns and figures (notably winged lions). It is not hard to imagine Larthia sitting, as it were, in state; parts of a throne and footstool were also duly recovered from her grave.

Not all of these items were imported: the pectoral, for example, is considered to have been locally made, as is a set of bronze cauldrons with lion-head extensions or *protomes* which seem to belong to the 'warrior's niche'. Eight bronze shields with stamped decoration, and many weapons, spits and andirons lend this burial a military character. A metal couch, and a 'food trolley', or, as is more likely, a mobile

incense-burning basin, further indicate that the occupant was a gourmet or hedonist. But perhaps most touching is the humbler assemblage of thirty-three little effigies made of bucchero, caught in various postures of grief or lamentation. These, surely, represent those left behind: the mourners who howled as they escorted the funeral waggon, with its distinguished corpse, to the grave.

The burials in the Regolini-Galassi Tomb belong to *c.* 650 BC and later. Before leaving the chronological limits of the Orientalizing period in Etruria, it is worth noting two further tombs of the later seventh century. One is situated in the internal territory of Cerveteri, near Ceri. Called the Tomb of the Statues, it features two enthroned figures carved into the rock at the end of the tomb's passageway. Each is sitting with his arms laid across his lap in the 'assize' or judgmental mode, and his feet resting on a cushioned stool. One holds a magisterial club of the sort known in Greek as a *lagobolon*; the other, a palmette-headed sceptre. The parallels with Near Eastern images of lordship are precise enough to suggest that these figures may actually be the work of Syrian-Hittite sculptors, 'guest artists'. Whoever commissioned the tomb certainly had (or was given) a particularly Oriental idea of how family status should be shown. In the ancestral dwelling place, the figures seem to demand the same obeisance that they were doubtless shown (or at least desired) in life.

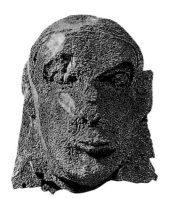 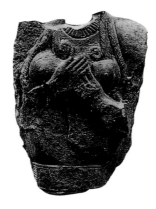

36, 37 Head of a female figure, and a female torso, from the Pietrera Tomb, Vetulonia, *c.* 640 BC.

Fragments of female figures from the Pietrera tumulus at Vetulonia, on the other hand, suggest attitudes not so much of authority as bereavement, with hands clasping the chest in stock lament. These figures, datable to *c.* 640 BC and already showing the influence of Greek 'Daedalic' style, may be considered large-scale versions of the multiple bucchero grieving figurines recovered from the Regolini-Galassi Tomb.

When summarizing this period, it must be remembered that most of the tombs described as Orientalizing also include small quantities of Greek pottery, particularly perfume vessels from Corinth. Considering the supposedly itinerant way of life of Archaic merchants in the Mediterranean, it would be very odd if 'princely' tombs displayed homogeneous sets of treasures. Ships had numerous ports of call between East and West. And the tombs' own occupants may, while alive, have travelled themselves: perhaps, like Homer's Menelaus in *Odyssey* 4, the 'warrior' honoured in the Regolini-Galassi Tomb might have been able to recite a list of his treasure-collecting expeditions ('Cyprus, Phoenicia, Egypt; Ethiopia, Sidon, Erembi: I visited them all').

Yet the Orientalizing tag remains historically valid, and useful. If we follow the Homeric picture of the Phoenicians, they may be seen as middlemen, merely transferring glittering prizes from Sidon or Cyprus or Egypt to Etruscan customers. But in the light of Aristotle's remarks about Etrusco-Carthaginian treaties, we should imagine more substantial interaction. The fact that early Etruscan wine amphorae are modelled on a Phoenician shape known as the 'Canaanite jar' suggests that Etruscans and Phoenicians may have drunk together and formed the individual 'guest-friendships' that eventually became the joint temple building operations at Pyrgi and the interstate accords described by Aristotle. By 500 BC, a generalized amity between the Phoenicians (or at least, the 'Punic' Phoenicians of Carthage) and the Etruscans seems to have prevailed. It was underpinned by a mutual interest in blocking the increasingly expansive colonial ambitions of the Greeks. Although the Etruscans did not wish to cede territory to the Greeks, they were to offer them little cultural resistance.

Etruria Hellenized

THE GREEKS IN THE WEST

According to Herodotus, Greeks from Phocaea on the Asia Minor coast opened up the route to the Adriatic, Etruria and the Spanish peninsula. Archaeologists disagree. Pointing to evidence from the site of Pithekoussai, they prefer to credit the Euboean Greeks with the pioneering role. And early samples of Greek or imitation Greek pottery from Etruria seem to confirm this preference. The Quattro Fontanili cemetery at Veii, for instance, yielded drinking cups with characteristically Euboean geometric decoration of the eighth century BC: running chevrons, or the concentric design known as the 'pendant semicircle'.

Herodotus was never as well informed about the western Mediterranean as he was about the eastern. But one of the stories he had heard about the Phocaean pioneers should be recalled here. In the *Histories* (1. 165–6), he tells how the Phocaeans settled a colony at Alalia, on the coast of Corsica. From there they launched a series of pillaging raids, bringing them into conflict with Etruscans and Phoenicians. Some twenty years later, in *c.* 540 BC, they battled with a combined Etrusco-Carthaginian fleet in the seas off Sardinia. Though claiming victory, they lost so many ships that they had to yield the colony. In the aftermath, a number of Phocaean prisoners were taken ashore at Agylla – which was the Greek name for Cerveteri – and stoned to death by locals. This atrocity, Herodotus reports, brought about a supernatural curse: when any person or animal went near the place where the stoning had happened, they were afflicted with bodily paralysis. The people of Cerveteri beseeched the oracle of Apollo at Delphi for advice on how to expiate their crime, and were told to honour the murdered Greeks with funeral games, an injunction which, says Herodotus, 'they still observe today'.

The archaeology of Pithekoussai is important in revealing the Greek intrusion upon the Orientalizing process. But this story from

Herodotus is perhaps more effective as an explanation of the 'Hellenizing' dynamic in Etruria. The Etruscans, with their Punic allies, are understandably hostile in the face of Greek encroachment upon their territory. Yet to make amends for a 'war crime', they are obedient to the protocols of Greek religion. They send a delegation to Delphi – a site normally categorized as pan-Hellenic, or 'Greek only' – and are invited to return to the sanctuary on a regular basis. This means, among other things, that Etruscans from Cerveteri would have been exposed to the enormous display of war trophies, sculpture and painting at Delphi: towering marble monuments, such as the Naxian sphinx; relief sculptures, such as those on the Siphnian Treasury; free-standing bronzes, such as the Delphi Charioteer or the thirteen figures executed by Pheidias to commemorate the battle of Marathon; and large murals, such as those painted by Polygnotus on the walls of the Meeting House of the Cnidians.

The Greeks also came to Etruria. During the seventh and sixth centuries BC, Greek colonies were planted in Sicily, southern Italy,

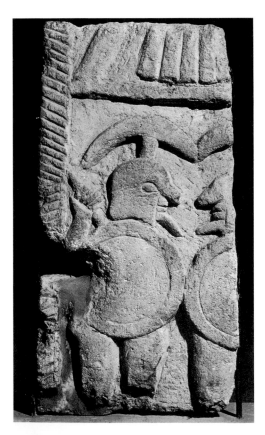

38 Relief showing two warriors from Tarquinia, early sixth century BC. This was probably part of a gravestone or *stele*. The warriors are equipped with the armour of the Greek foot-soldier or *hoplite*.

southern France, and Spain. In Plato's phrase, they were like 'frogs around a pond', sitting on the Mediterranean shoreline, always facing out to the sea as their salvation. The Euboean craftsmen and traders who had set up a base on Ischia eventually moved to the mainland, and established the colony of Cuma. There was, in due time, settlement of rural hinterlands, as studies of Poseidonia (Paestum) and Metaponto have shown. But the fact that, unlike other native Italic peoples, the Etruscans resisted outright colonization did not preclude commerce and exchange. Special trading posts (in Greek, *emporia*) were created precisely for that purpose. One of these, Pyrgi, has already been mentioned. A second was Gravisca, which served Tarquinia. Among the finds from excavations there is a stone anchor dedicated to Apollo, possibly by the same Greek trader, Sostratos, who is mentioned by Herodotus (*Histories* 4. 152), and who we believe carried vases among his cargo; a proprietorial *graffito*, 'SO', is scratched on the base of a number of surviving pots. Less is known about a third, Regisvilla, which evidently served Vulci. But it is clear that these port sites were the conduits of passage for much Greek art into Etruria. The term 'trading posts' is inadequate, since they also had both industrial and residential areas, and offered places of worship and recreation. They signalled Etruscan power, and not only spending power (thus *pyrgoi*, in Greek, means 'the towers', and may imply defensive structures). But above all they were places of intense receptivity.

Whether in the process of formal colonization it was a case of 'trade before the flag' has become a stale academic question. It is better to talk of 'paracolonial' rather then 'precolonial' trade – trade around and beyond colonization, not its precondition. Even 'trade' should be qualified in some way, so as to permit some survival of the old patterns of gift exchange and aristocratic 'networking'. However, the capacity of Etruria to host not only art but also artists, and to engage those artists in some form of local instruction, becomes increasingly evident during the seventh and sixth centuries BC.

So we witness, in the first decades of the seventh century, the phenomenon of 'Etrusco-geometric' pottery, developing in parallel to various styles of geometric decoration in the Aegean. It quickly ripens from simple linear and circular patterns into systems of figurative motifs – herons, fishes, soldiers – and more colourful schemes, such as those evident on the splashy 'white on red' impasto vases from Cerveteri and elsewhere. Iconographical interest also develops precociously. Scenes depicting the deeds of Theseus, the birth of

55

Athena, and Medea battling with the dragon of Colchis are among those recognized on vases produced in Etruria between 680–650 BC. They are capped by the first artistic signature in Italy – indeed, in the Greek world – found on a vase from Cerveteri which dates from c. 650 BC.

This signed vase is a *krater*, or bowl for mixing wine and water. One side shows a sea battle, whether actual, generic or heroic we cannot tell. The other side is readily identified as an Odyssean episode: the blinding of the Cyclops Polyphemos as recounted in *Odyssey* 9. Here, in a retrograde script of Euboean Greek characters, the artist has left his mark: *Aristonothos epoiesen*, 'Aristonothos made [this]'.

The name is curious. It means 'best bastard', perhaps implying a servile or renegade background for the artist. The use of Euboean script is not a surprise, since in c. 700 BC the Etruscans adopted the Euboean alphabet (which in turn derived from Phoenician letters) for the purposes of becoming literate in their own language. We may even suppose that the wine-drinking owner of this vase at Cerveteri could read a Greek signature such as this. But what of the rest of the decoration? Were bards circulating epic tales, such as the blinding of the Cyclops, in Etruria as they were in Greece? Did Aristonothos work directly to an Etruscan commission? Or is this simply an imported *objet d'art*?

The discovery and publication of vases decorated with Greek mythological scenes and made in Etruria prior to the Aristonothos piece renders untenable a former scholarly view that the Etruscans copied the form of Greek myth (sometimes erroneously) without comprehending its significance. Naturally, individual myths would have taken on new meanings as they travelled, and it would of course be rash to assert that the average Etruscan artist had a copy of Homer at his elbow (even in Athens, the poems made canonical under the name of Homer were not collected and written down until the second half of the sixth century BC). But we must assume a basic coherence between image and patronage. Archaeologically, there is no reason why Aristonothos should not have come in person to Cerveteri in the mid-seventh century BC, perhaps from Euboean Pithekoussai, or Cuma, and we must assume too that his cultural baggage came with

39 (*opposite*) Krater signed by Aristonothos from Cerveteri, mid-seventh century BC. One side (*above*) shows a sea battle. On the other (*below*) Odysseus and his men drive a stake into the single eye of the Cyclops Polyphemos. Above the giant's head is the basket of cheese – all as described in Book 9 of Homer's *Odyssey*.

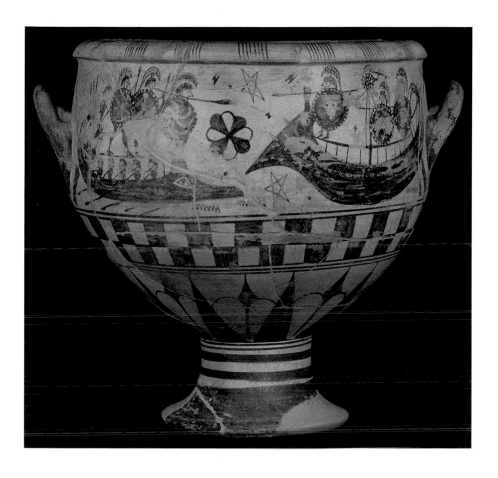

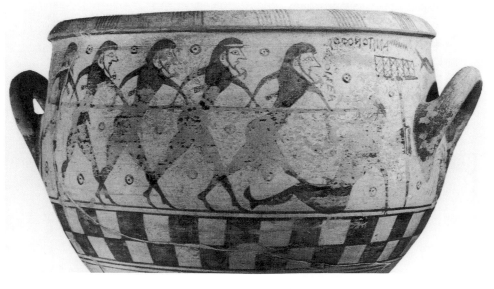

him. As long as he was armed with technical ability and not coloniz-
ing ambitions, he was *persona grata*. Eventually he may have taken on
native apprentices. As such, he enters our account not only as an artist,
but as a named representative of the many anonymous but influential
protagonists of cultural change in Etruria.

A number of external factors impinged upon the policy of
Etruscan aristocrats to Hellenize. The most important of these was
the Persian invasion of East Greece during the late sixth century BC.
Stylistic details of art in Etruria at this time plainly reveal East Greek
affinities or handiwork. It is generally accepted that the first group of
painted tombs at Tarquinia was executed by immigrants from East
Greece (or Ionia, as it is also known). A good small-scale example of
such displaced creativity is the Swallow Painter, an Ionian vase
painter who seems to have settled at Vulci, and provided the locals
with drinking vessels executed in the distinctive 'Wild Goat' style of
his homeland.

40 Jug attributed to the
Swallow Painter, early sixth
century BC.

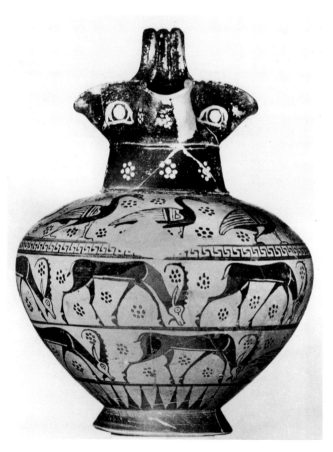

The itinerant tendencies of Greek artists would in any case have been encouraged by the colonizing dynamic which led to a 'Greater Greece' (Magna Graecia) in South Italy. The colonies, famously, offered bounties to all who could bring them authentic Greek 'culture', be it a tragic drama, a temple design or a mathematical system. And to the north were the Etruscans. They possessed mineral and other natural resources which were attractive in the Mediterranean market. And unlike the Athenians and Spartans and others at the time, for whom sumptuary legislation prevailed, the Etruscans were not bound to stint on the practice and principles of symbolic extravagance.

DEMARATUS AND THE ELABORATION OF CLAY

As we shall see in Chapter Five, the city of Rome was once ruled by a dynasty of Etruscan kings, the Tarquins. Roman historians, in particular those writing at the time of Augustus, came up with a comforting non-Etruscan ancestry for these Tarquins. They claimed that the first Tarquinius was the son of an exiled Greek aristocrat called Demaratus. Demaratus, so the story goes, was forced to flee Corinth, his native city, when it was seized by a tyrant in the middle of the seventh century BC. Since he had 'amassed great wealth' in previous trading with Etruscan cities, he came to Etruria. And in his entourage he brought three skilled individuals, Diopos, Eugrammos and Eucheir. These, we are told, introduced to Italy the various arts of shaping clay.

The political significance of this story need not concern us now. There is no direct evidence whatsoever for a figure called Demaratus, and no reason to give credence to the story at all, except that, in a general sense, it can be attuned quite nicely to archaeological evidence. That is, at a number of Etruscan sites – including Acquarossa, Veii, Cerveteri and Murlo – from the mid-seventh century BC onwards, architectural terracotta sculptures begin to appear. And the link with Corinth seems to be substantiated by the large quantity of Corinthian imported pottery in Etruria, beginning with examples of 'proto-Corinthian' vessels in *c.* 675 BC.

So there is a specious or paradigmatic truth to the Demaratus tale. The names of his attendant experts are suspiciously apt. Diopos, translatable as 'straight-liner', must connote an architect or surveyor. Eugrammos implies a graceful draughtsman. And Eucheir simply means 'dexterous' – perhaps someone skilled in the moulding of clay figures, whom the Greeks would have termed a *koroplastes*.

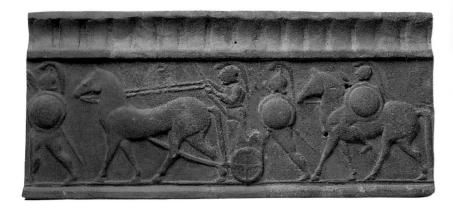

Why did Roman historians fix upon terracotta to define the arrival of art in Italy? The answer is not simply that there were antique examples of terracotta work still to be seen in late Republican or early Imperial Rome, but rather that the medium itself had become recognized as a 'native' form of expression. The nationalistic politician Cato, in a typical speech reported from the second century BC, declares angrily: 'I hear too many people praising the knick-knacks [*ornamenta*] of Corinth and Athens, and laughing at the terracotta antefixes of our Roman gods' (Livy 34. 4. 4). He thus endows terracotta sculpture with an earthy local integrity in contrast to the flashier products of foreign countries.

And there is some justice behind this rhetoric. At Latin, Faliscan and Campanian sites – such as Rome, Velletri, Satricum, Falerii or Capua – no less than Etruscan, the revetments, akroteria, antefixes and plaques affixed to temples or distinguished residences demonstrate a basic unity of design and content. It may seem odd to introduce these in a chapter entitled 'Etruria Hellenized' if they are to be billed as native products. Yet although they undoubtedly take on a local Central Italian homogeneity of style, again it appears that Greek workmanship provided the initial impetus.

Corinth had a seventh-century tradition of painted terracotta plaques, but better parallels can be found further eastwards. For the figured friezes, in particular, antecedents exist at sites such as Neandria in the Troad, or Larisa in Aeolis. The Near Eastern imagery of power – feasts, hunting, processions – blends with intermediate Greek Orientalizing (files of panthers and sphinxes) to

41 (*left*) Architectural terracotta plaque from Veii, sixth century BC.

42 (*right*) Bronze *lituus* from Cerveteri, early sixth century BC. In Etruscan iconography, magistrates and priests are shown with such curled staffs.

43 (*below*) Reconstruction of a Tuscan order temple according to Vitruvius, by Gottfried Semper dating from 1878. We now know that many more figured terracotta antefixes would have been attached to the roof gable of such a building.

furnish the Etruscan aristocracy with programmatic statements of privilege. We shall return to some of these friezes in the discussion of Acquarossa and Murlo in the following chapter. For now it is enough to note that the iconography belongs to a zone that is neither entirely private nor entirely public, with some symbols – the double axe, or the curved 'magisterial' staff we term a *lituus* – verifiable as instruments of terrestrial power, and other elements indicative of myth (the Minotaur) or divinity (in a procession, for instance,

winged horses may appear). This public/private ambivalence may also extend to the function of the building on which terracotta friezes, akroteria and antefixes were placed. Residences and temples could be given very similar decorative revetments. Presumably divine pretensions among Etruscan clan leaders were rife. But if we consider now the origins of the Etruscan temple, we can appreciate the manifold opportunties its design offered to the terracotta specialist; roof tiles were only the beginning.

'Small, dainty, fragile, and evanescent as flowers.' D. H. Lawrence applauded the Etruscan eschewal of monumental stone temples. 'Give us things that are alive and flexible, which won't last too long and become an obstruction and a weariness.' It is true that the mainly wooden and mud brick construction of Etruscan temples ensured that none would survive as impositions. Even the treasury dedicated at Delphi by the people of Cerveteri has vanished, while its little marble neighbours stand. Yet ephemeral as they now seem, Etruscan temples must once have presented a gaudy and arresting sight, thanks to their terracotta elaboration.

As codified by the Roman architectural historian Vitruvius, there
43 is indeed a 'Tuscan order', which can be remodelled from his description of proportions, and is partially attested by some surviving ground-plans at Pyrgi (Temple A), Orvieto (Belvedere Temple) and the early layout of the Temple of Jupiter Capitolinus in Rome. Essentially the structure as defined by Vitruvius should be quadrangular, with the main room of worship (the *cella*) fronted by a colonnaded porch. The *cella* could (or should, following Vitruvius) be split into three separate rooms, or comprise one room with two side wings. This was certainly logical for temples like the Capitoline in Rome, where a triad of deities was honoured, but it does not seem to have prevailed as a general norm.

Vitruvius knew about the rooftop fantasies of the Tuscan order. Greek temples had figures at roof level too, and the Greeks managed to hoist them aloft in ponderous marble. But the sheer quantity of roof-borne figures and their polychrome paintwork must have rescued most Etruscan temples from excessive simplicity, and the fact that they are hollow and made of terracotta adds credibility to their position – a certain lightness of being, as it were. At gutter ends would be projected smiling, bejewelled female faces, or more puckish satyrs, or wild gorgon masks, or other mythical terrors, such as the half-man, half-beast figure known as Acheloos. Often these were presented in patterned horseshoe-shaped frames. Some temples

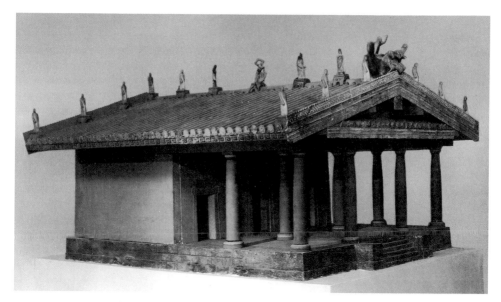

44 Reconstruction of the Portonaccio Temple, Veii (the original was constructed *c.* 500 BC). Unlike a Greek temple, this was clearly to be appreciated by a viewer approaching from the side (though the placement of akroterial figures is uncertain).

– Temple A at Pyrgi is an early and striking example – had complex mythical scenes worked in relief above the entrance, and most featured 'flying' akroterial figures along the gable ends.

Evidently the designers of Etruscan temples expected viewers to approach not only from the front, but sideways too. Only thus would anyone have appreciated the narratives enacted by the quartet of large figures on top of the Portonaccio Temple at Veii. Here large saddle-shaped tiles, slung over the ridge-pole, acted as the bases for divinities whose background, as perceived by a side-on viewer, was none other than the heavens. Built towards the end of the sixth century BC, this temple appears to have been dedicated to Menerva, the Etruscan version of Athena. The rooftop figures, however, relate more to Apollo. One appears to show the juvenile Apollo, carried by 46 his mother, Leto; another depicts the full-grown, 'far-shooting' Apollo, striding along with his bow and gesturing towards a third 45, 47 figure. This appears to be Herakles, clubbing down the Hind of Keryneia, which was sacred to Apollo's sister Artemis. A fourth figure was Hermes, who, like Herakles, had a history of disputes and 48 reconciliations with Apollo, but here appears perhaps as an arbitrator, holding his wand.

63

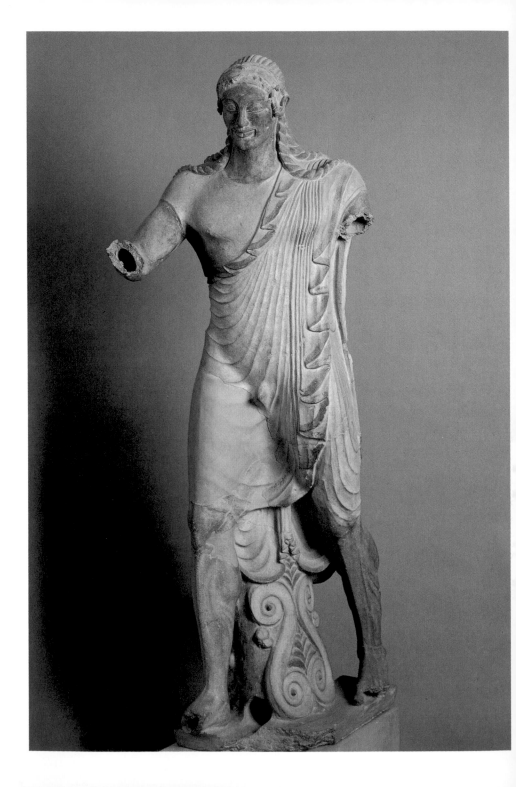

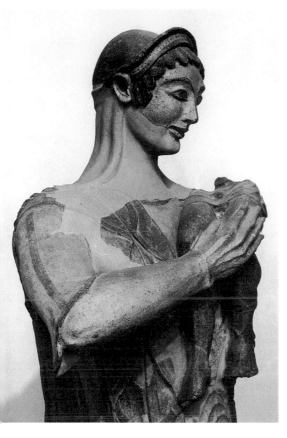

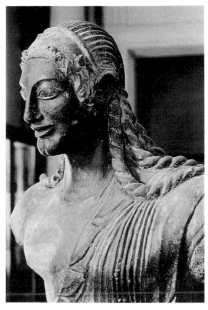

47 Detail of Apollo of Veii, *c.* 510 BC.

45 (*left*) Apollo of Veii, *c.* 510 BC.

46 (*above*) Figure of Leto from the
Portonaccio Temple, Veii, *c.* 500 BC. Leto
is shown in her child-nurturing
(*Kourotrophos*) role, as she was worshipped
at Delos and elsewhere in the
Mediterranean.

48 (*right*) Head of Hermes from the
Portonaccio Temple, Veii, *c.* 500 BC.

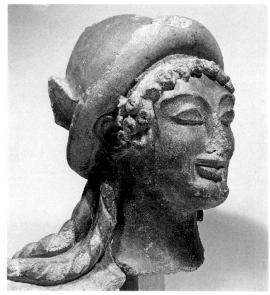

Perhaps the cult of Menerva here was oracular in nature and Etruscan commissioners had absorbed some of the convoluted twists of Apollo's mythography (worthy of the plot of a Verdi opera) directly from Delphi. But whatever the significance of the elevated drama on the Portonaccio Temple, there is no doubt that its discovery in 1916 had a tremendous effect upon the fortunes of Etruscan art history. The Apollo of Veii, with his cursive sweep of forward motion, wearing a smile at once easy and implacable, regenerated both scholarly and popular interest in Etruscan art. Like the Sarcophagus of the Married Couple from Cerveteri, the Apollo seemed to express an eager vitality unique to Etruscan culture.

Actually, the profile of the Apollo, with forehead curving directly along the line of the nose, is typically Ionian, as can be revealed by a comparison with East Greek paintings of the same period. And his smile is the same Archaic smile as that found on most Greek representations of Apollo in the sixth century. But this is not to deny an Etruscan stamp on the image of a deity who could transport himself, swift as a thought, across the Mediterranean. Along with Hera, Aphrodite and Demeter, Apollo enjoyed a cult following in the port of Gravisca by the late sixth century; in due time, the god would be regarded as resident on Mount Soracte, not a great distance from Veii. On his temple, he is shown fully clothed, at a time when Greek sculptors would invariably have shown him naked. This is an understandable decision on the grounds of effect. The plasticity of terracotta makes breeze-blown drapery a ready option and, besides, Apollo cannot be frozen immobile on the apex of a temple – he must be seen to be rushing.

PAINTING AND STORIES IN THE LATE SIXTH CENTURY

In what some describe as the 'Demaratean phase' of Etruscan art (roughly between 670 and 600 BC) certain phenomena are relatively easy to explain and chronicle: one, for example is the appearance of 'Etrusco-Corinthian' painted pottery. The importation of Corinthian vessels (themselves Orientalizing in style, and often containing unguents or perfumes from the East) provoked local imitation on a scale sufficient for scholars to attempt the individuation of painters and workshops. Inevitably some coarse generalizations surface here. We learn, for example, that whereas a Corinthian artist might show a prowling panther, an Etrusco-Corinthian imitator, being barbaric, liked to put some savaged prey in the panther's jaws or, by varying

49 Detail of 'Etrusco-Ionic' black figure amphora from Chiusi, late sixth century BC.

the theme of combat, to show vultures settling on a corpse. But close stylistic analysis has at least highlighted the flux of influences operating in individual cases. For instance, the artist endearingly called the Bearded Sphinx Painter (after a supposed personal idiosyncrasy, since, like all Etrusco-Corinthian painters, he never signed any work), to whom a hundred-odd vases have been assigned, has been shown to produce a Corinthian effect without actually copying any original

50 Detail of Etrusco-Corinthian jug, perhaps from Cerveteri, early sixth century BC.

Corinthian details. Apparently based at Vulci around 630 BC, he may even have worked in association with the East Greek Swallow Painter: both, for example, use an outline technique for rendering heads.

But what happens when the problem shifts from identifying a style to identifying the subject? As long as Etrusco-Corinthian painters were content to evoke the busy and colourful patterned effect of the Corinthian style, their work is not an iconographical challenge. As soon as figures outside the usual repetitive repertoire are introduced, we struggle to decipher.

A notorious example of this problem is posed by a small wine jug (*oinochoe*) found at Tragliatella, near Bracciano in the hinterland of Cerveteri. It has been placed in an Etrusco-Corinthian workshop – the Group of the Polychrome Vases, to be precise – but remains little short of a riddle wrapped in a mystery. To describe its two figured registers with minimal assumptions about meaning is enough to indicate the jug's enigmatic status. In the upper register are depicted a goat; a scaled down ship, placed vertically; a man taking a woman by the wrist with two birds nearby and a man reining in a goat. In the lower register a man, accompanied by a diminutive figure, offers a circular object to a woman, and a woman offers a circular object to a man. Behind them, seven armed dancers prance, their shields decorated with a motif of a boar. Behind them, a man holds a staff; behind him are shown two armed horsemen whose shields are emblazoned with birds, and a monkey who sits on one of the horses. Then follows a seven-ringed design labelled Truia, Troy; then two copulating couples and finally, a woman gesturing beside two objects which could be empty chairs.

An ingenious reading of this imagery has reconciled it more or less with the tale of Theseus and Ariadne. The two figures exchanging circular objects represent Theseus presenting a pomegranate (a symbol of love) to Ariadne, who in return gives him the ball of wool he will need to negotiate the Cretan labyrinth (suggested by the seven-ringed maze). The small figure hereby becomes the nurse of

51, 52 (*opposite*) The Tragliatella *oinochoe*, late seventh century BC. The detail below shows armed dancers. The shield motif of a boar anticipates a similar blazon depicted on shields in the Giglioli Tomb at Tarquinia (painted *c*. 300 BC), and also the image used for the local coinage of Tarquinia in the fourth century BC.

Theseus, and other elements relate to Theseus' heroic initiation and celebration, including sacrifice (hence the goat), armed dancing (what would later be known as 'the Trojan game') and 'divine union' (*hieros gamos*) with Aphrodite, as well as consummation with Ariadne. The two empty chairs are therefore regal thrones and the whole vase a miniature summary and justification of divine right (and rites) to power.

Various onomastic inscriptions on the Tragliatella jug do not clarify the identity of the protagonists. If the Theseus interpretation sketched above is correct, we shall have to remember that his appropriation as an 'Etruscan' hero in the mid-seventh century is unlikely to tally neatly with our more familiar knowledge of him, which comes essentially from Athenian sources concocted in the late sixth or early fifth century. This anachronism is important to consider in assessing the Hellenization process. To what extent are we dealing with 'alien wisdom'?

The stories which are generally described as 'Greek myth' were not, as we have stated earlier, copied uncomprehendingly in Etruria. They were retold and reshaped in the same way that an Athenian playwright such as Euripides might have changed an old story's setting, its characters and its plot-line to bring it up to date for an audience in fifth-century Athens. Each Etruscan centre must have possessed its own local heritage of stories. There is no direct proof, only some probability, that the Etruscans fostered the theatrical medium for transmitting stories; it is likely also that they patronized itinerant bards or rhapsodes. What we have to remember here, however, is that the figurative illustration of stories was largely entrusted, in Archaic Etruria, to Greek artists. They may well have been serving local needs – creating, perhaps, for the ruling élite a genealogy of heroic ancestors – but naturally they brought a didactic element to this process.

Artists, therefore, were at the cutting edge of acculturation in Etruria. Again, painted pottery provides a workable example of their activity. From the tombs of Cerveteri we have some thirty to forty vases (depending on how fragments are counted), largely homogeneous in style, execution and figurative themes, which have been estimated as representing about two per cent of the production of a particular workshop during the last two or three decades of the sixth century BC. They are all water carrying pots, or hydriai, of around eleven litres capacity. Beyond the general similarities of these 'Caeretan hydriai', as they are known, the works of two separate

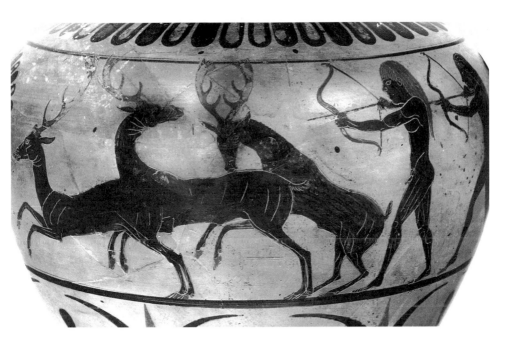

53, 54 Details of Caeretan hydria, late sixth century BC.

painters have been distinguished, and, more importantly, a highly
interesting repertoire of subjects has emerged. Broadly, the themes
53 are designed to make appeals to the aristocratic lifestyle. Hunting –
young men shooting stags, or eagles swooping on hares – is a
favourite. Horsey pursuits are also reflected, and the thrill of the
54 chase is extended to sexual conquest too, as mirrored by satyrs grap-
pling with maenads. The wine drinking world of Dionysos is evoked
by those satyrs and maenads, as it is with the depiction of the return
of the drunken Hephaestus to Olympus.

But the painters expected some literary sophistication from their
clientele too. One vase, for instance, shows the comical story of how
the infant Hermes escaped from his cradle, stole a herd of cattle, and
then tucked himself back up again, a picture of gurgling innocence
to the enraged Apollo, owner of the herd. The spirit in which this is
painted surely demonstrates that the artist was familiar with the
Homeric *Hymn to Hermes*, which recounts the same good-humoured
episode. And a key piece of another hydria, now in the Louvre,
shows us a set of named figures in procession. One is labelled Odios.
In company with Ajax and others, he is plainly part of the embassy
to Achilles listed by Homer in the *Iliad* (9. 167). Now Odios is men-
tioned only once by Homer. Why should an Etruscan want to know
about him, unless as part of a rather learned and pernickety trans-
mission of Homer's verse by an artist determined to 'illustrate' the
epic without compromise?

The two distinguishable painters of the Caeretan hydriai are
thought to have been East Greeks, settled in Etruria. Some believe
that they may have tried tomb painting too, and see in the beefy
forms of the wrestlers and others in the Tomb of the Augurs at
Tarquinia (dated to *c.* 510 BC) a scaled-up version of the same style.
And the question of vase painters tackling larger commissions natu-
rally takes us to the slightly earlier Tomb of the Bulls of *c.* 530–520
BC. Since it presents us with a rarity – a central episode of epic
narrative – it deserves particular attention.

The Tomb of the Bulls was designed by an artist unused to paint-
ing on this scale. That is clear from the several botched attempts to
58 render the head of the horse being trotted towards a fountain, a focal
component of the main scene; it still looks too small. This main
scene presents us with a story, which happens to be one also chosen
for depiction by a number of vase painters in late sixth-century
Etruria. It is the ambush of Troilos by Achilles – one of those sub-
plots of the Trojan War which were never collected in the *Iliad* itself,

72

55 Caeretan hydria, late sixth century BC, showing Hermes and cattle of Apollo.

56, 57 (*above, above right*) Details from the main chamber of the Tomb of the Bulls, Tarquinia, *c.* 530–520 BC.

58 (*below*) Detail from the main chamber of the Tomb of the Bulls, Tarquinia, *c.* 530–520 BC. Troilos, naked on horseback, trots towards the fountain behind which the helmeted Achilles is lurking, with knife raised.

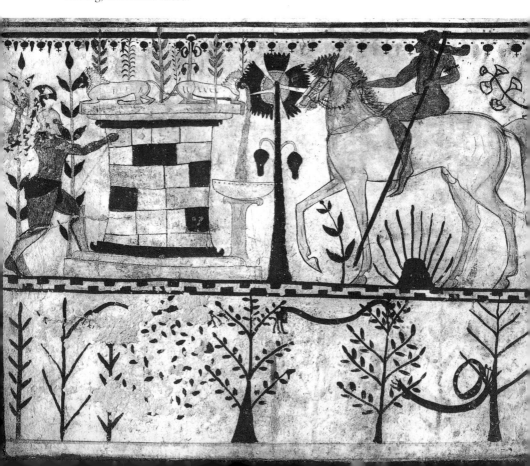

but which circulated in other epics. An oracle foretold that Troy would not fall until Troilos, the youngest son of the Trojan King Priam, had met his end. Accordingly Achilles plotted his murder. It was an ambush: Achilles lurked behind the fountain to which the boy brought his horses for water.

This we see on the tomb wall: Troilos, naked apart from his curly slippers, on horseback and Achilles behind the lion-spouted fountain, knife held ready. Above, however, there are images of buggery and copulation to which the eponymous bulls react either with contentment or anger. What do these mean, and do they have any connection with Achilles and Troilos?

59 Cheekpiece from a bronze helmet found in the Tomb of the Warrior, Vulci, sixth century BC, showing the ambush of Troilos.

As so often, we clutch at straws when interpreting Etruscan imagery. In this case, it is a much later mythographical source. Servius, in the course of his fourth-century AD commentary on Vergil's *Aeneid* tells us that Achilles was in love with Troilos. His obligation to kill the boy was thus to kill a personal passion.

There is no evidence to suggest that an Athenian, say, was ever aware of this erotic slant to the story: it may have been a piece of story-telling embroidery, stitched into the tale as it travelled westwards. But supposing it to have a pre-literate pedigree, we may see how it informs our understanding of this Etruscan scene. The pretty-boy nudity of Troilos falls into place, as does the weapon which Achilles has chosen – not a sword, but the curved blade of sacrifice (the Greek *machaira*). And perhaps the sexual entanglements above the main fresco are related to its moral significance. In other words, there may be full Etruscan coherence to what we would otherwise regard as a perplexing rendition of a Greek myth.

A similar uncertainty about the amount of indigenous input in certain myths confronts us in the study of engraved gems in Etruria. Inscriptions added to the motifs upon such sealstones or finger rings leave no doubt that heroes such as Herakles (Ercle) and Achilles (Achle) were appropriated by families or individuals as symbolic representatives. Probably, as in Greek cities, spurious genealogies were created, whereby a family claimed descent from some mythical figure. (It was never a problem for a poet to concoct some Italian adventure for a hero otherwise associated with the Aegean, and late sixth-century bards who practised this, such as Stesichoros who was based in the western Greek colonies, gained great authority.) And what eventually confirms the sensible articulation of Greek myth is the imagery upon Etruscan mirrors. Though it takes us at a chronological jump into the mid-fifth century and beyond – eventually, Greek artists indeed slipped into the norm of Roman patronage – some attention to this imagery is now called for by way of summary.

MIRRORS: THE MYTHS OF PERSONAL ADORNMENT

In the beginning was Narcissus, and a world without mirrors. Transfixed by the beauty of his reflection in a pool, Narcissus wasted away and died. The very considerable quantity of mirrors that survives from Etruria superficially implies that their users were generically 'narcissistic', and may even contribute to the Etruscans' reputation for being effeminate and vain, a people ruined by their

excessive fondness for luxury. Etruscan mirrors survive, however, because they were placed in tombs. They must have been used by men as well as women, though there is some evidence that a mirror formed part of the formal bridal endowment of a woman, and acquired special sentimental value as such. One side of the mirror would be burnished or silvered for its reflective function. The other side was often engraved, or, less commonly, executed in shallow relief. Though they tend now to be difficult to discern, these engraved images constitute probably the single clearest indication of the extent of Hellenization in Etruria. A survey of the range and sophistication of mirror iconography would require a book in itself. We shall limit ourselves here to remarking upon only one set of themes to illustrate the potential interest of these now frequently overlooked objects.

What is a mirror for? In Etruscan (and Central Italian) terms, the obvious answer is not necessarily always apposite. If a girl from an aristocratic family in Veii were being married to a youth from a similarly aristocratic family from Tarquinia or Rome, then a mirror may have become part of an inter-clan agreement, and its iconography would have been accordingly portentous. (The same goes for the celebrated fourth-century Latin and Etrusco-Latin engraved bronze *cistae* or caskets, mostly associated with Praeneste.) But if we assume that at least some mirrors were designed purely for vanity's sake, then the question of which stories were suitable for their decoration arises.

The answer, quite simply, is any tale in which vanity or individual comeliness gained its rewards. And indeed we find a consistent collection of such 'sexy' tales. There is the Judgment of Paris, the mythical prototype of all beauty contests, with Aphrodite, the Etruscan Turan, triumphant. There are many scenes showing Aphrodite/Turan in her gardens amid her girlfriends and attendants, 60 bathing and perfuming, or cosseting the pretty Adonis (Atune). There is Ganymede ravished by Zeus as an eagle, Ganymede whose 61 name when transliterated into Etruscan emerges as 'Catamite', and hence provides us with a generic term for a boy who serves the lusts of an older, more powerful man. Other favourite scenes include the winged amours of Eos, 'Dawn', who likes to swoop upon well- 62 favoured boys such as Kephalos and have her way with them, and, perhaps a more kinky or oblique form of union with a goddess, the scene of the strapping, bearded Herakles suckling at the breast of Hera (his powerful attentions caused the milk to jet out, thus giving us the astronomical scatter we know as the Milky Way).

60 Incised bronze mirror, late fifth century BC. Turan (Aphrodite) visits the recumbent Elina (Helen): the most beautiful goddess confers with the mortal whose face 'launched a thousand ships' (Helen's beauty was the cause of the Trojan War).

61 Incised bronze mirror, fifth–fourth century BC, showing abduction of Catamite (Ganymede).

62 Relief bronze mirror, fifth century BC, showing Eos and Kephalos. The result of their liaison was the boy Phaeton, the attendant of Aphrodite.

These, then, are not schematic forms used to fill a spare tondo space on an everyday utensil. True, they belong to a consumer economy which required expenditure upon clothes, cosmetics and other items of personal hygiene or adornment. But the narratives etched on these mirrors perform a purpose of pseudo-duplication: if the view on the plain side displeased the viewer, he or she had recourse to the gratification of a changeless image simply by turning it over. And just as that image was not schematic, neither was it exotic. 'What leaf-fring'd legends haunt about thy shape/Of deities or mortals . . . What mad pursuit? . . . What wild ecstasy?': these questions from Keats's 'Ode on a Grecian Urn' would not have taxed the Etruscan viewer, whose share of the mirror's power was equally valid on both sides.

The Etruscan Cities as Centres of Art

Etruria was never a nation-state. Some political unity was reportedly achieved by a federation of twelve cities, whose common rendezvous was a sanctuary at Velsna, which the Romans called Volsinii. We presume that this must be Orvieto, though Bolsena is a rival candidate: however, in neither place has any grand centralized meeting arena been located. It is not even definitively established which twelve cities made up the membership of the federation. A fragmentary Tarquinian source of the Roman period appears to mention a Velthur Spurinna as *praetor Etruriae*: this may be the same Velthur Spurinna who is commemorated in the fourth-century Orcus Tomb I at Tarquinia, implying that the office of 'prefect of Etruria' was operating in the late fifth century. But further evidence for national cohesion is scarce.

The fragmented politics of Etruria would eventually make the country vulnerable to Roman expansion. Such fragmentation, however, encouraged the localization of Etruscan art. Although it is likely that, much as in the competitive cities of Renaissance Italy, artists were of no fixed address, local schools and characteristics can nevertheless be picked out. Varying topographical conditions and availability of resources naturally determined local specialities (such as alabaster sculpture at Volterra). At the neglect of minor and more mobile arts such as gems, mirrors and bronzes which are all difficult to provenance, we now survey some of these individual centres.

This proceeds not as a gazetteer, but a selective tour. No ancient traveller ever recorded the varied sights of Etruria, as did Pausanias for Greece in the second century AD, but we might think of ourselves as retrospectively sympathetic tourists in the Pausanias mould, noting what catches our eye as locally unusual. Some of the places chosen for discussion here do not strictly qualify as cities at all, but particular or recent archaeological interest may earn them space (Murlo, for instance). Where a city's art or architecture has been discussed incidentally elsewhere in the book, we shall avoid repetition (hence Perugia, Tuscania, Veii and others are omitted). The Etruscan

63 (*opposite*) Tombs along the Via degli Inferi, in the Banditaccia necropolis, Cerveteri.

colonies in Campania are excluded, as are Etruscan transappennine settlements with the exception of Marzabotto. If a bias towards southern Etruria is manifest, it may reflect an ancient situation in which two coastal cities, Cerveteri and Tarquinia – plus Vulci, slightly inland – exerted, in cultural terms, a gravitational pull.

And so it is in the south that our journey begins, at Cerveteri. It has to be said immediately that the unlovely sprawl of modern Cerveteri (Roman Caere; to the Greeks, Agylla) is deceptive. Anyone able to visit its main Etruscan cemetery at daybreak, however, will soon sense the ancient dignity of the place. Wandering past the tufa-cut tombs of this necropolis, called the 'Banditaccia', while dew is still lively on the plants around the lintels, one is struck by a profound stillness. It is time's maturity. Deep ruts in the lanes leading through the site were probably made by medieval traffic. But thousands of funerary carts came along these tracks too, colonizing the 'city of the dead': the necropolis was more or less continuously used from 700 to 200 BC.

63

64 Terracotta antefix from the Vigna Parrocchiale site at Cerveteri, late sixth century BC, at the time of excavation.

65 (*right*) White on red *pithos* (storage jar), mid-seventh century BC, showing a female figure (perhaps Helen) between two males (possibly Castor and Pollux), who are flanked by two sphinxes.

66 (*below*) White on red *krater*, mid-seventh century BC, showing horses facing each other over a cauldron.

Quilted with lichen, the beds inside the tombs are now empty, and often marooned in stagnant pools. Although the mock architectural features and internal relief decoration convey some of the original pseudo-domestic atmosphere, a large effort of the imagination is required to envisage the integrity of design in any single tomb. Most were cleared out long ago. Successive intruders have not been deterred by the carved stones (*cippi*) – of vaguely phallic shape though some are like huts or houses – that were placed outside the entrances as guard totems.

The Banditaccia necropolis, however, is at least obliquely instructive about the city of Cerveteri. As an extreme simplification, it is evident within the necropolis as it has survived for modern tourists that circular tombs of varying dimensions gave way to rectangular types, some laid out in gridded lines. The change is dated to between 550 and 450 BC; we assume that something akin to a planned 'urbanization' on the central plateau of Cerveteri must have taken place at this time.

Excavations have been conducted in three small areas of the expanse that was once the city which reveal the foundations of what must have been an imposing urban landscape by the early fifth century BC. The foundations of several temples have been uncovered in the Vigna Parrocchiale (parish vineyard) area of the city: these are of shared monumental alignment, and one evidently served for the cult of Hera (Etruscan Uni), to judge from a quantity of associated Greco-Etruscan dedications to the goddess. In the Sant'Antonio area, a further temple has been discovered: it seems to have hosted the cult of Herakles.

Accumulative testimony to the primary role played by Cerveteri as a place of interaction between Etruria, Greece and the pan-Mediterranean world is scattered throughout this book. Perhaps the sophisticated level of such interaction is best summarized by a huge drinking cup now in the Getty Museum at Malibu, attributed to the Athenian vase painter Onesimos. A signature on the edge of the base tells us that another Athenian artist, Euphronios, shaped the cup, but to Onesimos is given the credit for the vivid scenes of Trojan epic on its inner and outer surfaces. Of particular significance to us here are two minor details. The first, evidence that the cup was broken in antiquity and repaired with bronze staples, implies that while it may not have been worth the equivalent of millions of dollars, neither was it an ephemeral piece of pottery. The second is a scratched Etruscan inscription on the base: 'This is the Greek cup which

64

67 The Etruscan inscription on the foot of an Athenian red figure cup, early fifth century BC, showing scenes from the fall of Troy, with a dedication to Herkle (Herakles).

belongs to Herakles [Ercle].' We have lost the name of the Etruscan who dedicated it, but it is comforting to know that the item was specified as 'Greek' [*craice*]. Cerveteri, the most Hellenized of all Etruscan cities with temples to Hera and Herakles and doubtless other Greek deities too, nonetheless had a profile of its own. In the sixth and fifth centuries the city even sent out colonists to its interior hinterland. Establishing themselves at sites such as Tolfa, in the hills to the north of Cerveteri, these settlers diffused 'Caeretan' styles of art and architecture (as is evident, for example, from the carved tomb furniture at the Pian della Conserva necropolis near Tolfa).

85

68, 69 Polychrome terracotta slabs recovered from the Vigna Parrocchiale site at Cerveteri, late sixth–early fifth century BC. They once belonged to an urban house or temple.

70, 71 Part of a painted terracotta slab (*left*), and a fragmentary painted terracotta slab (*right*). Both from Cerveteri (city), mid-sixth century BC.

We have not yet finished at Cerveteri. What follows now is a diachronic and selective résumé of the city's imagery. This includes images reserved for display to the dead, or those paying respects to the dead. As we shall see in this case, the traditional dualistic approach to the Etruscans generally – speaking in terms of 'cities and cemeteries', to cite the title of George Dennis's book of 1848, discussed in Chapter Six – masks a complex rapport between the society of the living and the community of ancestors. Tradition, or the 'democracy of the dead' (as G. K. Chesterton once defined it), meant the ancestral validation of civic powers, property and status. At the same time, innovations (such as literacy) were also the self-defining attributes of those in the role of 'opinion leaders'. As more is revealed of the city at Cerveteri, so we can better appreciate how fluid the boundaries were between city and cemetery, and how compromising the negotiations between tradition and innovation.

From Villanovan times, Cerveteri was a place where both immigrant and native artists could work. The ornate assemblages of the Regolini-Galassi Tomb are witness to the arrival of Eastern experts in granulated gold-work techniques and the formation of local workshops. Large-scale stone sculpture, too, for example the Tomb of the Statues, may have been directly promoted by Syrian or Phoenician masons. The successive arrival of Euboean Greeks (such as Aristonothos) and East Greeks (such as the painters of the Caeretan hydriai) maintained the dynamic of innovation from abroad, but Cerveteri's 'open door' policy did not overwhelm home-grown iniative. Bronze working was established by the early seventh century. Bucchero production was an indigenous, original technique devised in *c.* 675 BC which complemented a local form of impressed impasto decoration. 'Heron class' geometric pottery was locally made, as also was the fabric known as 'white on red'.

65

66

72, 73, 74 'Boccanera' plaques from the Banditaccia necropolis, Cerveteri, mid-sixth century BC.

Several painted tombs are known from late seventh-century Cerveteri, mostly from the Banditaccia necropolis: featuring lions and other animals, they appear to have been strongly influenced by the designs on imported Corinthian pottery. A number of Etrusco-Corinthian workshops, including the Group of the Polychrome Vases, have been assigned to the city. One wine mixing bowl recovered from a Banditaccia tomb of the early sixth century shows, on one side, Herakles worsting Geryon, the many-membered monster of the far western Mediterranean; on the other, a possible representation of the sacrifice of Polyxena, the Trojan princess, to the spirit of Achilles.

From the Banditaccia, too, come the 'Boccanera' plaques now in the British Museum. These are the best preserved of a series of large polychrome terracotta slabs recovered not only from the necropolis, 68, 69 but also from the city, where they may have decorated the reception

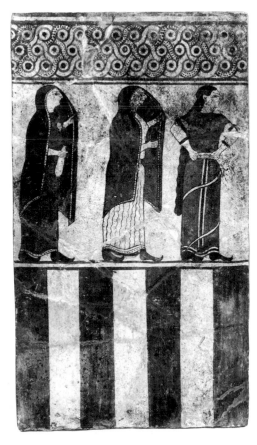

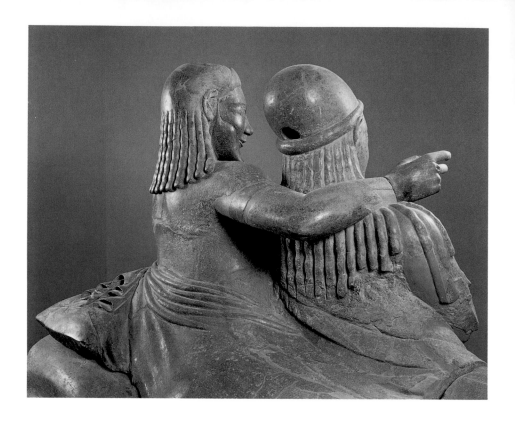

rooms of large houses. Again, there are Corinthian parallels (the painted metopes from Thermon) though 'Ionic' style prevails, but no inscriptions assist our reading of what must once have been self-contained sets of narrative sequences. Fragmentary plaques from the city show the feet of warriors, and blazing gorgons. The Boccanera pieces, dated to the mid-sixth century BC, have been variously interpreted, assuming the different directions of the figures to imply a gap in space, time, or subject. Some suggest, for the first half, the Judgment of Paris: Paris, holding a pastoral wand of foliage, first appraises Athena, holding a spear; the lady lifting her skirt might be Aphrodite and we would have Hermes, in his usual broad-brimmed hat, mediating. Others note that this Hermes figure is carrying a sceptre surmounted by a bull, and think immediately of Crete and the dynasty of Minos: perhaps, then, this shows a Cretan episode in the story-cycle of Theseus (in which case the lady carrying the garland, or 'crown of light', would be Ariadne and the girls waving

70, 71

72
73

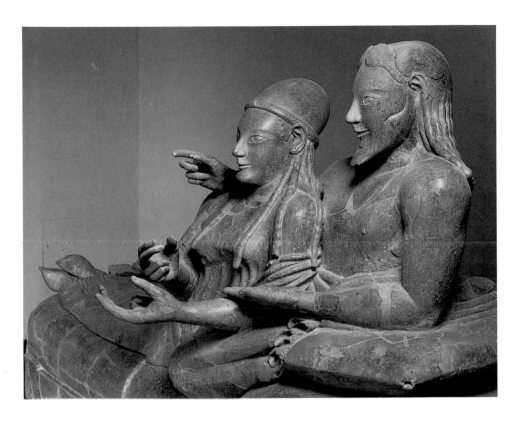

75, 76 Sarcophagus of the Married Couple from the Banditaccia necropolis, Cerveteri, late sixth century BC. Each of the couple once held separate objects, perhaps eggs.

pomegranate sprays might be maidens rescued from the maws of the 74
Minotaur). But what of the women moving away with jars or little
flasks in their hands? The safest generic reading here is to call the
scene a 'hero's reception'. Given that the plaques come from the
necropolis, Hermes would play his 'psychopompic' role as soul-
bearer: by their acclamation and preparation of unguents, the
women assure the hero both a rapturous welcome home and an
immaculate funeral.

Slightly later in date, the 'Campana' plaques in the Louvre stimu-
late further mythological speculations, but again these seem best
couched in terms of afterlife hopes or beliefs. One attractive

possibility is that Herakles is shown rescuing Alcestis from her self-sacrificing death. The faith that muscular virtue can enlist assistance from even the winged demons of mortality was surely a key to the widespread popularity of Herakles in the Mediterranean and beyond: at his temple in Cerveteri, dedicants would offer not only cups, but appropriate attributes, such as little bronze clubs.

75, 76 Cerveteri's single best-known piece is the Sarcophagus of the Married Couple, in the Villa Giulia Museum. It comes from a tomb, and though we do not know whether it actually once contained the joint remains of husband and wife (which is unlikely), it has been taken as emblematic of nuptial bliss. A second example of the same type of sculpture has been preserved (now in the Louvre), suggesting that we should not be looking for 'portraits' as such, and a number of earlier and smaller types establish a pattern of gestures whose eloquence has faded.

The couple on the celebrated sarcophagus stretch out not on the marital bed, but on a piece of symposium furniture, the *kline*. The man holds his left palm flat, as if expecting a gift of some sort; his right arm, resting on the woman's shoulder, is extended as if holding a small object, of about the size of an egg. For her part, the woman must also have been holding two items, made separately and now

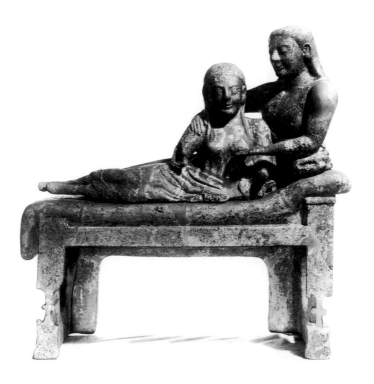

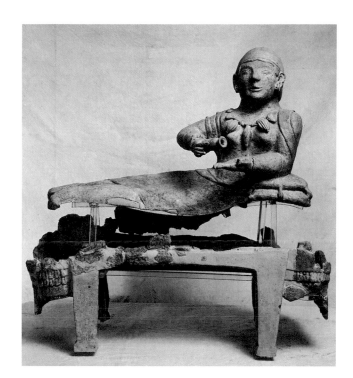

77 (*left*) Small-scale sarcophagus of a couple from Cerveteri, mid-sixth century BC.

78 (*right*) The Girl from Monte Abatone from the Monte Abatone necropolis, Cerveteri, mid-sixth century BC.

lost. One was probably a small perfume flask; the other perhaps a piece of fruit.

On an earlier single sarcophagus, the Girl from Monte Abatone (Monte Abatone is another necropolis of Cerveteri), a woman pours from a flask onto her own outstretched palm. She is, so to speak, supplying the 'male' gesture for herself. The only clue we have to the motion of pouring perfume comes from Greek lyric poetry and comic drama, implying that anointment of self and partner was an aphrodisiac device. Our single girl here may be a tragic figure, taken before marriage, but now preparing herself to be a bride of Hades. The Married Couple may then be seen as affirming more of an erotic pledge than connubial commitment.

The figure of another single youth on top of a cinerary urn may again be the memorial of an early death. Unbearded, he seems the Etruscan equivalent of a Greek *kouros*: a young man full of vigour and promise. Unlike his Greek counterpart, however, he wears a loincloth and is shown not in the 'nimble-knees' posture of stepping forward, but rather lying arrogantly in the quaffing position. If he

79

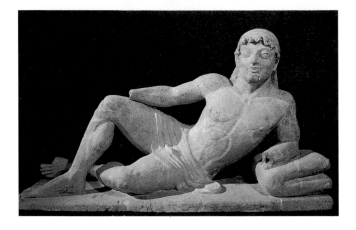

79 (*left*) Recumbent youth on the lid of a cinerary urn from Cerveteri, late sixth century BC.

80 (*below*) Travertine sarcophagus from Cerveteri, late fifth century BC.

died young, he had at least been initiated into the prerogatives of symposium access.

One further sarcophagus warrants mention. Carved in travertine towards the end of the fifth century and now housed in the Vatican, it is a precocious memorial – a careless glance might have considered it medieval. Such full-length effigies, surmounting a coffin carved or painted on all four sides, would become common enough during the third and second centuries in various parts of Etruria. This appears to be the earliest. The relief scene is continuous, and shows the progress of a musical or threnodic procession, escorting the deceased (aboard a chariot) to his place in the community of the dead.

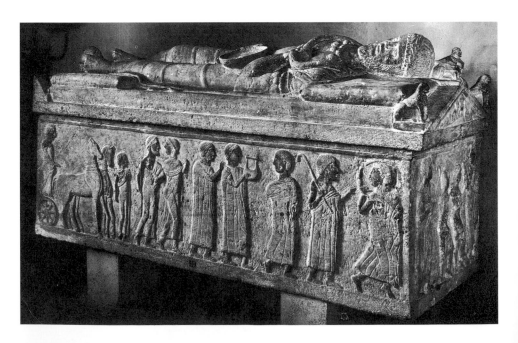

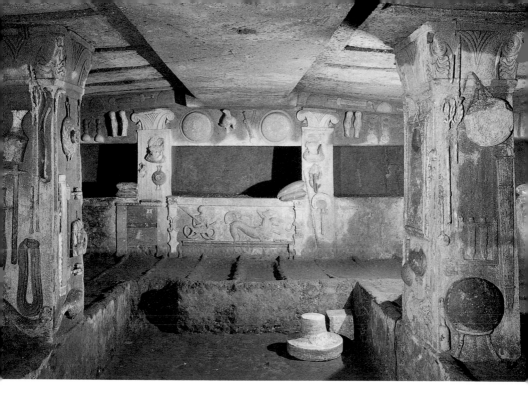

81 Interior view of the Tomb of the Reliefs, Cerveteri, mid-fourth century BC.

How did such aristocrats live in the city? To judge from the debris accumulated in wells and cisterns (the urban quarters were riddled with water-collecting points), their houses were richly decorated, and they used fine painted pottery too. But we must again turn to the necropolis for a more comprehensible vision of 'lifestyle'. This comes most extravagantly from the mid-fourth-century Tomb of the Reliefs, a spacious hypogeum whose multiple couches and niches must over time have accommodated an extensive family burial.

The columns of this tomb may imitate the supports of a large hall with gently sloping roof; in a solid rock-cut chamber, they have no functional purpose and nor have the mock beams in the ceiling. But they have been used here as vertical galleries of items at once prestigious, domestic and fantastic. So on one side of a pilaster we see, apparently suspended, a large drinking cup, the curved staff of authority known as the *lituus* and a magisterial seat, with a goose

95

pecking below. On another side, the objects include a jug, an axe, two banners or scarves, a length of rope and at the foot, a weasel trapping a mouse. Various pieces of armour and military gear are displayed around the tomb, including a pair of great curled trumpets. Two bulls' skulls above the entrance provide reminders of past sacrificial piety. And the mythological underworld is summoned by images of a reptilian-tailed monster, and Cerberus, the three-headed dog of Hades, below a dining couch. Possibly we are mistaken to question the juxtaposition of 'private' and 'public' tokens here. The Tomb of the Reliefs may virtually replicate the heraldic reception room of a house where the head of a powerful clan (*gens*, in Latin) would conduct both business and pleasure.

The conduct of everyday life at Cerveteri – the organization of food supply, textile production and so on – has yet to be established by ongoing excavations. But if now we move inland and northwards, we may note several sites where such information has been forthcoming, largely as a result of Swedish excavations. When a king develops a passion for archaeology, his subjects dig with unusual enthusiasm. In the 1960s, Gustavus Adolphus VI of Sweden was largely responsible for a series of small but highly important projects in southern Etruria: at Luni on the River Mignone, at San Giovenale in the territory of Tarquinia and at Acquarossa, just north of Viterbo. None of these sites were known from written historical sources, but without San Giovenale, and Acquarossa in particular, we would know very little about how Archaic Etruscans organized their lives. Because both sites were destroyed in *c.* 500 BC and never properly reoccupied, much of the sort of evidence normally dispersed in places of continuous occupation was preserved intact. For instance, the courtyard areas of the houses at Acquarossa had loomweights and other weaving relics *in situ*, so making clothes here does not seem to have been the solely indoor occupation that it was in contemporary Athens. A full range of everyday cooking utensils was also recovered from the site.

Acquarossa might seem a simple and provincial community. But its domestic architecture and relics attest a certain commitment to beautifying the everyday. The portable terracotta braziers, for example, may be decorated with moulded rams' heads. Part of the settlement (Zone F) has been marked off as 'monumental' as it seems to constitute a grander residence than the rest, which was certainly colonnaded; from its area came terracotta friezes figured in magisterial terms such as banquets and processions. But humbler houses, grouped

82 Samuel Ainsley, engraving of Castel d'Asso, November 1842.

around courtyards, displayed painted tiles, fascias with running guilloche patterns, or friezes of Orientalizing animals. Moulded figures such as griffins projected from other parts of the roof.

These private dwellings should not be dismissed as 'primitive' because of their wattle-and-daub single storey construction. It was not long before Etruscan architects came up with such concepts as the rainwater collecting basin known to the Romans as the *impluvium* as a late sixth-century house at Roselle shows, and the interiors of certain tombs elsewhere suggest, for example, that coffered timber ceilings were desirable as early as 500 BC.

Still in the same Viterbese territory, we pass on to the phenomenon of cliff-cut cemeteries. For connoisseurs of the picturesque, these have always commanded attention. Their topographical extent ranges from San Giuliano and Blera in the south, to Sovana, beyond Vulci. Here we briefly focus on the two best-documented sites, Castel d'Asso and Norchia.

Why carve a tomb into a sheer cliff face? In other parts of the Mediterranean, most notably the coast of Lycia (western Turkey), the desire for conspicuous commemoration seems paramount. Faced with the Lycian tombs, the viewer (who must be seaborne, for full effect) immediately wonders how they were carved at all. Here the trades of stonemason, sculptor and steeplejack must all have been combined in one effort. The Etruscan variants are no less impressive, but rather more functional. Systems of stairways allowed access to the tombs, and, although they now seem like no more than monumental façades, this state of survival is misleading, for many of the tombs were originally fronted with porticoed platforms which once served for the regular performance of rites or obsequies. Slippage of rock or overgrowth of foliage makes this feature less obvious now, and we have also lost the brightly-coloured stucco decoration which once enlivened the carved details – cornices, mock doorways, and even temple-style pediments.

The ruins of Castel d'Asso offer a prospect not much altered from that which enchanted Victorian visitors, whose sketchbooks remain a valuable source of information about the site. At Norchia, sheep bells still clink alongside the stream that cuts through the steep glen. And at both sites, apart from the Romantic sensations of ruined splendour, we should be aware that there is more than mimetic domesticity attempted in the architecture. These are sacral precincts. If collectively they amount to (in George Dennis's words) 'an amphitheatre of tombs', then individually they constitute a vertical complex of little temples. Sacrifices, remembrance rituals and processions will have animated the platform or podium projections. To strengthen the ambivalence between tomb and temple, a pair of fourth-century BC graves at Norchia even presented sculpted pediments. Not much can now be picked out on what remains *in situ*, but it looks as though the death of the Niobids was the subject of one of these pediments. If so, it is conceivable that this inland retreat in Etruria once echoed some temple of Apollo on the Greek mainland, for it was by her affront to Apollo and his sister Artemis that Niobe was punished with the death of her children.

We return to the Tyrrhenian coast where the principal site, Pyrgi, has been under patient yet dramatic excavation for decades. The drama began in 1964, when scholars were thrilled by the unexpected discovery of several gold lamina and bronze plaques, inscribed in two languages. Rather than being bilingual in Etruscan and Greek, the temple dedications – naming Thefarie Velianas as ruler of Cerveteri –

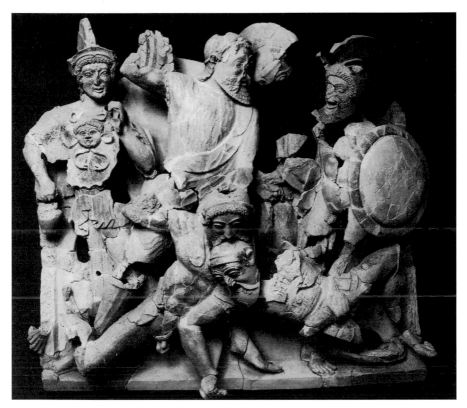

83 Terracotta pedimental decoration from Temple A, Pyrgi, *c.* 460 BC, showing the Seven Against Thebes; in the centre, Tydeus bites the head of Melanippos. The expression on the features of Melanippos recalls the battling centaurs of the west pediment of the Temple of Zeus at Olympia, carved *c.* 470 BC.

were Etruscan and Phoenician, linking the Etruscan goddess Uni not with the Greek Hera but the Phoenician Astarte.

Since then, it has become clear that Pyrgi was a rich and cosmopolitan port. Its excavator, Giovanni Colonna, claims to have found actual traces – bullets, arrowheads, scorched layers – of the raid upon the port by Dionysius of Syracuse in 384 BC, when the Sicilian tyrant made off with reportedly vast amounts of booty. The economic success of Pyrgi was matched by its architectural and artistic enhancement. Though the larger of its two temples was Tuscan in architectural design, emphatically Greek styles and subjects were chosen for its decoration, most importantly the high-relief terracotta tableau erected around 470–460 BC in the temple's rear pediment.

99

To say that this shows the legendary Seven Against Thebes is a weak summary. It shows an episode from the Theban epic cycle which an Athenian dramatist would have baulked at staging: the point in the siege of Thebes when Tydeus, the raging assailant, sinks his teeth into the cranium of his opponent Melanippos. Tydeus himself is wounded, Melanippos dying: but when Athena, guardian of Tydeus, hurries along to dispense healing ambrosia to her charge, she is so disgusted by his cannibalism that she withholds her cure, allowing Tydeus to die too. In the mêlée as it is shown at Pyrgi, we also see another besieger of Thebes, Kapaneus, struck down by a thunderbolt as he swore that even Zeus could not block him scaling the walls. It is a paradigm of hubristic impiety and its divine punishment. Picked out in polychrome, the tableau was a dense and furiously powerful piece of admonition.

Northwards up this coastline, it is pertinent to anticipate Talamone, where we find a later and no less florid working of a different moment in the same Theban saga. A promontory site, Talamone's very name evokes the heroic past, as Telamon (Etruscan Tlamu) was the father of Homer's Ajax, and curiously, a piece of Mycenaean pottery has been found at the site. Like Pyrgi, the terracotta pedimental relief of the temple here was executed in high relief. But the thematic emphasis was not on the miscreants of the Seven Against Thebes, but less culpable victims. In the centre was blind Oedipus, bewailing the fighting between his two sons Eteocles and Polynikes. And to either side of the pediment, torch-wielding Furies beset two protagonists of the tale who are retreating in their chariots. So we see Adrastos, the king who launched the expedition, availing himself of his marvellous horse Arion for escape from the disastrous siege, and Amphiaraos, whose fate was to be swallowed alive by the earth as he tried to flee Thebes. The choice of Amphiaraos may have been particularly significant for this temple, for he was a 'faded god' with oracular powers, a seer who continued to issue advice from the underworld. With its suggestive elevated site, Talamone – looking out, as it were, to the mythical Aegean – may have hosted a cult of divination. Stylistically it certainly acknowledges the Trojan hinterland: the agonized expressions here reflect figures on the Great Altar at Pergamum, and argue a date of the mid-second century BC.

Between Pyrgi and Talamone, set slightly inland, lies Tarquinia. Now Tarquinia, like Cerveteri, was a substantial centre for both native and immigrant artists: among the interesting early examples of

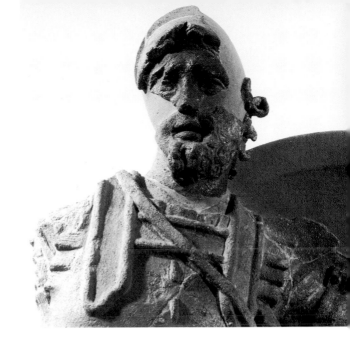

84, 85 Terracotta pedimental
decoration from Talamone,
mid-second century BC. The
detail (*right*) shows Amphiaraos.

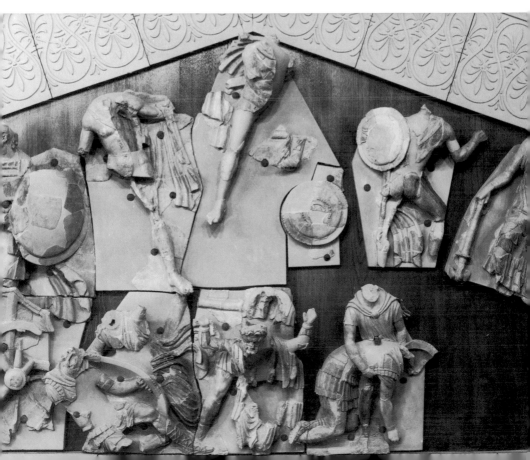

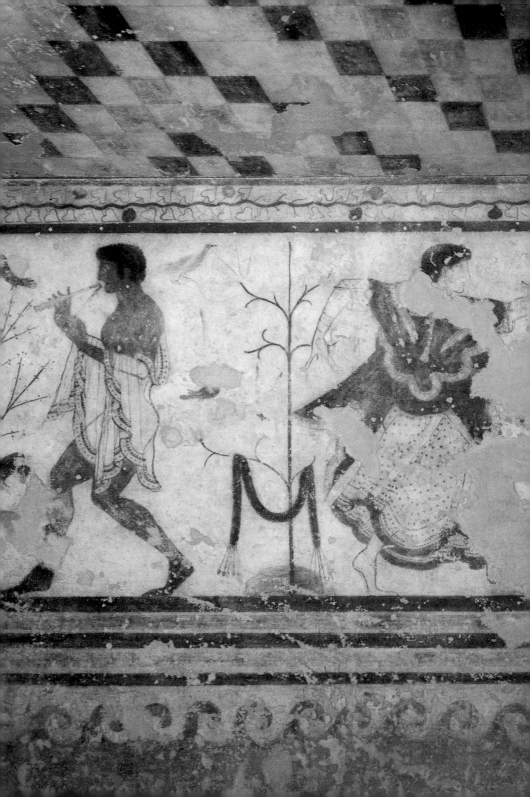

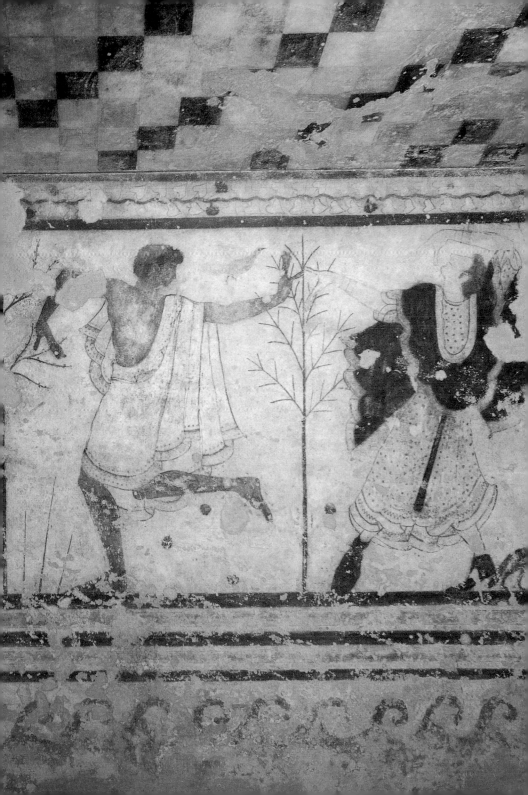

their output is a series of *nenfro* stone reliefs done in the sixth century, including a coarse but effective rendition of the suicide of Ajax. The local speciality, however, was painting tombs. How accessible these were even to the living members of the families that used them is open to debate. And the developed imagery of these paintings (after, that is, *c.* 400 BC) is a subject to be approached in the next chapter. But suppose we could explore a range of tombs *in situ* at the end of the fifth century BC. What might the locals have told us, regarding the style and significance of the murals inside?

As it is now, Tarquinia is an extraordinary site. But it is clear from literary descriptions that large-scale painting was widely practised around the ancient Mediterranean. The Painted Stoa at Athens, for example, was a highly public space where grandiose panel paintings were on permanent display; there was also a 'picture gallery' (*pinakotheke*) within the monumental gateways on the Athenian Akropolis. Painters who worked on this scale – Polygnotus, Parrhasios, Zeuxis, Apelles – were celebrated individuals. They travelled widely in the course of their work. Superb finesse of line; suggestive, almost perspectival modulations of light and shade; sophisticated figurative and landscape illusionism: these are some of the achievements recorded of these masters.

But their work does not survive. Miniature reflections of it have been detected in contemporary vase paintings. Otherwise, we rely upon buried evidence for allusions to its nature: the evidence of painted tombs. At sites in Lycia, Thrace, Macedonia, Magna Graecia and Etruria, such tombs have been found. In terms of quality, those of Vergina in Macedonia are the most exciting: these were royal tombs, and it is likely that the finest painters around in the fourth century BC were summoned to work on them. But in terms of quantity, the tombs around the city of Tarquinia prevail. Not until Pompeii is there such an effective survival of painting in the Classical world.

Like the householders of Pompeii, Etruscans at Tarquinia commissioned Greek or Greek-trained artists, who presumably drew upon a reservoir of motifs and acknowledged 'masterpieces'. But tombs are tombs even when there is the conceit of trying to recreate domesticity.

86 (*pp. 102–3*) Detail from the Tomb of the Triclinium, Tarquinia, *c.* 470 BC, showing dancers.

We have no evidence for how Etruscans painted the interiors of their houses, so we cannot say how far the frescos of tombs relate to schemes of domestic decoration. Fragmentary pieces from Gordion in Lycia give hints of an overlap. The consistency of images at Tarquinia, however – supplemented by much smaller numbers of painted tombs elsewhere in Etruria, and the further Mediterranean parallels, such as the Tomb of the Diver from Paestum – suggests that a particularly funerary iconography is possible. That is, we can more or less expect a generic decorum to be in operation. Certain subjects and certain concatenations of subjects recur not as a matter of fashion, but because it was expected that a tomb should contain them. And it seems reasonable to speculate on the social norms, if not the articles of religious faith, which created such expectations.

It is a matter of tangential interest that analyses of the bone structures of a range of individuals buried in Tarquinian tombs have concluded that these people enjoyed a relatively easy life. The stresses of hard work and poor diet were not apparent on their bodily remains. The amount of gold packed into their dental care alone is impressive. But it is perhaps more directly significant to point out that in terms of total proportionate numbers, only two percent of the tombs around Tarquinia were painted. Indeed their images may be seen as attesting leisured status, with no shortage of slaves. Yet this is an élite within an élite. A painted tomb goes beyond the rivalries of conspicuous consumption. No outsiders, save rarely admitted members of the family, would see it.

So how should we prepare ourselves mentally to sample this 'art without viewers'? Some of the tomb paintings at Tarquinia have been detached from their walls and put on display in the local museum. But even those now visitable *in situ* have little archaeological context to them. Concrete bunkers where stone slabs once blocked rock-cut doorways; handrailed stairways above precipitous descents; electric illumination of bare chambers where once flickering torchlight played over a rich clutter of grave goods and furniture: in all these ways the paintings are exposed to a clinical scrutiny never originally intended.

The technique of the painters may be very simply explained. The earlier seventh-century BC tombs at Veii and Cerveteri were painted directly onto rock. At Tarquinia a thin screen of plaster wash was applied to the solid tufa walls of the subterranean chamber, usually rectangular in shape, but with extra niches or chambers leading off a main room. Designs were sketched in charcoal or chalk, and then a

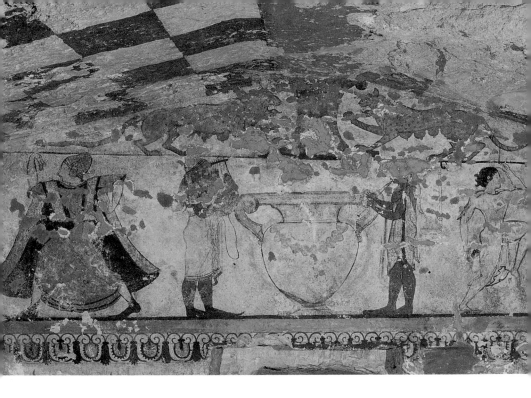

87 (*above*) Detail from the Tomb of the Lionesses, Tarquinia, *c.* 520–510 BC. The focal point is the massive *krater* used for mixing wine and water.

88 (*below*) Detail from the Tomb of the Baron, Tarquinia, *c.* 510 BC.

89 (*above right*) Detail from the Tomb of the Blue Demons, Tarquinia, *c.* 420 BC.

90 (*below right*) Detail from the Tomb of the Augurs, Tarquinia, *c.* 510 BC. Either side of a mock door, professional mourners (*ploratores*) strike attitudes of grief.

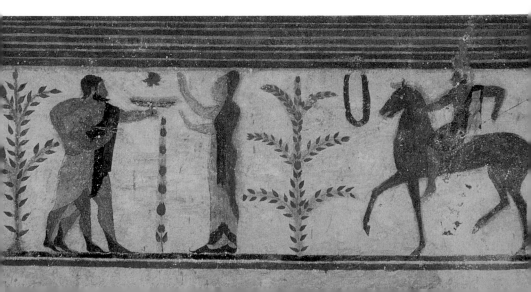

range of organic dyes or paints were used for colouring and limited shading. In themselves the colours must have carried varying connotations of expense. Reds, yellows and ochres were readily extracted from local iron oxides. White came from chalk or kaolin, and black was a vegetable concoction. Blue and violet were compounds relying on foreign material, and probably prized accordingly (traces of them have been found as dedicatory samples at Tarquinia's port sanctuary, Gravisca). Green was derived from malachite.

But what of the imagery? Though it does not directly concern Tarquinia, one feature of archaeological circumstance may be mentioned prior to approaching the tomb paintings themselves. This is the evidence for funerary tents. Outside the entrance to a tomb on the Pian della Conserva necropolis near Tolfa, one such has been quite clearly excavated: a series of post-holes in a large circle, arguing the erection of a shelter or catafalque for visitors to the tomb. We may guess the reason for its visitation. On a regular basis, members of a family might gather at the burial place of their ancestors for a commemorative event: probably a meal (which the Greeks would have called a *perideipnon*), with sacrifices, toasts, libations and perhaps other pious festivities.

So we have a key to the imagery of the tombs, suggesting that there is an activity practised here, not only a projected ideology. The painted figures we see feasting and drinking on the walls of the tombs are not only doing so in order to declare their status (though that is surely an element of motivation, even if it is not a public display). They know the reality of their own depiction. Capacious wine storage jars, both locally made and imported from places such as Samos and Chios, have been recovered from tombs at Tarquinia and elsewhere, implying as much. A commonplace of Greek historical comment about the Etruscans reinforces the notion. 'They spread out sumptuous banquets twice a day,' observes Diodorus Siculus, in his famous passage (5. 40) about how the Etruscans' love of luxury, *tryphe*, made them 'unmanly' (*anandroi*). 'Their tables are laid out with every delicacy. They surround themselves with richly embroidered cloths, and are served wine copiously in silver vessels. They are waited on by a multitude of slaves.'

Yet the iconography is not decoded so easily. Looking at an image of feasting Tarquinians, there remains a compound ambiguity. Is this a feast enjoyed by the deceased at the height of his or her powers, or is it a feast held in his or her honour at the funeral? If the latter, is the deceased pictured as if present? Or if neither, is this an image of the

91 Detail from the Tomb of the Hunter, Tarquinia, *c.* 500 BC. Scenes of the chase occupy the narrow upper register. Textile surrounds are strongly suggested and the hunter's soft domed hat hangs in the centre.

life to come, a nice inversion of the Tantalus myth, in which the tables of the Blessed are kept perpetually loaded and accessible, and the wine never stops flowing?

And beyond these questions lie more. How much of this image is symbolic, not of status, but of belief? Or is the feast a metaphor for some state of the soul after death?

Given the intrinsic obscurity and vagueness of Greek beliefs about the afterlife – the cults called 'Mysteries' were never intended to sustain full documentation – our chances of answering such enquiries are poor. Only a few tombs exhibit direct references to funerary activity such as lamentation (as in the Tomb of the Augurs), or 'lying-in-state' (*prothesis*) of the deceased (as in the Tomb of the Corpse). More often, painted 'closed doors' may indicate a symbolic nether-world. Three Greek names – Dionysos, Orpheus, Pythagoras – have to be reckoned with, since there is every possibility that cult activities associated with these names and their respective (but inter-related) eschatologies reached Etruria from the late sixth century BC onwards. But we shall proceed in a spirit of positive speculation by assuming that no one commissioned a painted tomb purely as an act of discreet extravagance.

That a number of the Tarquinian tombs evoke a temporary outdoor banqueting ambience is undeniable. The ceilings of such tombs as the Tomb of the Lotus Flower, or indeed the walls of the Tomb of the Hunter, distinctly mimic patterned textile awnings. We might take these as interior 'throws' or hangings (what the Romans called *aulaea*), were it not that open country is also frequently

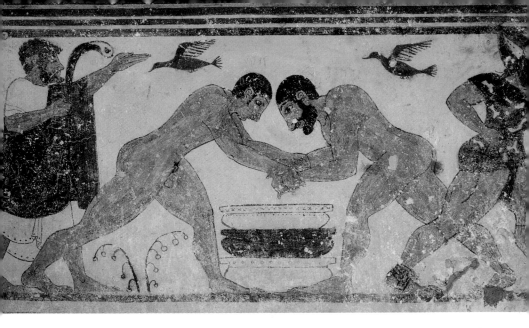

92 (*above*) Wrestlers in the Tomb of the Augurs, Tarquinia, *c.* 510 BC. Though he has been interpreted as a referee of the contest, the gesturing figure with a staff gives the tomb its name: he may be taking omens from the flightpath of the birds above. Between the wrestlers are three metal cauldrons which were probably the victors' prizes.

93 Etruscan black figure *kalpis* (water carrier), late sixth century BC, showing the transformation of 'Tyrrhenian pirates' into dolphins by Dionysos (whose presence is indicated by the strand of vine leaves to the left).

suggested by shrubs and trees, festooned with garlands and scarves for the occasion. Dancers and musicians spill into this landscape as if Nature might join them in these honorific revels. 86

The pictorial references to games may likewise indicate actual funerary protocols. Beyond Homer's description of the funeral games of Patroclus in the *Iliad*, the custom of staging athletic and other contests as part of the bereavement process is widely attested in antiquity. In terms of general anthropology, this can be related to the process of sorting out a successor when a 'big man' dies. Historically, it was the understanding of the Romans that their gladiatorial shows were distantly descended from combats staged at Etruscan funerals. And duly there are tombs which show us a range of contests, from

94 Detail from the second chamber of the Tomb of Hunting and Fishing, Tarquinia, *c.* 510–500 BC.

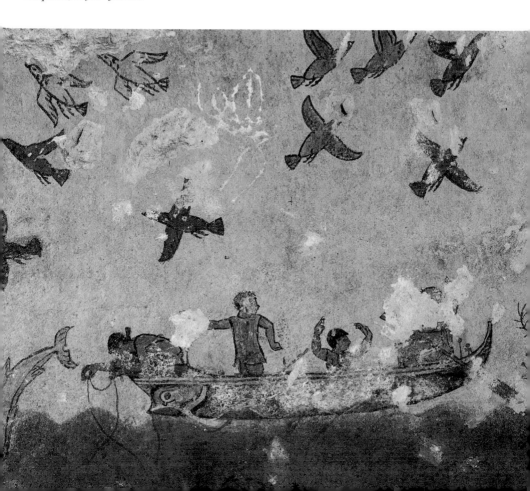

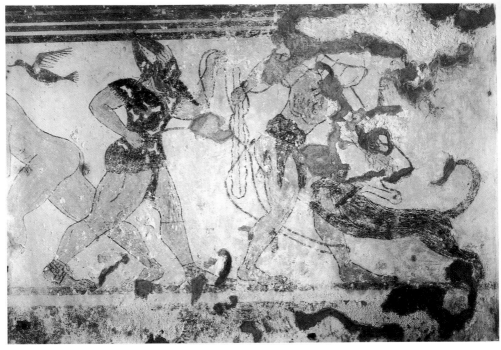

95 Detail from the Tomb of the Augurs, Tarquinia, *c.* 510 BC, showing a man with a sack over his head battling with a dog; to the left the masked figure of Phersu goads the dog and entangles the man.

96 Detail from the Tomb of the Black Sow, Tarquinia, mid-fifth century BC.

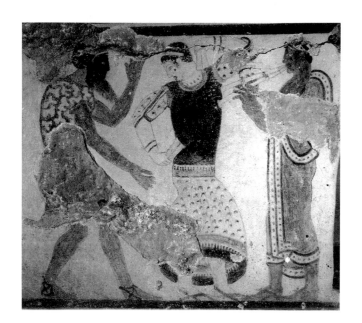

97 Detail from the Tomb of the Cockerel, Tarquinia, *c.* 400 BC.

the conventional events of Greek athletics (running, wrestling, boxing, jumping, discus throwing and so on), to more gruesome challenges. (In the most notorious of these, a grotesque figure called Phersu – probably the origin of the Latin *persona*, or 'masked character' – provokes a dog to savage a man holding a club, but entangled in string and handicapped by a sack over his head.)

More folk-style recreations may also be shown, as in the Tomb of the Jugglers. There were probably recitations to the memory of the deceased: the double flute, which we see in the Tomb of the Leopards and elsewhere, was the standard instrument for accompanying elegaic poetry. Tortoiseshell lyres are also played, and dancing takes place to castanets. Drinking is pursued seriously to the point of formality. Wooden couches (*klinai*) are disposed as they should be according to the Greek model for the symposium, the participants resting on their left arms. In the Tomb of the Lionesses, pride of place is given to the big bowl (*krater*) for mixing and consecrating wine, and in the Tomb of the Ship and several other tombs we see a 'drinks cabinet' assembled. It is what the Greeks would have known as a *kylikeion*, a place for keeping cups (*kylikes*) and other vessels. Jugs, ladles and strainers are all part of the usual equipment, accurately delineated. And in a number of tombs, such as the Tomb of the Black Sow, we see Etruscan symposiasts playing the game the Greeks

92

Frontis.

87

113

98 Detail from the first chamber of the Tomb of Hunting and Fishing, Tarquinia, *c.* 510–500 BC, showing a grove festooned with garlands and wreaths.

called *kottabos*, which involved launching the contents of a cup at a target – perhaps some receptacle balanced on a candelabrum, or else someone on the other side of the room with whom the thrower wished to flirt.

The term 'conjugal symposium' has been devised to allow for wives to be present at this sort of party. Such a description would have puzzled a Greek, for whom the symposium generally took place in the man's quarters (*andron*) of a house; if females were admitted, they were courtesans, not wives. Genealogical inscriptions on the later Tarquinian tombs make it clear that the Etruscan women who participated in drinking were respectable enough. And there is little evidence that they were admitted as sex objects. One tomb, the Tomb of the Whipping, contains a Sadean threesome, now prudishly partly obliterated. But compared with the pornographic licence displayed on many Athenian painted vessels of the time, instances of any sort of sexual congress are rare in Etruscan tombs.

How much has Dionysos to do with this? The answer is difficult to quantify, though we know that his Italic cult (in Etruria he was known as Fufluns or Pachies, echoing the cry of 'Bacchus') spread during the fifth century, earlier than Roman historians such as Livy

thought. One late sixth-century Athenian vase featuring on both sides a large beaming visage of the god was itself adopted as a mini-tomb by a Tarquinian. In the late sixth-century Homeric *Hymn to Dionysos*, it is to 'Tyrrhenian' sailors that the god reveals himself, turning them into dolphins: an Etruscan black figure vase is the first ⁹³ depiction we possess of this story.

That the vine and its fruit may belong to the grave is a very old principle. The Eighteenth Dynasty Tomb of Sennefer in the Valley of the Nobles at Egyptian Thebes is one of its most striking manifestations. 'Dionysos is Hades,' declared the sixth-century Ionian guru Herakleitos. But before we consider the symbolic import of Dionysos in Etruria, we may generally notice how many of the decorative schemes in the Tarquinian tombs are indebted to systems of ornament used on 'Dionysiac' vessels. Dividing the wall space into registers immediately makes a link with vase painting. The creation of a tympanum space immediately below a sloping roof is used, especially in Archaic tombs, for motifs commonly associated with the shoulder space of an amphora or similar vase, such as felines besetting their prey or prancing hippocampi. Later, the abstract devices used for filling non-figurative spaces on vases – such as palmette and volute patterns – are also applied to tombs (for example the Tomb of the Gorgoneion or Tomb 808). It has also been suggested that certain main figurative scenes in the tombs were adapted directly from 'sympotic' Athenian vases. The twin riding figures of the Dioscuri, as they may be in their soul-escorting or 'psychopompic' mode, on the walls of the Tomb of the Baron, strongly recall a drinking cup by Oltos now in the British Museum. And more generically, certain Dionysiac signifiers used on vases recur in the tombs, such as the motif of the flying phallus, conspicuous in the Tomb of the Mouse.

99 Detail from the Tomb of the Mouse, Tarquinia, early fifth century BC, showing the flying phallus, a motif which appears centuries later in Roman erotic bronzes.

The cult of Dionysos was one which promised regeneration. The god, like Osiris before him and Christ after him, exemplified triumph over death. His promise of breaking through from death – the spectacular rebirth the Greeks termed the *anodos* – was figured on a number of Etruscan vases. And we know that the story of the god's death and resurrection formed a key part of the mantic literature concerning Orpheus. The 'hubbub of books' implied by the fragments of surviving Orphic literature might not go far in decoding Etruscan tomb images even if we possessed them entirely, but scattered clues are still useful. Take the striking central gesture of one of the reclining figures in the Tomb of the Lionesses. Why does he hold out that egg so significantly? D. H. Lawrence intuitively salutes it as 'the egg of resurrection, within which the germ sleeps as the soul sleeps in the tomb'. He may be right, but it is valuable to know that Orpheus sang a solution to the riddle of which came first, the chicken or the egg: the Orphic account of the beginning of the universe championed the egg.

Plato disparaged Orphic ideals, saying that the Orphists' heaven amounted to no more than a state of eternal drunkenness (*Republic* 363 c). For some adherents, no doubt, that was perfectly desirable. But it must have been more complex. Parts of a fourth-century commentary on Orphic hymns were found charred in the pyre within a tomb at Derveni, in northern Greece. Enough of the commentary has survived to show that the rhapsodic utterances attributed to Orpheus were subject to peculiar local interpretation. Such is the nature of a shamanistic religion. As with Pythagoreanism

100 Detail from the Tomb of the Lionesses, Tarquinia, *c.* 520–510 BC.

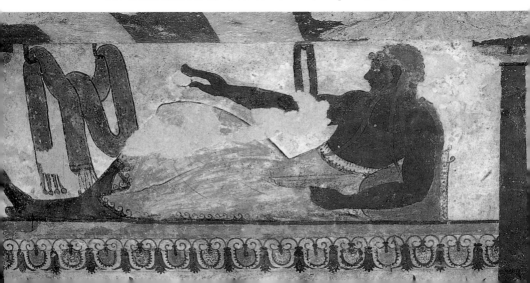

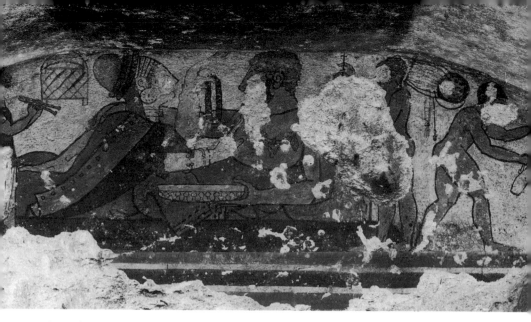

101 Central scene of the tympanum of the second chamber of the Tomb of Hunting and Fishing, Tarquinia, *c.* 510–500 BC. The couple relaxing on a couch together are toasting and garlanding each other; to either side, small attendants pipe music and fetch wine.

— certainly followed in the colonies of southern Italy — we cannot tell how profoundly such migrating cults penetrated into Etruria. But it is a mistake to consider the tomb paintings as empty of afterlife philosophies. As we shall see in the next chapter, the later tombs of Tarquinia make explicit references to an underworld, and the means of passage to it. For now, summary consideration of two further tombs suffices to indicate the generous iconological possibilities of these remains.

The Tomb of Hunting and Fishing, painted around 510–500 BC, has two communicating chambers. On the walls of the first, we see 98 figures uproariously dancing in a garlanded grove, amid what may be myrtle bushes. Mirrors and other items of vanity are picked out in this ambience, evoking youth, delight, and general *joie de vivre.* Above the entrance to the second chamber, a tympanum scene shows young hunters and their valets returning from the chase. Their quarry has been the hare: we see one still at liberty. Passing into the second chamber, attention is immediately demanded by birds tum- 94 bling skywards, birds which could have been painted by Picasso. They are escaping another hunter, this time a slinger standing on a

117

rock. Youths are bobbing in a boat on a dolphin-crowded sea, fishing, and others are diving into the sea from the sheer face of a colourful cliff. Above all this, a couple indulge affectionately in repose at a symposium: the woman strokes her man, and offers him a garland; he drapes his leg around her. Minions fetch wine, play music and make more garlands.

As usual, we know nothing of the deceased. But an internal logic can be fixed upon this medley of images, even if its components are ambivalent. The dancers in the grove show Bacchic abandon, but perhaps the gardens of Aphrodite are being suggested here. Certainly an erotic gloss can be put upon the associated hunting scene – not only because the chase itself evokes amorous pursuit, but more specifically because the quarry here, the hare, was a recognized gift of seduction – as scenes on a number of Etruscan black figure vases confirm.

Would those progressing into the second chamber then be surprised by the overt mutual petting displayed by the honoured couple, or by the seascape, the sea which was Aphrodite's midwife? Attempts to relate the images on the Tomb of the Diver at Paestum to Greek afterlife beliefs have called upon Pythagorean doctrines to explain the symbolism of 'diving' into the mouth of Hades. Here in the Tomb of Hunting and Fishing we may have an alternative (though equally oblique) significance to the diving motif, the plunge into the waves and foam that were Aphrodite's realm. And we may note that the myth of Adonis – eternally beautified and beloved of Aphrodite – became popular in Etruria, at least to judge from the incidence of its depiction upon mirrors.

At Delphi, in the Meeting House of the Cnidians, the mid-fifth-century artist Polygnotus painted a demon called Eurynomos. His image of this demon – whose name implies 'Just Deserts', and 'who feeds off the flesh of the dead, leaving them mere bones' – was, we are told, 'coloured between black and blue, like the flies that settle on meat' (Pausanias 10. 28. 4). When a tomb was discovered at Tarquinia in 1985 containing images of several beaky demons, two of them painted in this repellent electric blue, it was taken as further proof of stylistic associations across the Mediterranean. But recent analysis of the Tomb of the Blue Demons (painted around 420 BC) has proposed trans-Mediterranean cultic associations too. The shawled female figure holding a pomegranate wand and nursing a child is read as Demeter, with her daughter Persephone or Kore: she barters with a personification of the underworld, Eubouleus, for the return of a figure in long white vestments. In turn this figure is

89

clutched desperately by one of the demons (possibly Hypnos, 'Sleep'). But the figure seems to be getting away, and a ferry is ready to assist his retrieval back to the central symposium. Such was the promise on offer to the white-robed initiates of Demeter's cult at Eleusis. The goddess will negotiate freedom from the clutches of Death. The Emperor Augustus was a latter initiate to these Mysteries. Why should not a Tarquinian of the late fifth century BC have preceded him?

Such is the nature of the imagery of painted tombs at Tarquinia: neither sufficiently idiosyncratic to enable much in the way of attributions to individual artists (only desultory attempts have been made at this), yet curious enough to provoke speculation about symbolic value. We will return to the later tombs in the following chapter; now we move to another tomb-riddled centre, Vulci, whose tombs are celebrated not for the paintings on their walls (local geological conditions were less conducive to that custom), but for their numerous trappings, and in particular their painted vases.

Vulci presented a dismal ambience to D. H. Lawrence and does so to this day. Plagued for centuries by malaria, its modern aspect is dominated by a neighbouring nuclear power generating plant, whose pylons straddle grim and dusty empires of grain. Little is to be seen of what was once a large Etruscan city, and relatively little is to be seen, at Vulci's own rather Gothic antiquarium, of the once prolific contents of the many tombs of Vulci's Etruscan population. Intemperately emptied from 1828 onwards, those tombs have furnished the Greek vase collections of museums the world over. But that is a matter for discussion in Chapter Five. Imported Greek vases are not the beginning and end of Vulci's artistic culture.

Here we should take stock of two areas of activity. Neither can be said to be entirely confined to Vulci, but by virtue of sheer quantity, it is probably safe to regard Vulci as an ancient centre of production. The first is large-scale sculpture in the local volcanic stone known as *nenfro*. Given its bulk, this has mostly travelled far beyond its original siting, joining the general diaspora of objects ransacked from Vulci during the nineteenth century (and later). But more controlled excavations of similar figures from nearby Ischia di Castro, and at the Pian di Mola cemetery near Tuscania to the south-east of Vulci, confirm the impression that, during the sixth century, a regional tradition evolved of marking the access of certain tombs with vigilante figures. Curly-horned rams, snarling lions, smiling sphinxes: these are the usual markers, whose sacral semiotic pedigree can be traced around

102, 103

the Mediterranean and beyond (the lions of Delos, the sphinxes lining the route to the temples at Karnak, and so on). The underlying logic of such images is that they become associated with a boundary: they state where the community of the dead begins. And they may also symbolize a rite of passage by their very form. A sphinx, for example, is neither woman, bird, or big cat, but rather a hybrid of all three. A centaur embodies the border between man and horse. And as for the boys gleefully astride horses or hippocampi, they too may be considered as surfing the limits of this world and the next.

104–107

A similar iconographic logic can be applied to many of the images found on vases painted locally and deposited in tombs along with Greek imports. By default, a number of Etruscan vase-painting workshops have been localized at Vulci, simply because that is where most of their products have been found. Like the earlier Swallow Painter, some of these artists appear to have been Greek immigrants such as the various painters connected with the gaudy mid-sixth-century style known as Pontic, and probably also the painters of the 'Ivy Leaf' and 'La Tolfa' vases.

108

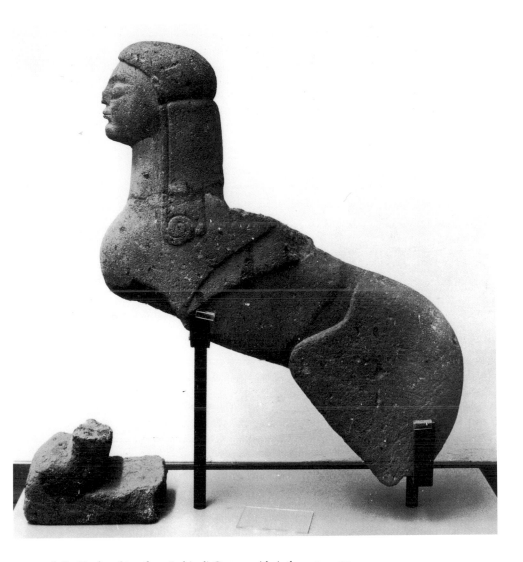

102 (*left*) *Nenfro* sphinx from Ischia di Castro, mid–sixth century BC.

103 (*above*) *Nenfro* sphinx from Vulci, mid–sixth century BC.

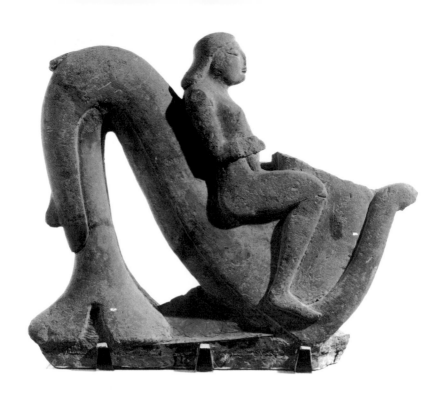

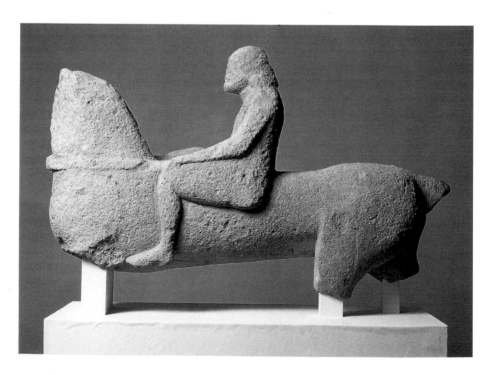

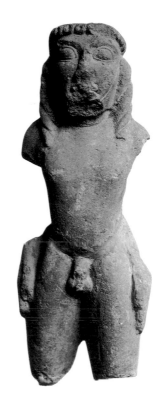

104 (*left*) *Nenfro* statue of a boy on a hippocamp from Vulci, *c.* 520 BC.

105 (*below left*) *Nenfro* figure of a youth on horseback from Vulci, mid-sixth century BC.

106, 107 (*right, below*) *Nenfro* centaur from Vulci, *c.* 550 BC.

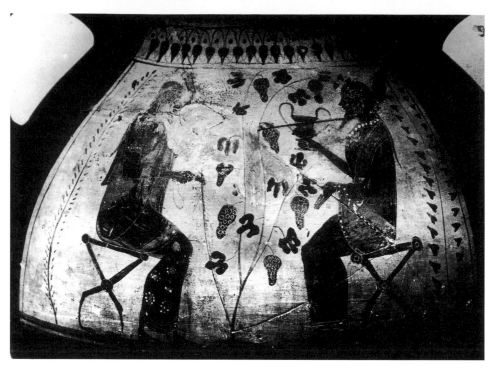

108 Detail of black figure amphora belonging to the 'Ivy Leaf' group from Vulci, late sixth century BC. Dionysos, patron of the vintage, and an associate (or communicant) sit amid fruit-laden vines.

One character – if the word can be used of someone whose existence is only imagined by connoisseurs – seems to have been particularly prolific in this sphere. With over two hundred pieces attributed to his name, the Micali Painter is the only Etruscan artist so far to have been honoured with a one-man show of his work (at the Villa Giulia Museum in Rome, in 1988). Though in technical terms they do not compare favourably to Athenian products of the same period, his vases present us with an engaging 'wonderworld' of 110, 112 jaunty centaurs, sirens, sphinxes, satyrs and winged horses, cursively challenging the limits of the ceramic space to which they are confined. Undoubtedly the Micali Painter knew the graven bestiary associated with approaching the local tombs at Vulci – on one vase he shows us two satyrs and a woman dancing between a pair of pedestalled sphinxes – and he also knew something his Athenian counterparts probably did not: that the vases he painted were largely

109 Hydria by the Micali Painter, *c.* 500 BC, showing satyrs dancing.

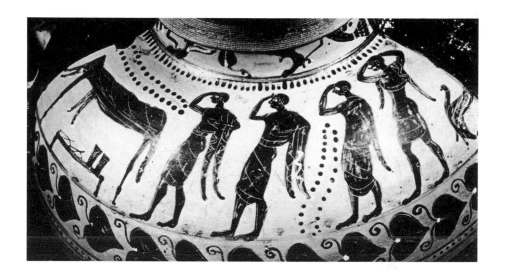

110 (*left*) Amphora by the Micali Painter from Vulci, late sixth century BC, showing winged dancers.

111 (*above*) Detail of hydria by the Micali Painter from Vulci, *c.* 510 BC, showing a *prothesis*. Mourners of the deceased (laid covered on couch to the left) slap their brows or tear their hair in the histrionics of grief.

112 (*right*) Amphora by the Micali Painter, late sixth century BC, showing winged horses.

or ultimately intended for deposition in tombs. Hence some direct allusions to funerary ritual are apparent, such as the 'lying-in-state' or *prothesis*, with realistic touches of pathos (under the draped bier of the deceased, stands a stool with a now unneeded pair of sandals or boots). That some understanding of Dionysiac eschatology was also projected in these images is suggested by several representations of 'rebirths' (*anodoi*), and the symbolic appearance of multi-teated animals. Mythical narratives as such are negligible in the repertoire: with so many thousands of intimidatingly literate vases arriving from Athens, the Micali Painter created an iconographic niche of his own.

Thanks to his early and eponymous promotion by Giuseppe Micali, an avowedly patriotic archaeologist, the Micali Painter has long been appropriated as a 'genuinely Etruscan' artist. Beyond a broadly 'Ionic' influence in style (which applies to the coeval stone sculptures too), anything other than a home-grown talent is difficult to identify. But it would be rash to equate naïvety or clumsiness of style (in both potting and painting) with a necessarily indigenous origin. Red figure vase painting developed belatedly in Etruria with respect to its advancement in Athens. Indeed the first 'red figure' vases made in Etruria were not executed in the reserving technique of Athens, but applied: instead of figures being left in outline in clay colour and the black background painted in, in the Athenian technique, the Etruscans painted buff figures onto a solid black background. The first such attempts seem to have been made at Vulci from *c.* 480 BC onwards. They are mostly insipid evocations of horsemen, athletes and dancers, in pairs or as solitary figures. But a signature occurs, complementing a number of Greek inscriptions on these vases. Tellingly, it reveals an artist whose name – Arnth Praxias, 'the doer' – strongly suggests a Greek who took up Etruscan citizenship.

Vulci became a Roman habitation, but eventually, in the early Middle Ages, it was sacked by the Saracens, and thereafter more or less abandoned. The same cannot be said of the truly prominent city of Orvieto, just inside the region of Umbria. As already mentioned, it has not been absolutely proven that Orvieto corresponds to the Etruscan city of Volsinii, nominated in Latin sources as *Etruriae caput*: the sacred or moral capital of Etruria. Confusion is generated by historical reports that the Romans destroyed Volsinii in 265 BC, and moved its inhabitants to a newly founded site. Does the 'old town' (*urbs vetus*) origin of Orvieto signal an authentic claim to be identified as the site of pan-Etruscan meetings, the sanctuary known as the

113 Applied red figure amphora, c. 470 BC, belonging to the Praxias Group. The clumsy proportions of the two discus throwers are typical of much Etruscan vase painting in the fifth century BC.

Fanum Voltumnae, probably an oracular centre like Delphi or Dodona in Greece?

Although medieval or modern buildings occupy Orvieto's ancient site (spectacularly, in the case of the gilded façade of the cathedral), traces of at least four temples have been located, both inside (Belvedere, Via San Leonardo) and outside the main city area (Cannicella, Campo della Fiera). The most evident Etruscan remains are the cemeteries laid out in the lower approaches to the city – neat regular streets of tombs, some of them even labelled with the names of their occupants. Prior to c. 500 BC (which is when the orthogonal

129

planning begins at the Crocefisso necropolis), sculpture and painting at Orvieto are unremarkable – a particularly crude school of black figure pots (the Orvieto Group) and some isolated examples of tufa statuary. Subsequently, until the time of the presumed Roman attack, there is a flowering of temples and temple decoration.

The late fifth-century Belvedere Temple had three inner chapels beyond a colonnaded porch, which in turn projected onto a large sacred enclosure. The terracotta statuary decorating both this and the slightly earlier San Leonardo Temple is very fragmentary, but not so fragmented that we cannot recognize its sensitivity of form, and even its sophistication of theme. One of the pedimental groups on the Belvedere Temple appears to have represented the drawing of lots among the Greek heroes to see which of them should challenge the Trojan champion, Hector. As we shall see in the next chapter, Etruscan identification with the Greek heroes at Troy was encouraged by the opposing Roman predilection for the Trojans. Here at Orvieto-Volsinii, perhaps some symbolic allusion was also being made to some ceremony within the sanctuary – the annual investiture of an Etruscan leader, possibly. It is worth noting that the same

114 Part of the necropolis of Crocefisso del Tufo, Orvieto, late sixth–early fifth century BC.

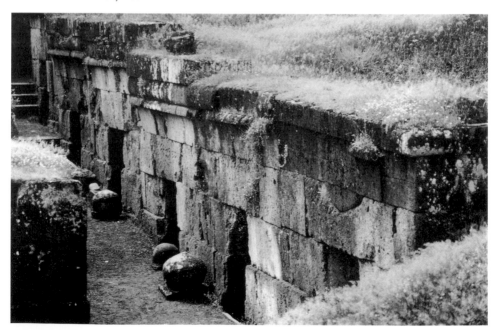

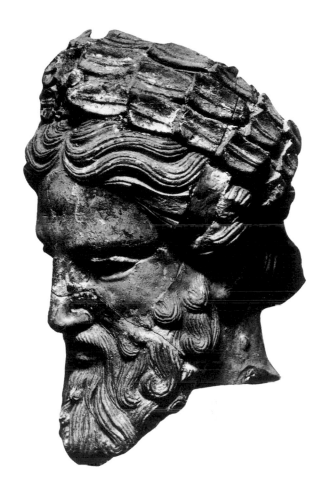

115 Terracotta bearded divinity from the San Leonardo Temple, Orvieto, late fifth century BC.

subject, executed as a group of bronze statues, was on display outside the Temple of Zeus at Olympia from the mid-fifth century onwards, and also that the postures and modelling of these terracottas shows a full awareness of the Classical 'canons' of sculpture created by Pheidias, Polykleitos and others during the fifth century in Greece. The severe features of a bearded head wearing a diadem from the San Leonardo Temple, are surely those of the Etruscan Zeus, Tinia – to whom numerous inscribed dedications have been found in Orvieto – and are respectably close to his image as it might have been seen in Olympia.

Some tomb painting has been found near Orvieto: the Hescanas Tomb at Casale Rubello, and the two Golini Tombs at Settecamini, the earlier of which unusually shows not only a banquet, but the kitchen preparations – hanging carcasses, chefs rolling pastry – beforehand. Attributing sculptures from elsewhere to an Orvietan origin is problematic but a case has been made for one of the most Classicizing of Etruscan bronzes, the Mars of Todi, to have originated from Orvieto. Made in *c.* 400 BC, its significance is heightened when we learn that it was dedicated at an Umbrian sanctuary by a Celt (in 390 BC a band of Celts sacked Rome).

Mention of the Celts reminds us that Etruria enjoyed (or suffered, as it may be) transalpine connections. And in this respect our next site, Chiusi, is important. Chiusi occupies a singular place in the topography of Etruscan art. Though deep in the interior of northern Etruria, it was never isolated from the influences operating at coastal

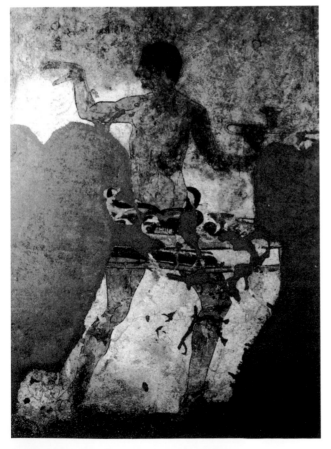

116 Detail from the Golini Tomb I, Orvieto, fourth century BC, showing servants filling cups.

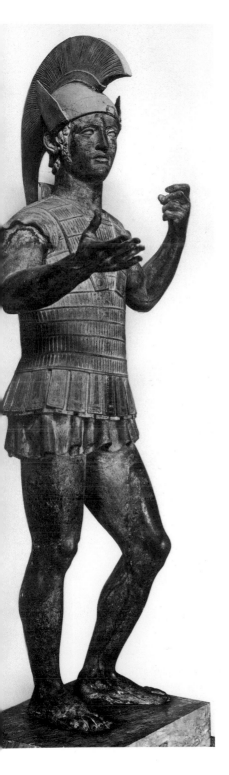

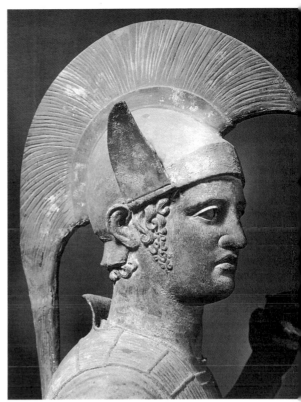

117, 118 Bronze statue, the Mars of Todi, from Orvieto, early fourth century BC. In the palm of the god's right hand there was a libation bowl and in his left a spear.

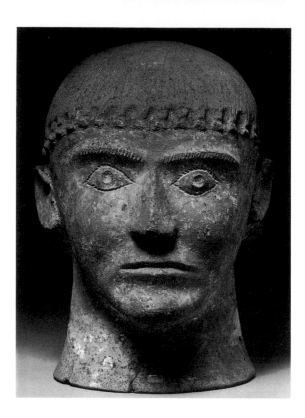

119 (*left*) 'Canopic' urn from Chiusi, mid-sixth century BC.

120 (*right*) 'Canopic' urn from Chiusi, early sixth century BC. So-called because of a superficial resemblance to vases from Egyptian Canopus, these anthropomorphic cinerary vessels can almost assume 'portrait' status in their developed form.

sites. So while there are unusual local forms, such as the anthropomorphic 'Canopic' urns beginning in the seventh century BC, there are also examples of committed Orientalizing (such as the intricate ivory vessel known as the Pania *pyxis*, probably brought up from southern Etruria). But unlike the southern centres, Chiusi also maintained links with places north of the Alps. A number of seventh-century bronze buckets (*situlae*) from Chiusi, elaborated with relief decoration, have been recovered from Celtic sites in Switzerland, southern Germany and the Danube basin. The sixth-century bronze pitchers known as *Schnabelkannen* were probably also exported from Chiusi to thirsty Celtic chiefs.

Several painted tombs are also known at Chiusi. Stylistically stilted, they nevertheless show proper acquaintance with the generic repertoire of contemporary funerary imagery – games, dancing and feasting. In the Tomb of the Monkey, for instance, we see a female dancer swaying about with an incense burner on her head: she is the

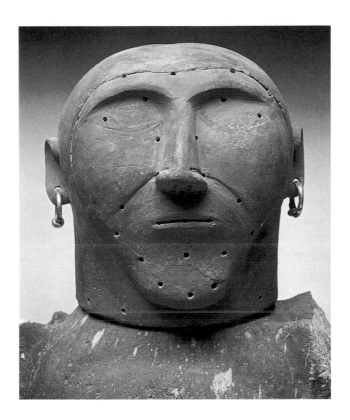

mobile target for the wine-throwing game the Greeks called *kottabos*. But the better-known contributions to funerary art from Chiusi are the 'Clusine reliefs', a series of relief-carved sarcophagi spanning *c.* 550–460 BC. Due to a manœuvre designed to fortify the unsteady notion of Italian unity in the 1870s, many of these were put on display in the museum of Palermo in Sicily; a large quantity survive.

Made from the sort of limestone sometimes called 'stinkstone' (*pietra fetida*), they were hailed by George Dennis as 'the most gen-uinely national works of the Etruscan chisel'. Though the quality of carving can be rough, their style and imagery is consistent. East Greek influences are there for those who want to find them, but there is no reason to suppose that a reality of local aspirations is not present in the cursive representations of banquets, drinking parties, games and ceremonies. Duels, bridal preparations, even orgies, come into the range, and it is not unusual for a sarcophagus to show carousing at a symposium on one side, and on another the solemn

121–125

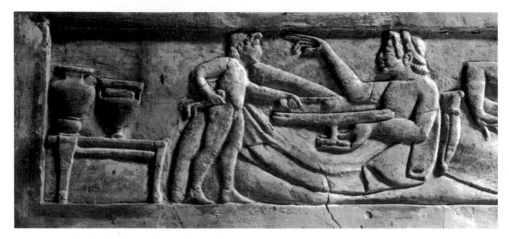

121 Detail of relief from Chiusi, late sixth century BC.

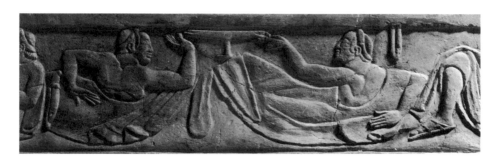

122 Detail of relief from Chiusi, late sixth century BC.

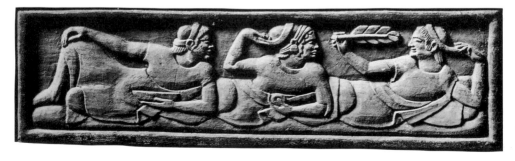

123 Relief from Chiusi, late sixth century BC, showing banqueters.

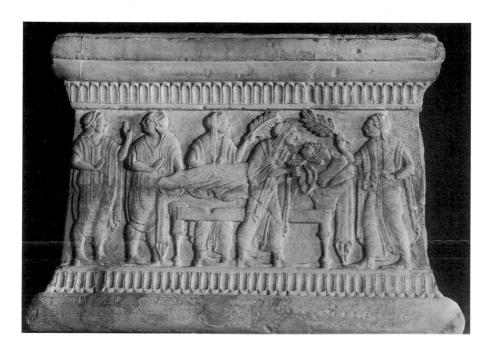

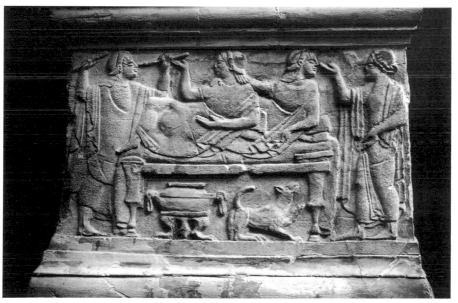

124, 125 Clusine reliefs on two sides of a carved sarcophagus, early–mid-fifth century BC, showing (*above*) a *prothesis* and (*below*) banqueters.

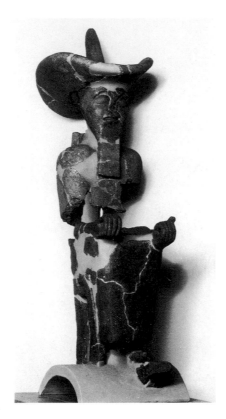

126 (*left*) Akroterial enthroned
figure from Murlo,
sixth century BC.

127 (*right*) Akroterial terracotta
sphinx from Murlo,
sixth century BC.

exposure, bewailing and embalming of a corpse. The workshops pro-
ducing these pieces served a wide regional territory, well beyond
secondary centres such as Chianciano Terme. One of their most
accomplished pieces, the Sperandio Sarcophagus, seems to have been
commissioned for the burial of a notable at Perugia.

Straying westwards to the Sienese parts of Tuscany, the hill-top site
of Murlo presents a conundrum. It is also known as Poggio Civitate
– 'the hill with *civitates*' – for which the translation 'hill with settle-
ments' is not quite adequate. A *civitas* implies some central and
regulatory place. Unpromisingly forested over, but chosen for a
modest student excavation project in 1966, Murlo has indeed
revealed itself as a place of regional importance, but quite what
power was concentrated there is still hard to define.

The main structure exposed by the excavation of Murlo is a

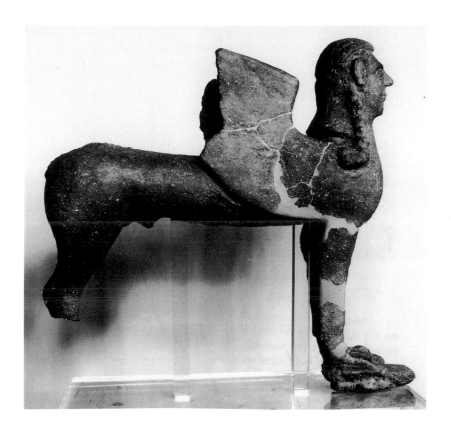

court-style building, with sides (three of them porticoed) about sixty metres long. Erected in the early sixth century BC over a simpler predecessor of the Orientalizing period, this building was at first supposed to have been a sanctuary. The fictile decoration of the roof, with generous akroterial figures, initially suggested as much, though the ground plan had little in common with Etruscan temples. Its excavator, Kyle Phillips, later designated it the 'Archaic Meeting Hall'. It seems to have been systematically dismantled and buried by 530 BC, and the site then lay undisturbed until modern times.

The problem with the meeting place hypothesis is that it requires some sort of localized political league or federation to exist – that is, a set of outlying communities whose representatives would gather to meet in this court. So far, there has been insufficient survey of Murlo's wider territory to substantiate its role as a place of

convention. So perhaps a more attractive hypothesis (that advanced by Italian scholars) is that Murlo served as the residence or palace of an aristocratic clan or dynasty.

The architectonic decoration can readily be interpreted in terms of aspiring regal insignia. A series of terracotta friezes running along the inside walls of the court display several themes, each of them contributing to a collective impression of prestigious activity. We see couples at their banqueting couches, some being waited on with food and wine, others strumming their lyres while hunting dogs crouch beneath. Then there is a wedding procession, with a couple being drawn along in a canopied waggon; then, past ceremonial tripod-cauldrons, canters a file of cavaliers and, finally, a divine assembly seems to be taking place, with deities seated magisterially upon folding stools.

This was not a palace in the 'megaron' tradition of the Aegean: the courtyard may have served as a throne room (a space for a throne, in front of the wall without portico, has indeed been located), but so far the Murlo complex has not yielded evidence of multiple storage areas. However, there is evidence for industrial activity *in situ*, including the manufacture of terracotta tiles and revetments. The friezes may be regarded as more examples of the sort of elongated plaques found at other sites in the sixth century BC; the large figures
126 on the roof, though, are more singular. The presence of a sphinx and other supernatural beasts suggests an other-worldly intention. It is
127 possible that the seated figures, with their memorable 'ten-gallon' hats and various attributes of power, represent distinguished ancestors of the resident leader: in which case, to anticipate Roman terminology, they are the *imagines maiorum* ('images of greater ones' or heroized ancestors) on public display in the reception court (*atrium*) of a palace (*regia*).

The building may indeed have hosted meetings of local potentates. Since we have resorted to Latin terms here, it is also worth citing the description the poet Vergil provides of an antique Italian palace in Book Seven of his *Aeneid*. Of the building where King Latinus occupies his ancestral throne to receive a delegation of newly-landed Trojans, we are told: 'Here, to ensure a happy reign, every king at his coronation must accept the sceptre, and take up the rods [*fasces*] of rule. The palace was a temple, and a senate-house [*curia*]; it was also the hall for sacred banquets, when by custom the elders sacrificed a ram . . .' (173–6). Murlo may have resembled this imaginary centre of clan power, in which the rank endowed by ancestral tradition and

the assumption of divine residence are combined to legitimate a regular series of feasts, ceremonies and political meetings.

Still in Tuscany, we reach Volterra, an enclosed centre which claims the remnant of an Etruscan archway (with three very time-worn lion-heads). The town specializes in the quarrying and sculpture of the same local stone – translucent alabaster – sometimes exploited by its Etruscan inhabitants. Like their counterparts at Chiusi and Perugia, Etruscan sculptors in Volterra were predominantly engaged in the production of coffins. And at Volterra, cremation seems to have been the favoured mode of deposition, so the ancient speciality was the ash-urn. In the old-established Guarnacci Museum at Volterra, some six hundred are displayed *ad nauseam*.

The dimensions of these urns may be suitable for a repository of ashes, but they do not favour elegance of proportion when it comes to carving figures on the lid. Gazing over an assembled mass of them – the mocked-up Inghirami Tomb in the Archaeological Museum at 129 Florence shows a typical concentrically serried arrangement – it is hard to believe that some element of portraiture was not intended. If not, why exaggerate the scale of the head with respect to the body, and allow these pouchy, sagging faces? But on closer inspection, one realizes that these heads are not animated by physiognomic likeness. Their appearance is due more to a generic prevailing taste for realism than the desire for accurate rendition of personal features.

Generic too are the indicators of status or piety attached to these images. Men hold the 'umbilical' libation saucers known in Latin as 128 *paterae*, or display writing materials in a studiously casual manner, or grasp drinking horns. Women hold mirrors, torches, fans or pome- 130 granates. At Volterra, the finer urns were carved in the local alabaster. Otherwise limestone or tufa was used, and in any case, the urns were painted. The standard of execution seems remarkably variable and there appears to have been much copying, some of it slipshod, at a local level.

But even allowing for the copying procedure (and therefore a standard stock of both figured lids and relief-carved urns), these objects show iconographical subtlety. At Volterra, some fifty mytho-logical types were used. These present excerpts rather than epitomes of mythical narratives, and though they may relate thematically to Greek or Hellenistic models, their schematic appearance seems locally formed (a distinctly Etruscan cast of demons can be traced). And there may be all sorts of reasons for associating particular myths with death at Volterra. In the many episodes of the Seven Against

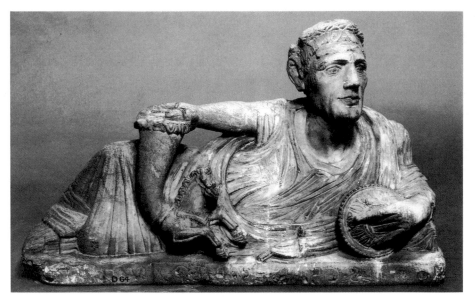

128 (*above*) Cinerary urn from Volterra, second century BC.

129 (*below*) The Inghirami Tomb from Volterra, late third–early first century BC, as recreated in the garden of Florence Archaeological Museum.

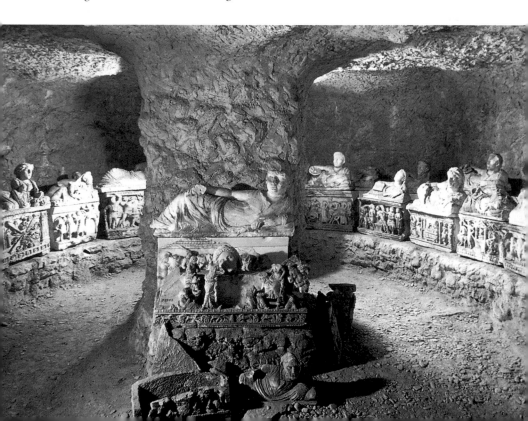

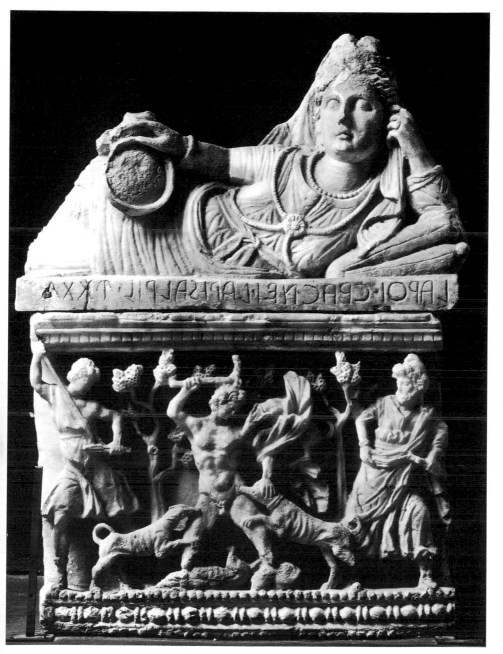

130 Cinerary urn from Volterra, second century BC. The deceased woman holds a libation saucer or *patera* in her hand. The scene below shows the death of Actaeon who was torn apart by his own hounds when he accidentally espied the goddess Artemis bathing.

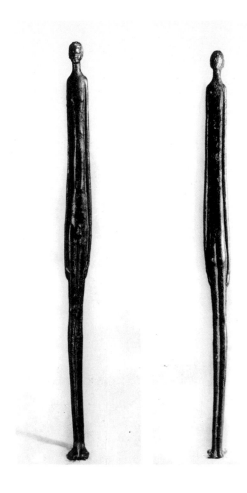

131 'Evening Shadow', votive bronze
from Volterra, third–second century
BC. Front and rear views.

Thebes saga, for example, we may note that Thebes is shown with
arched gateways, rather like the one which has survived at Volterra.
Did the city ideologically twin itself with Thebes? And did individu-
als in Volterra seek parallel lives in the heroes (or victims) of myth,
such as Philoctetes? Subjects such as the Rape of Persephone may
readily be matched symbolically to the moment of death. More
elusive allegorical meanings may have once belonged to the many
melodramatic or downright bloody scenes of violent death. Over
time, these yield to quieter scenes of departure and the funerary
journey. But the survival of a large theatre at Volterra, albeit Roman,
is a reminder that stories of the sort seen on the urns were more

likely to have been popularized by staged enactment than by the sterile medium of a pattern book.

One local peculiarity of Volterran art should be mentioned for the sake of completeness. In the third century BC or thereabouts, a fashion for elongation of votive statuettes produced the proto-Modernist figure, 'Evening Shadow', celebrated for its influence upon the style of the twentieth-century Italian sculptor Alberto Giacometti. To understand the original elongation, we must imagine a cluster of votive offerings around an altar. How could a worshipper's representative catch the attention of the deity presiding? To rise tall above other statuettes seems a reasonable answer to the problem.

A really diligent tour of Etruscan Tuscany should encompass further sites: Arezzo, for example, which yielded the famous bronze Chimera, and Fiesole, which was converted into a handsome Roman town. The late sixth-century and early fifth-century BC gabled chapel tombs of the Podere Casone necropolis at Populonia ought also to merit exploration, though it is hard to tell whether they mimic civic or sacred architecture. We have already resolved not to follow the Etruscans over the Appennines, where they established the Adriatic emporium of Spina in the fifth century, and where traces of their settlement have been located as far north as Mantua.

132 Gabled tomb at Populonia, early fifth century BC.

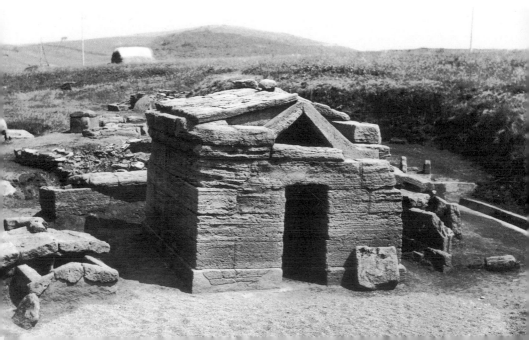

But one transappennine site demands our notice here. *En route* from Florence to Bologna, Marzabotto is notorious in modern times as the locus of a Nazi massacre. The Etruscan settlement, however, completes our tour as the first indigenous paragon of ideal urban geometry in Italy.

Roman writers tell us that the arcane rules of Etruscan religion, the *disciplina etrusca*, extended to town planning. These regulated not only the fixing of a sacred site and an orientation for a temple, but could also determine the shape and layout of urban quarters.

Haruspicy and augury – the prediction of events by examining the entrails of sacrificed animals, or by interpreting natural phenomena such as comets, or the flightpaths of birds – were specialities of the Etruscan priesthood. It is no accident that the soothsayer who warns Julius Caesar to 'beware the ides of March' has the old and distinguished Etruscan name of Spurinna. Needless to say, the principles of this divination remain obscure to us. However, we can at least regard the archaeological evidence for an Etruscan 'ideal city' as testament to some sort of consecrating geometry. This evidence may be

133 View of Marzabotto, showing restored house foundations.

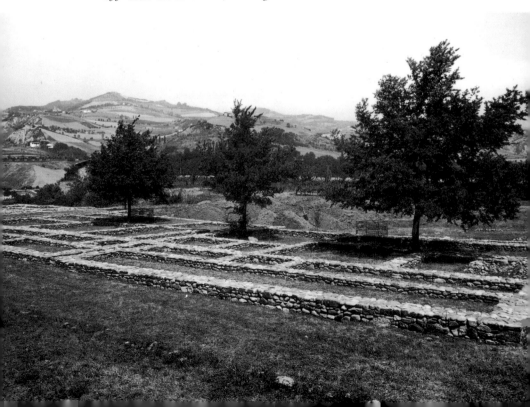

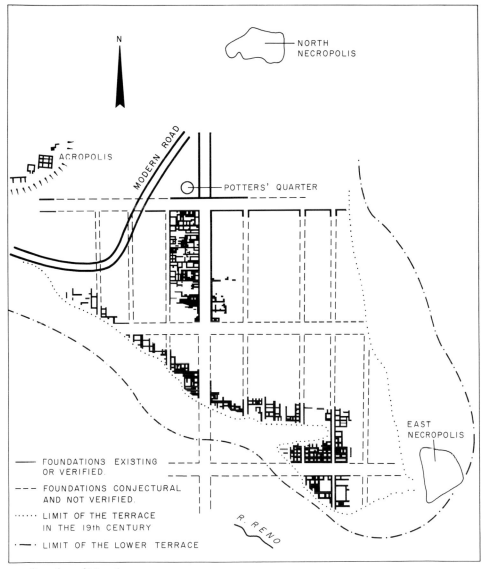

N

NORTH
NECROPOLIS

ACROPOLIS

MODERN ROAD

POTTERS' QUARTER

EAST
NECROPOLIS

——— FOUNDATIONS EXISTING
OR VERIFIED.

– – – FOUNDATIONS CONJECTURAL
AND NOT VERIFIED.

· · · · · LIMIT OF THE TERRACE
IN THE 19th CENTURY

·—·— LIMIT OF THE LOWER TERRACE

R. RENO

134 Site-plan of Marzabotto.

traced at certain cemeteries, such as the Banditaccia at Cerveteri, the Crocefisso at Orvieto, and at a late-developed, fourth-century BC town called Musarna, in Tarquinian territory. But it comes most clearly from the site of Marzabotto, in the valley of the River Reno.

Orthogonal city layouts appear in Greece, Sicily, South Italy and Etruria from c. 500 BC onwards, all at around the same time. In Greece and the Greek colonies the phenomenon is sometimes called 'Hippodamian', after the Ionian architect who both practised and codified the rational mathematics of rectangularly gridded street plans, creating a model at Miletus early in the fifth century. It is also sometimes given a 'democratic' impulse. Everybody lives in the same sort of house in the same sort of street: this has at least a sheen of egalitarianism about it. But while Marzabotto shows the characteristics of regular 'islands' of houses and workshops (iron smelting and pottery making have been located near or amid residential houses), it has not shown up any obviously public meeting places: no *agora* or piazza, so germane to the Greek democratic city.

Central planning is certainly evident here, including a system of covered drains running along the street margins. G. Mansuelli, a leading excavator of Marzabotto, characterizes its layout as fundamentally 'gerarchic', with several main routes of passage, some fifteen metres wide, integrating a network of multiple minor streets (five metres wide). Shrines and temples on the small 'acropolis' area and around the settlement limits seem to dictate the north–south orientation of these streets. The design was planted upon a much smaller organic settlement of undetermined ethnicity, and epigraphic remains suggest that the colonizers came from southern Etruria, mixing with locals. In due time (during the fourth century), the region was visited by Celtic invaders, who appear to have sacked the settlement. Gazing over its neat foundation structures, it is hard to resist the conclusion that Marzabotto represents the Etruscan annexation of a politically fashionable form, but not its accompanying ideology.

One wonders how often, in the course of a hypothetical grand tour of Etruria in the fifth century BC, a visiting Athenian might have come to the same conclusion. But that, of course, was his problem.

From Etruscan Rome to Roman Etruria

THE CESSPIT OF ROMULUS AND THE GREAT ROME
OF THE TARQUINS

In a letter to his familiar correspondent Atticus, the first-century BC Roman orator Cicero makes the following remark about Cato, a mutual friend of theirs: 'As for dear Cato, I feel as affectionate towards him as you do. But for all his good spirit and integrity, he can be a political liability. He expresses himself in the Senate as if we were all in Plato's Republic, not the cesspit of Romulus' (Cicero, *ad Att.* II. i. 8).

This sentiment – sometimes cited as a classic plea for pragmatism in politics – may tell us more about Cicero's gloom regarding the state of the late Roman Republic than his assessment of its mythical origins. But it raises a serious question about the perception of Rome's urban prehistory. For already in Cicero's time there was what we might call a 'heritage park' developing in Rome. Centred on the south-west slope of the hill legendarily chosen by Romulus for his walled settlement, the Palatine, this 'trail' of prehistoric sights would eventually include the following: (i) a primitive thatched hut, 'the hut of Romulus'; (ii) another hut, where the twins Romulus and Remus were sheltered by Faustulus, the shepherd who found them; (iii) a leafy enclosure called the Ficus Ruminalis, also associated with the abandonment and salvation of the twins, where a statue of the infant twins suckling from the she-wolf (lupa Romana) could be seen; (iv) the Lupercal, a grotto where the she-wolf nurtured the babes, and (v) a shrine called Roma Quadrata, with a platform for augury or divination and a repository for relics associated with the Romulean foundation of the city.

Much of the elaboration of this theme park can probably be ascribed to the Emperor Augustus, who once considered calling himself Romulus. His own house was very close to the alleged hut of Romulus, and he generally revived antique customs as part of his programme for the moral regeneration of Rome after protracted civil

wars. How much actual archaeology was known at the time is difficult to say, though Salvatore Puglisi, a modern excavator of the Palatine, was sure that late Republican Romans had some objective acquaintance with early Iron Age remains on the hill. It is not doubted, however, that the literary fabrication of Rome's indigenous origins – the tale of Romulus and Remus – was actively promoted from the third century BC onwards. Specific Roman families had vested interests in encouraging such folklore. But the general partisan motive for this literary fabrication was to erase the memory that the foundations of the city of Rome had been laid not by Romans, but by Etruscans.

Neither the historiography nor the archaeology of this issue are free from polemic and irresolution. The phrase coined by those who support the notion of a Rome monumentalized by Etruscans is 'la grande Roma dei Tarquinii', 'the great Rome of the Tarquins', invoking an Etruscan royal dynasty from either Tarquinia or Cerveteri (where there is a Tarquin family grave, from the fourth century BC). Roman annalists admitted the presence of these Tarquins as kings of Rome, beginning with Tarquin the Old (Tarquinius Priscus) in *c.* 616 BC, and ending with Tarquin the Proud (Tarquinius Superbus), who was expelled with his family in *c.* 509 BC. The expulsion was dramatized in the story of the rape of

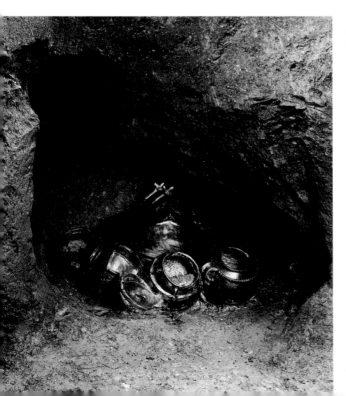

135 Grave Q of the Forum cemetery, Rome, showing eighth-century BC pottery.

Lucretia, a chaste Latin lady, by Tarquin's braggart son, Sextus Tarquinius, and rationalized as an anti-tyrannical revolt which prepared the political basis of the Roman Republic.

The dates quoted here are those supplied by Roman historians, and are suspect, not least because the sequence of seven kings, commencing in 753 BC with Romulus, requires each of them to have enjoyed exceptional longevity of reign. But in terms of the absolute chronology established for archaeological finds, there is a degree of consonance between myth-history and dated structures. Early traces of cult and habitation at Rome (in the Comitium area) belong to 750 BC. A wall or palisade seems to have been thrown around the Palatine around 730–720 BC. So much for 'Romulus'. Various votive deposits, for example on the Capitoline hill, belong to the seventh century BC. But efforts at paving areas of the valley that would become the Forum are insignificant until the end of the seventh century. Graves attest a humble level of settlement, with none of the princely tombs of the Orientalizing period that have been found in Etruria and inland Latium (Praeneste, or Palestrina).

Then, and throughout the ensuing sixth century, there is a marked impact of urban development. The Forum is paved. The priestly palace known as the Regia is established. A riverside sanctuary is created at Sant'Omobono, in what would become the Forum Boarium. A large temple, over sixty metres in length, is dedicated on the Capitoline. And in the centre, a sewerage system is designed: the vaulted drain to the Tiber known as the Cloaca Maxima, constructed 'on a scale so gigantic', as Lewis Mumford noted in his *The City in History* (1961), that 'its builders must have clairvoyantly seen . . . that this heap of villages would become a metropolis of a million inhabitants'.

Was all this the work of the Tarquins, between 616 and 509 BC? If we follow the practice, popular among the Romans themselves, of 'twinning' mythical and historical figures across the Mediterranean, then we should follow Plutarch and pair Romulus of Rome with Theseus of Athens, therefore treating him as a poetic-religious symbol. To the Tarquins we should then match the sixth-century tyrants of Athens, the Peisistratids, who also undertook an ambitious programme of public works, and were likewise deposed at the beginning of the last decade of the sixth century BC. The difference here – and this makes it a sometimes emotional zone of scholarship – is that the Etruscans were of course never linguistically akin to the Latins, beyond a number of loan-words and transliterations. So even when

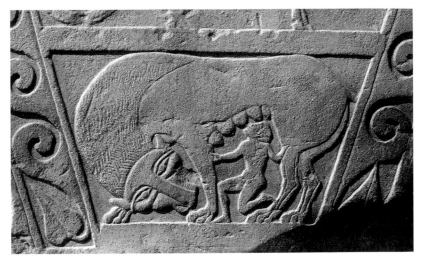

136 Detail of funerary relief from Bologna, late fourth century BC, showing a boy with a (?) she-wolf. The absence of a second figure makes it unlikely that this is a representation of Romulus and Remus, but we do not possess the Etruscan version of that story.

certain Archaic images suggest an Etruscan element to stories such as the wolf-raised boys, or Aeneas arriving in Italy, the integrity of the Latin language naturally harboured a proprietorial mythology. In due time the fireside ballads of the Latins, which the Victorian writer Thomas Macaulay tried to recreate in his *Lays of Ancient Rome* (1842), caricatured the Etruscans as maniacal enemies: 'Lars Porsena of Clusium/By the Nine Gods he swore/That the great house of Tarquin/Should suffer wrong no more.'

Whichever way historians choose to divide on the 'Great Rome of the Tarquins' issue – which is made more complex by the intrusion of a demagogic usurper within the Tarquin period, known to the Romans as Servius Tullius – one thing remains certain. Regardless of whether the Etruscans ruled Rome at the time, the art and architecture of the nascent city was made possible by Etruscan and Greco-Etruscan craftsmen. Even the Augustan (and therefore pro-Romulean) historian Livy specifies that for the decoration of the Temple of Jupiter Capitolinus, King Tarquinius Superbus summoned artists 'from all over Etruria' ('undique ex Etruria': Livy 1. 56. 1). Another source tells us that a terracotta specialist from Veii, called Vulca, was hired for the commission. And akroterial terracotta

137 Akroterial terracotta head of Athena from the Sant'Omobono sanctuary, Rome, late sixth century BC. Further fragments indicate that she belonged to a group with Herakles, escorting the hero to his apotheosis.

figures and relief plaques recovered from the Sant'Omobono sanctuary indeed seem typical of Etruscan 'Ionicizing' sculpture in the sixth century. One group shows Athena presenting Herakles to Olympus, an image plausibly indebted to the self-trumpeting sculptural programmes of the Peisistratids on the Athenian Akropolis. In addition, a good deal of bucchero pottery, some of it inscribed in Etruscan, has come from 'palatial' sixth-century buildings on the Palatine and elsewhere in Rome. Further excavation in the city areas of Cerveteri and Tarquinia should continue to clarify the extent to which the community of artists and architects in Etruria contributed to Rome's early urban shape. They built a city whose eventual success was Etruria's disaster.

VULCI: THE FRANÇOIS TOMB

By the mid-fourth century BC, the cities of southern Etruria were already threatened by Rome's expansion. In 396 BC the city of Veii was taken. Significantly, after a reported debate in the Rome Senate about what to do with Veii's cult statues, the Romans chose to

138 Detail from the François Tomb, Vulci, *c.* 350 BC, showing scenes of battle.

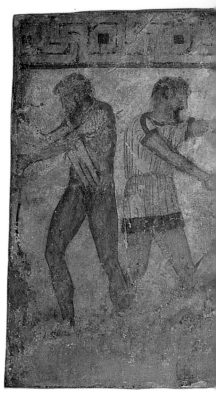

139, 140 The François Tomb, Vulci, *c.* 350 BC. (*Left*) A detail showing mythical combatants (Eteocles and Polynikes). (*Right*) A detail showing Charun and Vanth assisting in the sacrifice of the Trojan prisoners.

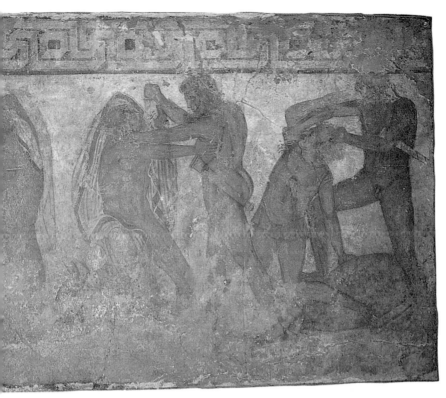

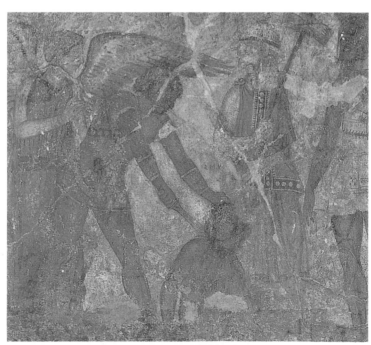

transfer the images to their own sanctuaries, more in the spirit of shared beliefs than as an act of triumph. But not surprisingly, some Etruscans of this period tried to put an ideological distance between themselves and Rome. This at least seems to be the purpose of the paintings of the François Tomb, discovered at Vulci in 1857, and now rather secretively preserved in Rome at the Villa Albani.

Revealed in flickering torchlight, these murals cannot have failed to secure a visceral response from their ancient viewers. Fountains of blood pulsed from figures enacting a mytho-historical narrative of capture and revenge. Whoever emerged from the tomb's long corridor or *dromos* was faced with opposing walls showing twinned frescos. Thus a savage event from Homeric epic (the sacrifice of the Trojan prisoners, part of the wrath of Achilles) is made the pendant of local and more recent heroizing episodes of clan history, in which we see the champions of Vulci prevailing over opponents who seem by their names to be both Roman and Etruscan. One of those being slain, for example, is named Cneve Tarchunies Rumach, or 'Gnaeus Tarquinius of Rome', and immediately we are reminded of how little we know of either Etruscan or early Roman history. (Who is this Tarquin? Were the Tarquins of Rome actually enemies of other Etruscan cities?)

Thanks to a scholarly gloss made by none other than the Emperor Claudius, we know that the Etruscans heroized a figure called Macstrna or Mastarna, whom the Romans called Servius Tullius. This is the character in the Roman account of the sixth-century kings who usurps during the Tarquin period and introduces many important political reforms. On the walls of the François Tomb, he is seen releasing the bonds of a warrior called Caile Vipinas, who must be the Vulci-based adventurer known in Latin as Caelius Vibenna, and whose brother Avle (Aulus) also appears heroically in these scenes. Plainly we are in the midst of stirring events dear to local memory at Vulci, but little else is plain. Even the ideological significance of pairing the sacrifice of Trojan prisoners is questionable.

By appropriating the myth of Aeneas, a refugee from fallen Troy with his father and son, and inserting it (with some awkwardness) into the home-grown tradition of Rome's foundation, the Romans mytho-historically aligned themselves with Troy and the Trojans. (Many Romans eventually based at the city of Ephesus would go so far as to construct family trees leading back to named Trojan heroes.) So as a principle of ideological opposition, as it were, the Etruscans cleaved to the Greek side. Agamemnon, Achilles and Ajax among

143 (*right*) Detail of polychrome sarcophagus from Torre San Severo, Orvieto, *c.* 300 BC, showing the sacrifice of Trojan prisoners.

141, 142 Gemstones, *c*. 500 BC. (*Far left*), a gemstone showing the suicide of Ajax. Legend has it that Ajax was made virtually invincible when swaddled as a baby by Herakles. At only one point (under his armpit) could a sword enter. Etruscan artists seem to have been familiar with this aspect of the myth. (*Left*), a gemstone showing the seated Achilles.

others were their exemplary forebears, by whose actions – such as the sacrifice of prisoners, a motif of sedulous castigation encountered for example on the vivid Torre San Severo sarcophagus at Orvieto – most brutalities could be sanctioned. The Homeric warriors' triumphs, and misfortunes too, such as the suicide of Ajax, could serve as seals of personal honour. But if this taking of mythical sides was consistent, why are Etruscans seen killing Etruscans in the François Tomb?

144 Detail from the François Tomb, Vulci, *c.* 350 BC, showing Vel Saties.

The honorand of the sepulchre, a cloaked figure, was represented in its pilastered atrium amid characters from further Greek mythology, and underworld imagery. He is labelled as Vel Saties. Perhaps, like Socrates, he thought that death yielded the opportunity to meet up with figures such as Nestor, or 'relive' epic moments. Perhaps, too, he considered the Tarquins of Rome to be Romans by default. In that case, the Roman–Trojan and Etruscan–Greek symmetry can be allowed to hold. There are three time-scales converging here: presumed tension when the tomb was painted (the mid-fourth century BC), 'historical' conflict between Vulci and the Tarquins in the sixth century BC, and the mytho-historic combats between Greeks and Trojans once upon a time. We shall never be certain about the personal circumstances of Vel Saties and his family at Vulci. But we may depart all the same with an impression which will be confirmed by Roman historians: namely, that there was little unity between the various city-states of Etruria. Internal discord between Vulci and Tarquinia, or even between Vel Saties and his own staff of slaves, made the operation of conquest much easier for Rome.

145 Warrior from painted marble sarcophagus from Tarquinia, mid-fourth century
BC. Detail from polychrome scenes of Greeks and Amazons.

Etruria has been described (by Mario Torelli) as 'a laboratory of Roman imperialism'. This means that as the Romans advanced piecemeal into Etruscan territory, different strategies were evolved for the absorption or destruction of Etruscan power and property. What the Romans coveted were the natural benefits of Etruscan territory: from early squabbles over salt-pans at the mouth of the Tiber, the targeted resources included timber, metal and grain. Fertility was compounded by good land management (Etruscan engineers had laid out elaborate underground distribution channels or *cuniculi* in those few areas lacking a ready water supply): thus, as Vergil acknowledged, 'Etruria had grown strong' ('sic fortis Etruria crevit': *Georgics* 2. 533).

The military vicissitudes of the Romans' experimental campaign need not be chronicled here. But the process whereby Etruria became, in 90 BC, just another region of Italy (and the Mediterranean) comprising Roman citizens was not a superficial change. Effectively it was the obliteration, literally the burial, of a culture. This was an experience – a collective trauma, in modern parlance, or a form of ethnic cleansing – which art could hardly ignore.

'History is a graveyard of aristocracies.' Vilfredo Pareto's dictum regarding the cyclic rise and fall of élites has an attractive pungency, but disregards a key manœuvre in Roman expansionist policy. This was the maintenance, wherever possible, of an existing equilibrium of power. For the sake of narrative drama, it may have suited Roman historians to paint a picture of the Etruscan aristocracy as hopelessly degenerate, ripe for overthrow by a vast underclass of serfs. But Roman politicians realized soon enough that their rule could be more easily imposed by harnessing a local and provincial élite, and driving the functions of government through 'old hands'.

So if we look for art that represents Etruscan resistance, we will find remarkably little. Some speculative notions of calls for solidarity among threatened landholders may be indulged. For example, two recurring subjects on the cinerary urns of Chiusi during the second century could be read as rallying cries. One shows a figure wielding a plough against conventionally armed attackers. There happens to be a Greek name for this rustic hero (Echetlaeus, who rose up against the Persians at the Battle of Marathon), but does he here symbolize the plight of the Etruscan farmer versus the Roman army? The other

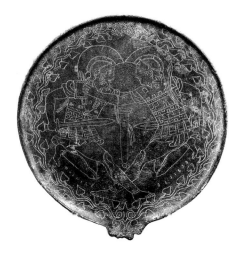

146 (*left*) Incised bronze mirror, fourth century BC, showing Eteocles and Polynikes duelling.

147 (*below*) Detail of sarcophagus from Chiusi, early second century BC, showing Eteocles and Polynikes.

is an old favourite from the Theban cycle, the duel between Eteocles and Polynikes, but could it be read as an urgent message in second-century Chiusi, broadcasting the disastrous results incurred when brothers fight among themselves?

Most historians of Etruscan art look for more general indicators of stress among the patrons of tombs, sarcophagi and minor objects, including mirrors, during the centuries of gradual Roman ascendancy. They call upon a delicate knowledge of Etruscan religious doctrines, the *disciplina etrusca* which partially survived into Roman times, to reconstruct the changing psychology of Etruscan aristocrats.

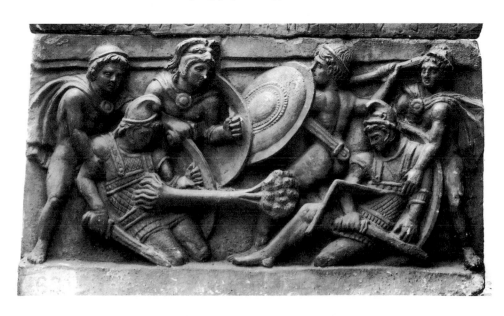

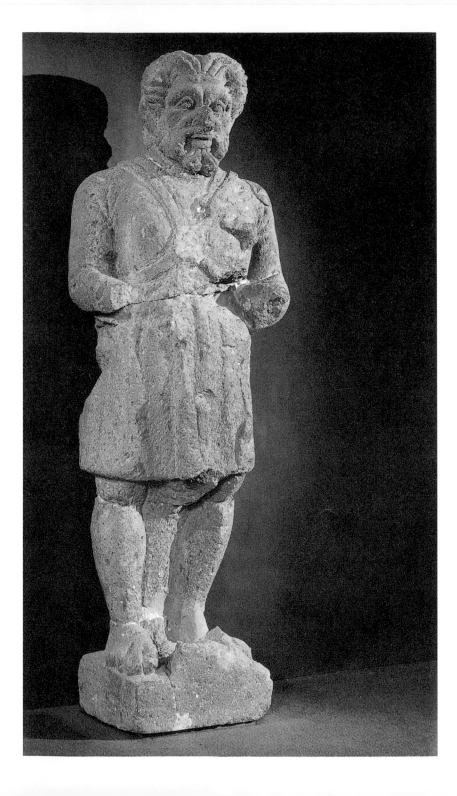

According to Romans privy to the texts of Etruscan dogma, a faith prevailed within the Etruscan priesthood that nations, like individuals, were allocated lifespans on earth. Each nation had its day of reckoning more or less at the end of a millennium; in the Etruscan case, the determined number of centuries, or *saecula*, seems to have amounted only to eight. There was nothing to be done about such cyclical predestination except surrender to its inevitability. Etruria's time had run to its allotted limits. Now the Romans' turn began.

The sceptical will feel that this plays suspiciously nicely into Rome's scheme for Etruria and wonder, if Etruria was such a disparate set of cities, how such a degree of 'national' self-consciousness came about. But apart from a considerable amount of direct evidence relating to the Etruscan practice of haruspicy, and images clearly showing individuals faced with the pages of destiny (the *libri fatales*), it does seem possible to construct a changed aristocratic pyschology from the fourth century BC onwards. Of course not all of the exuberance of Dionysiac commitment disappeared. Scenes of dancing and intoxication, symbolic or otherwise, are still to be found, especially on vases. Tomb paintings, however, show a shift of

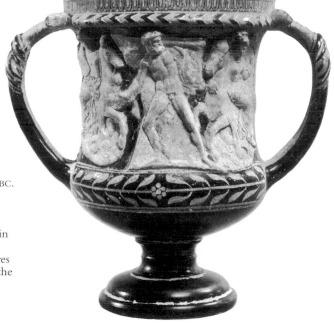

148 (*left*) Charun carved in *nenfro* from the Greppe Sant'Angelo grave complex at Cerveteri, late fourth century BC.

149 (*right*) Relief vase of the Malacena Group, late fourth century BC. The Dionysiac train or *thiasos* of reeling satyrs and maenads is depicted. The figures stylistically recall the frieze of the Mausoleum at Halicarnassos (*c.* 360 BC).

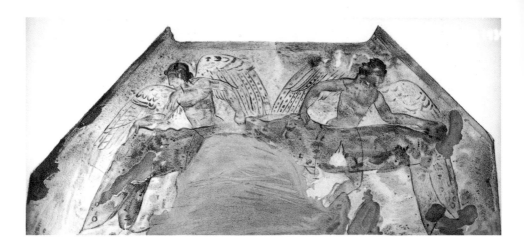

iconographic emphasis which is palpably melancholic in tone. In the frescos of the late sixth and the fifth centuries, bereavement is a sort of glory for the deceased, and loss marked by a celebration of life. The idea of death is virtually exorcised. In the fourth century, these iconographic intentions yield to a much more articulated image of the underworld awaiting the deceased. And the heightened scrutiny of this underworld does not induce much gaiety in those travelling towards it. Their stricken, sorry faces are easily read as expressing the resignation of a doomed and declining people.

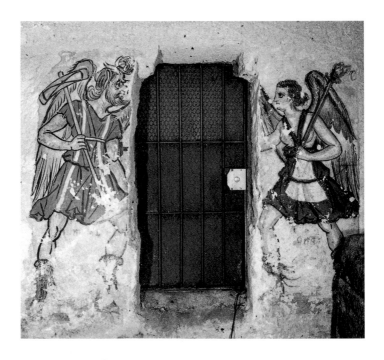

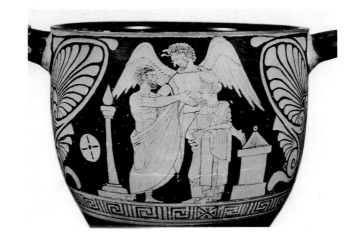

50 (*left*) Detail from the
Pulcella Tomb, Tarquinia,
c. 400 BC.

On foot, on horseback, by chariot, by ferry: these were the
diverse means of passage to Hades, whose entrance was signified by
an arched door. The deceased was claimed by two demons: Charun,
carrying the great mallet with which to open the doors of Hades,
and Vanth, an 'angel' bearing the torch with which to illuminate its
gloom. The twin soul-bearing or 'psychopompic' brothers Sleep and
Death might assist, and other more or less monstrous spirits too,
chivvying the deceased with snakes as goads. That the hook-nosed
Charun is the principal escort of the route to the underworld is

51 (*left*) Detail from the Tomb of
the Aninas, Tarquinia, *c.* 240 BC,
showing the tomb door flanked by
Charun and Vanth.

52 (*above right*) On this large red
figure drinking cup, fourth
century BC, Charun is shown
escorting a victim. The deceased is
not so much offering his hand in
final salute to his wife as indicating
the tombstone where she should
subsequently pay her respects; a
moment of tragic drama has also
been suggested.

53 (*right*) Detail from the Tomb
of the Charuns, Tarquinia, *c.* 300
BC, showing a mock door flanked
by demons.

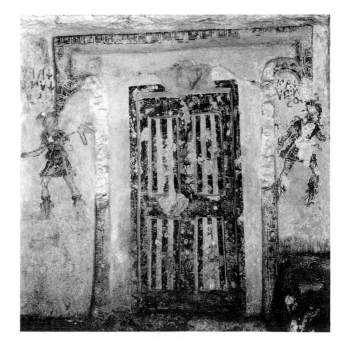

154, 155 The Orcus Tomb complex, Tarquinia, *c.* 400–350 BC. Details of Tomb II (*left*) showing banqueting service, and Tomb I (*right*) showing Charun.

made clear by his clumpy boots; though swamps or marshes might have to be negotiated on the way, he is not so much the stingy ferry-
148 man as Charon, his Greek counterpart. A graven image of him from the Greppe Sant'Angelo area of Cerveteri is suitably malign and severe. And there is also a doorman, Culsu, at the gates of Hades, who holds its keys.

Still, it is not all misery beyond. On the walls of the Tomb of Orcus I at Tarquinia, Charun leads us into an olive grove fringed with vines and scenes of a banquet. The earthly prerogatives of a land-holding family may be mirrored for them down below, it seems. And the 'send-off' that accompanies the journey of the deceased to this place may be full of civic honours: parades of digni-taries wearing togas stridently exhibit the various symbols of magis-
156 terial authority, as in the Bruschi Tomb or the Tomb of the Typhon. It may well be that the late fourth-century bronze figure known
157 for no sound reason as 'Brutus' once belonged to a sculptural equivalent of such honorific funerary painting: his tight-lipped
158 features very closely resemble those of faces in the Golini Tomb II at Orvieto, for example.

166

156 Detail from the Bruschi Tomb, Tarquinia, third century BC. Included in the toga-clad procession are members of the Apuna family, to whom the tomb belonged. The dolphin/wave dado below recalls Archaic traditions of decoration at Tarquinia.

The division of the damned and the blessed is never as clear in any Etruscan painting as it would become in later European church art, such as Luca Signorelli's frescos in Orvieto Cathedral. Greek and Roman visions of Hades imply such a sorting, and Vergil (in Book Six of the *Aeneid*) describes with particular plangency the fate of those who fail to cross the final liquid barriers of the Elysian Fields to the Isles of the Blessed. Naturally the patrons of painted tombs regarded themselves as the fortunate ones, but the passage was fraught with dangers. In the Tomb of Orcus II, the deceased are depicted in the judicial presence of Hades himself (with Persephone beside him). A repellent demon called Tuchulca supervises punishments nearby. Clearly there was Etruscan acquaintance with the

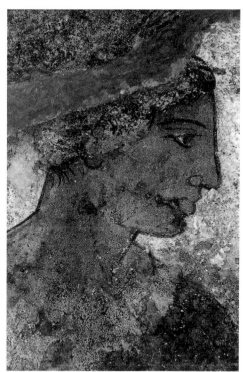

157 (*left*) Etruscan bronze head, late fourth century BC, sometimes called 'Brutus'.

158 (*right*) Detail from the Golini Tomb I, Orvieto, fourth century BC.

mythical damned: Sisyphus, endlessly rolling his rock uphill, Tantalus, reaching for elusive refreshment, and others. Noble Etruscans also apparently shared the Greek and Roman faith in an underworld rendezvous with the bloodless shades of epic heroes.

But the tombs at the time of the Roman conquest were also created as affirmations of dynastic history. A community of ancestors belonged here, and labelled, painted 'portraits' of them could be ranged around a perpetual banquet, as in the Tomb of the Shields, 159 created by one Larth Velcas of Tarquinia in *c.* 350 BC. In the Giglioli Tomb, belonging to the end of the fourth century, heirlooms of 160 martial virtue – helmets, spears, swords, cloaks and blazoned shields – are painted as if festooned around the walls of the family home.

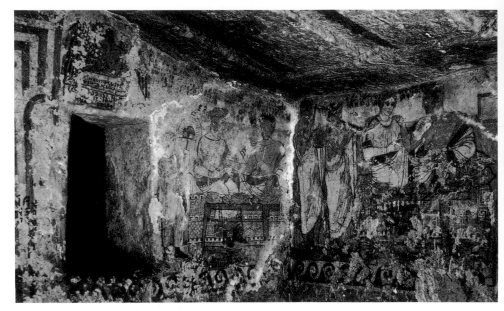

159 Interior view of the Tomb of the Shields, Tarquinia, *c.* 350 BC, showing a banqueting scene.

160 Detail from the Giglioli Tomb, Tarquinia, late fourth century BC.

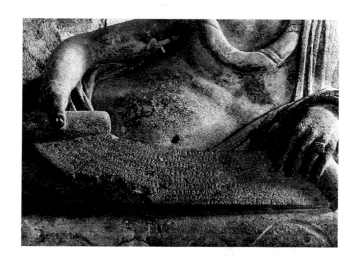

161 Detail of *nenfro* sarcophagus of Laris Pulena, early second century BC.

Behind the paintwork, was it all faded glory? If we turn to the sarcophagi produced at Tarquinia and other Etruscan centres from the fourth century onwards, it certainly seems so. Laris Pulena of Tarquinia, for example, semi-recumbent above a crudely carved scene of Charun and Vanth figures collecting their prey, is content to unroll beneath his flaccid paunch a scroll relating the great deeds of his predecessors. This evokes not only a nostalgic society, but also one obsessed with archives. Yet again we should be cautious in our sympathies for a ruined aristocracy. The typical iconography of the funerary cortège accompanying the chariot-borne magistrate, which shows him escorted by lictors, scribes and others, is intended as a reflection of social and political status. The demons who appear in this processional context are, as it were, interrupting an honourable civic career. And the physical obesity flaunted by the deceased is not necessarily an index of decline (though Roman writers, mocking the type of the 'pinguis Etruscus', 'pudgy Etruscan', took it as such). Plenty of ethnographic comparisons could be cited to demonstrate that power can be manifested in some societies by an abundance of subcutaneous padding.

Whether these constitute portraits it is difficult to say, even when large numbers pertaining to a single family, such as the Curunas of 162–166 Tuscania, are assembled together. The men often achieve a strong-featured look: not necessarily 'realistic' in a documentary sense, they show physiognomic signs of seniority and responsibility such as heavy jowls and furrowed brows. In this way, the accepted image of an Etruscan aristocrat in the third or second century BC strongly

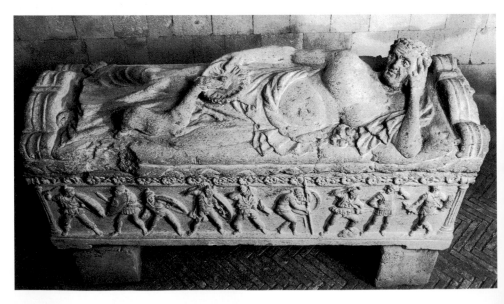

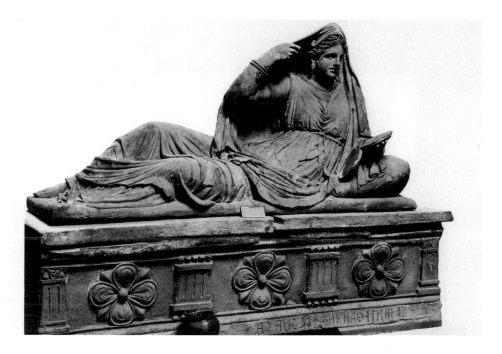

167–169 Sarcophagus of
Seianti Thanunia Tlesnasa
from Chiusi, mid-second
century BC. In her left hand is a
libation bowl. The rosettes and
triglyphs of the sarcophagus
panel recall a temple architrave.

(*opposite*)
162, 163 Details of male stone sarcophagus from Tuscania, second century BC.
164 Detail of terracotta female sarcophagus from the Tomb of the Treptie family, Tuscania,
mid-second century BC.
165 Detail of couple on terracotta sarcophagus from Volterra, early first century BC.
166 Stone sarcophagus from Tarquinia, late second century BC.

170, 171 The Orator ('Aule Meteli') from Pila near Perugia, *c.* 90 BC.

influenced the veristic mode of self-projection in the Roman Republic. Women may join the quest for desirable ugliness, but more often they are prettified, or even rejuvenated. The sarcophagus of a lady of the Seianti family at Chiusi, now in the British Museum, deserves special mention. One analysis of the teeth and bones preserved inside the coffin claims that these are the remains of an elderly woman. But the hands of her image are loaded with jewels, not wrinkles. So she entered the ancestral community not as a hobbling grandmother, but a matronly beauty, indeed drawing back her head veil as if she were a virgin bride.

167–169

An intact hypogeum may tell us much about the Romanization of the ruling families in Etruria. Two such family graves are known at Perugia, a city which struggled against Rome in 295 BC, but then submitted to the terms of a Roman treaty and remained loyal to Rome during Hannibal's invasion of Etruria and Umbria in 217 BC. The Tomb of the Volumni gathers many notables of the Velimna clan; the more recently discovered Cai Cutu complex contained some fifty travertine urns of the male members of the Cutu family, from the third to first centuries BC. As the Velimna family traded their Etruscan identity for Roman, so, by a simple change of suffix, the Cutu men's names were Latinized and became Cutius. And it was from Pila near Perugia that the bronze figure known as the Orator was recovered in 1566. This classic embodiment of a

174

172 Bronze statuette of Apollo, *c.* 350 BC.

'Roman' spokesman seems to have been yet another adaptable Etruscan worthy: a partial inscription on the statue reveals the Etruscan name (easily Latinized if necessary) of Aule Meteli.

It is impossible to gauge how much solace Etruscan religion provided for the local trials of defeat and negotiation. But we can point to a marked increase in votive activity at sanctuaries all over Etruria from the late fourth century BC onwards. At this time, cults of personal health and fertility were becoming popularly diffused all over the Mediterranean, either in tandem with or in opposition to the rise of clinical medicine. Since the archaeological relics of offerings associated with such cults are often transformed by their modern museum contexts into works of art rather than piety, some comment on them is called for here.

Many of these offerings are simply images of deities. Etruscan bronze-smiths probably operated like their Greek counterparts,

173 Bronze statuette of Tinia from Furbara, *c.* 350 BC.

travelling from sanctuary to sanctuary according to the calendar of religious festivals, and setting up temporary workshops for the on-site production of statuettes. This was a dedicatory tradition stretching back to the ninth or eighth centuries BC. Caches of such votives have been recovered from mountain-tops in both Etruria and Umbria, and indeed places with little else in the way of sanctuary structures (such as Brolio, in Tuscany). Rustic cults, emphasizing perhaps some special grove, or spring, could call forth the same votive attention as an urban temple; the woodland god Selvans (Latinized as Silvanus) enjoyed the status of a god with chthonic, or underworld, powers. But of course this wandering mode of production, not to mention distribution, of small-scale bronzes, makes them resistant to classification by locality. We must satisfy ourselves by merely identifying the deity – Aplu (Apollo), Tinia (Zeus) – and hoping that concentrations of identity will at least reveal the presiding genius of a place.

177

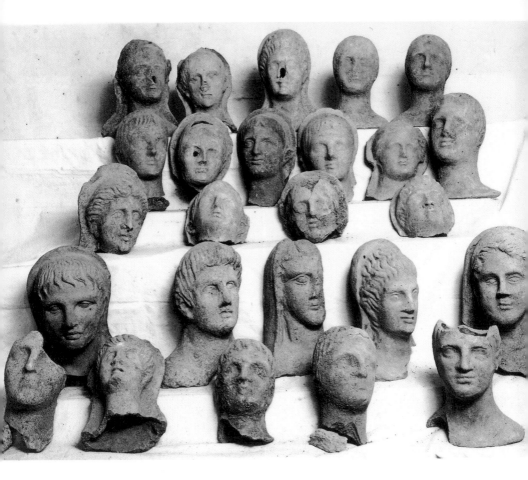

174 (*above*) Votive terracotta heads from Vulci, second century BC.

175 (*left*) Votive model of intestines from Tarquinia, third–second century BC. Such anatomical votive offerings have been found in many Etruscan and Latin sites (e.g. Lavinium).

Votaries also left souvenirs of their own presence at a sanctuary. These may be straightforward and stereotyped, such as terracotta heads, stacked about an altar to keep the images of those who worshipped there fresh in the divine memory. But more particular intercessions for troublesome body parts, such as arms, legs, hands, genitals and intestines are also turned into plastic form, and left with a prayer. Cults associated with childbirth were to be found near many Etruscan cities and ports (as at Pyrgi), and the hopeful image of a swaddled infant or a baby cradled in a mother's arms (ambivalently a mortal woman, or a birth-promoting deity such as Hera or Eilithyia) is common enough in a collection of Etruscan antiquities. But it is worth looking closer at these 'babies': sometimes their physiognomies are remarkably adult. In this case, we are dealing not so much with a fertility cult as a chthonic cult – that is, worship focused upon personal fortunes in an afterlife.

176, 177 Marble statue of mother and child from Volterra, third century BC.

A coherent example of such a cult is the votive deposit excavated in 1956 near the north gate of Vulci. It was originally supposed that the images of swaddled infants related to a child-rearing cult, presided over by Juno/Eilithyia. But again we find adult features on some of these 'babies'. The bearded, half-draped and enthroned statuettes found at the same site are not then Zeus nor Herakles, but Dionysos, who promises rebirth; the figures embracing in the pediment of a model temple are Dionysos and Ariadne (known to the Etruscans as Fufluns and Ariatha), whose 'sacred union' symbolizes the capacity for regeneration.

178, 179 From the votive deposit at the north gate of Vulci, late second century BC. (*Below*) a model temple showing Dionysos and Ariadne in the pediment. (*Right*) a terracotta statuette showing Dionysos enthroned.

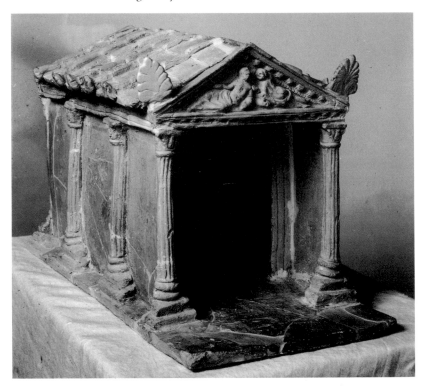

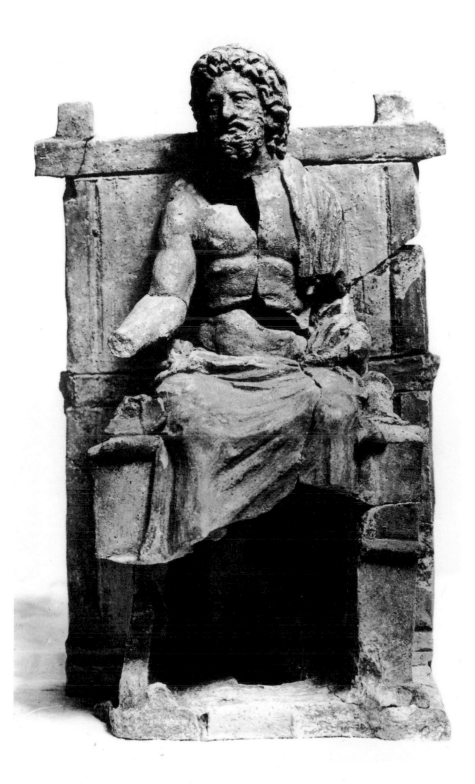

And we would do well to end our examination of Romanized Etruria with this votive assemblage at Vulci. Cult activity near the north gate does not cease after the Roman annexation of the city in 280 BC, but rather it changes. Images of Janus, god of gateways, and the Lares, guardians of crossroads and travellers, are now dedicated. What is important is that Vulci did not become a ghost town. Roman poets liked to wax elegiac about the crumbled splendour of Etruscan cities – Propertius, for example, gives us the image of sheep browsing through the ruins of Veii, where once a golden throne marked kingly power – but archaeologists have established that Veii was a decent bourgeois centre, a self-respecting *municipium* in the Emperor Augustus' seventh region of Italy.

At Cerveteri, near the small theatre erected in the Augustan period, the citizens sponsored statues of Augustus and his family as an obvious show of loyalty. However, it was not forbidden to boast about an Etruscan background. Maecenas, the camp but powerful confidant of Augustus and the leading patron of poets at the Augustan court, flaunted his Etruscan origins (he was a native of Arezzo); other distinguished 'Romans' were even keen to claim Etruscan forebears where none existed. At Tarquinia, members of the Spurinna family set up heroizing statues of their ancestors, each with an inscribed testimonial (*elogia*) recording excellent deeds.

The Etruscan language was put into rural exile, and gradually petered out. But there must have been plenty of Etruscan archives surviving into at least the mid-first century AD. When the Emperor Claudius composed his study of the Etruscans, it ran to twenty volumes. But perhaps the fate of Etruria and Etruscan culture in Roman times is encapsulated therein: twenty volumes about the Etruscans become an index of an emperor's dotage.

The Etruscan Legacy

'IMAGINARY ETRUSCANS'

'Every age has its imaginary Etruscans.' This truism dogs the history of Etruscan studies, and only a fool would refrain from adding, 'up to the present'. We return to themes intimated in the Introduction: the satisfactions offered by the prospect of ruined magnificence; the rumours of 'Oriental' origins; the apparently irrevocable loss of Etruscan literature, and the tease of unfamiliar inscriptions all combine to excite the speculative faculties of scholars and dreamers alike. The touristic colonization of Tuscany by northern Europeans (following a tradition founded by Goethe and others in the eighteenth century) compounds the precious status of the past there. And Italians themselves have created a special place for the Etruscans in their 'cultural patrimony'. Genetic (DNA) investigations have yet to settle the matter, but there is no doubt that many modern Italians vaguely regard the Etruscans as their true and natural forebears.

In the later Roman empire, and during the early medieval period, little notice was taken of Etruscan remains, beyond sundry pillage. (The actual abandonment of many erstwhile Etruscan cities, such as Cerveteri, Vulci and Tarquinia, may have been due as much to the local incidence of malaria as to any collapse of government after the third or fourth centuries AD.) It was in the early Renaissance, as one might expect, that imaginary Etruscans began to appear again. A Dominican friar at Viterbo, Giovanni Nanni or 'Annius', dug up certain sarcophagi in the area in 1493; he eventually produced an account of *Antiquitates* (1498), in which he argued that the Etruscans – a peaceful, agrarian race, unlike the bellicose Romans – had participated in the primal repopulation of the world after the Flood. To 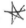 support this creed (whereby Herakles partnered Noah in saving humanity), Annius concocted a *mélange* of relics and cabbalistic lore. And in order to demonstrate that the Etruscan language was essentially Aramaic, he fabricated inscriptions that could accommodate such an ecclesiastical compromise.

If Annius is to be regarded as the starting point of interest in Etruscan art, he at least deserves our blessing for a sort of archaeological foresight. No doubt there were militants in the papal administration who would have destroyed an Etruscan sarcophagus on the grounds of its pagan imagery. In 1546, papal authorities collected six thousand pounds of 'antique' bronzes from Tarquinia and melted them down for the eventual decoration of the pillars of the church of St John Lateran in Rome. Duplicitous and partisan Annius most certainly was, but by virtually putting the Etruscans on Noah's Ark, he may have salvaged 'cultural patrimony' at Viterbo. If so, he is a model for our indulgent survey of 'Etruscomaniacs' through the ages. They are a motley of variously motivated individuals whose collective enthusiasm has, on the whole, done more good than harm.

COSIMO DE' MEDICI AND TUSCAN PRIDE

Arezzo, Cortona, Fiesole, Lucca, Perugia, Pisa, Pistoia, Siena and Volterra: all these towns, according to Annius and his scholastic disciples, such as the Florentine historian Giambattista Gelli, belonged to Tuscany's 'Aramaic'-Etruscan heritage. This assertion of ancient cultural identity suited the Florence-based dynast Cosimo de' Medici, whose expansionist campaigns led to his coronation as Grand Duke of Tuscany in 1569. Fortification works at Arezzo and elsewhere yielded two large bronzes for Cosimo, the Chimera in 1553, and then the Orator in 1566, and though we still know little about the Chimera, it was (and still is) seen as a particular showpiece of Etruscan sculpture. For Cosimo it was almost a heraldic device: the Grand Duke in person, as we learn from Benvenuto Cellini's *Autobiography* (II. 87), amused himself by chiselling away the rust from a set of statuettes also discovered at Arezzo.

Cosimo's annexation of Siena in 1555 also brought him control over the territory of Chiusi. Giorgio Vasari, Cosimo's art-historical hagiographer, reports one of several supposed discoveries of the labyrinth and huge Tomb of Lars Porsena at Chiusi; Cosimo was poetically cast as the new Porsena. His successor would be styled *Dux Magnus Etruscus*, 'Great Etruscan Leader', and in due time, a Scottish scholar based at Pisa, Thomas Dempster, would compose a courtly history, *De Etruria regali* (*Of Royal Etruria*) which asserted historical continuity between the ruling clans of ancient Etruria and the Tuscan Grand Dukes. Composed by 1619, this history was not actually published until a century later.

180 The bronze Chimera from Arezzo, late fifth century BC.

Scholarly and artistic institutions were being set up during this period, notably Cosimo's own Florentine Academy and the encyclopedic Accademia dei Lincei ('Academy of the Lynx-eyed') at Rome in 1603. Dempster was also writing at the time of the origin of the modern museum, with the naturalist Ulisse Aldrovandi at Bologna earnestly creating his cabinet of all sorts of rare and curious objects, and learned landowners (such as Cardinal Alessandro Farnese, whose family possessed extensive tracts of Lazio) actively encouraging archaeological explorations. So when it came to the posthumous

publication of *De Etruria regali*, there were reliefs, mirrors and vases to be included as etched illustrations; one Filippo Buonarroti (a descendant of Michelangelo) added drawings evidently made from visits to tombs at Civita Castellana.

This is not to say that scholarship was properly objective. But those who eventually saw Dempster's work into press in 1726 were aware that it contained apocrypha, and distanced themselves from it. Buonarroti himself grafted a series of archaeological comments onto the book. It is not too presumptuous to say that from 1726, archaeology superseded philology as the key towards understanding Etruscan culture.

'ETRUSCOMANIA' IN THE EIGHTEENTH CENTURY

The fantasies of Annius died with the natural progress of archaeological revelation. Fierce local sympathies still inspired extravagant claims for this or that Tuscan city (Tuscany would not be Tuscany without such intense city-state rivalries), but the value of disinterested erudition gained increasing respect during what was, after all, the century of the Enlightenment. The Etruscan Academy at Cortona was founded by the Venuti brothers in 1729. At Volterra, the cleric Mario Guarnacci became deeply involved with local antiquities, but not myopically so: in his three-volume *Origini italiche* (1767–72) he admits that distinctions between Greek and Etruscan art are difficult to make, thus mirroring the verdict of J. J. Winckelmann (delivered as part of his *History of the Art of Antiquity* in 1764), and indeed anticipating the thrust of this present study. And at Florence, the arrival of the former Jesuit Luigi Lanzi at the Uffizi Gallery in 1775 saw some intelligent and divulgative efforts at cataloguing and exhibiting *signa tuscanica*, 'Etruscan works of art'.

But what indeed were the differences between Greek and Etruscan art? Winckelmann's equivocal attitude did not please all of his contemporaries. Piranesi, for example, used the Etruscans polemically for his own anti-Classical attitudes, presenting in his *Cammini* (*Strolls*) of 1769 a series of Etruscan architectural details, allegedly transcribed in the course of visits to Tarquinia and Chiusi. Alas, these have been shown to be inventions, *pasticci*, cobbled together not from direct observation but from other people's books. (More accurate designs came from a Polish artist by the name of Smugliewicz, who accompanied a professional guide based at Rome, James Byres, to some large tombs uncovered at Tarquinia.) Yet it was reasonable

181 Robert Adam's design for the 'Etruscan Room' at 20 Portman Square, London, 1771. A pastiche – no single element in the room's design owes anything to Etruscan imagery.

enough, at the time, to assume that what came out of Etruscan tombs was Etruscan art. So it happened that in grimy English Staffordshire, a second Etruria was born.

The story of the ceramic entrepreneur Josiah Wedgwood, who came to christen his factory and mansion 'Etruria', is too peculiar to chronicle here. Perhaps sufficient explanation is the mid- to late eighteenth-century tendency to attribute all buried ancient art in Italy to the Etruscans, even when circumstances strongly argued otherwise. When the architect and designer Robert Adam produced 'Etruscan Rooms' for the homes of his patrons – 20 Portman Square in London, for instance, or Audley End in Essex – he was perfectly aware that the colours and components of their decoration were mainly indebted to schemes he had sketched at Herculaneum, one of

182 Vases from the Querciola Tomb, Tarquinia shown in a nineteenth-century drawing.

the Roman cities destroyed by the volcanic explosion of Vesuvius in AD 79. But patrons were not pedants. The term 'Etruscan' was enough to conjure up the essential snob value of Adam style, and displayed the fact that one had travelled to Italy and experienced the Grand Tour, without which, as Dr Johnson enviously perceived, one felt incompletely educated.

Neither was Wedgwood fussy when he announced, in 1769, 'The Arts of Etruria Born Again' ('Artes Etruriae Renascuntur'). Wedgwood's distinctive relief ceramic was in fact modelled on a Roman glass jug, the Portland Vase. Classicizing motifs were supplied by artists such as John Flaxman, who copied directly from Greek red figure vases. In Flaxman's case, the vases available for copying were those in the collection of Sir William Hamilton, British representative at the court of Naples; Hamilton's collection was chiefly formed from Campanian sites such as Nola, well distant from the Etruscan heartlands. It was beginning to dawn on Hamilton, and those entrusted with publishing his collection, that the vases cheerfully referred to by many as 'Etruscan' were in fact of Greek manufacture. The consistency of inscriptions and iconography made it difficult to support their Etruscan identity, and the more Hamilton

promoted vases as a connoisseur's rightful quarry, the more readily such vases could be seen as prestige objects circulating in antiquity too. But it was not until the second quarter of the nineteenth century that a fresh generosity of yield from Etruscan tombs enabled more rigorous discrimination.

Random discoveries of tombs occurred naturally in the course of agricultural activity. In the early nineteenth century, for example, three tombs near Perugia yielded elaborate caches of Archaic metal-working, notably the chariot from Monteleone (now in New York), and repoussé chariot pieces from Castel San Mariano (now in Munich). But what happened at Vulci was exceptional.

'In the early part of 1828 some oxen were ploughing near the castle, when the ground suddenly gave way beneath them, and disclosed an Etruscan tomb with two broken vases.' This account of farmers at Vulci being engorged by the soil seems restrained, but it prefigures one of the sensational events of archaeology, a 'novel harvest' – the most abundant yield of Greek painted vases ever.

183 Bronze relief, probably a chariot panel from Castel San Mariano, mid-sixth century BC, showing the Mistress of the Animals.

Imported Greek pottery has been found in tombs throughout Etruria. Depending on patterns of ancient trade and local circumstances or customs of burial, the quantity of vases varies. At the Etruscan outpost of Spina on the Adriatic, for example, imports were readily accessible during the later fifth century, at a time when Greek traders may have experienced difficulty in reaching the Tyrrhenian seaboard because of Sicilian hostility. But Vulci is the pre-eminent provenance of most of the Greek vases now scattered throughout the museums of the world. It is beyond the scope of this book to speculate why Etruscans at Vulci, especially during the second half of the sixth and first half of the fifth centuries, collected vases (mostly Athenian in origin) so passionately. But since the Vulci finds generated so much interest – in 1837, for instance, one of the Vulci entrepreneurs, Vincenzo Campanari, set up replicas of Etruscan tombs in London's Pall Mall, complete with painted walls, torchlight and authentic contents – some examination of their fate is required.

The territory around Vulci was given, as the princedom of Canino, to Napoleon Bonaparte's brother Lucien, in 1814. It had previously been a papal estate, and probably not a very productive one, as the land was badly drained and malarial. The tenant farmers of Lucien's land, however, soon realized the alternative resources of their tomb-riddled properties. The aristocratic taste for Greek vases established by Hamilton and others was greedy (unlike statues, vases made attractive and portable souvenirs of the Grand Tour), and scholars too were interested (at the Uffizi, Luigi Lanzi had attempted a preliminary classification of subjects and styles). The cemeteries of Vulci offered a timely embarrassment of riches. Lucien Bonaparte and his wife set up systematic excavations in October 1828, and by Christmas two thousand painted vases had been discovered.

'Excavations' means hardly more than clearance here. A decade or so later, cemeteries were still fruitful; indeed, too fruitful. Visitors found workmen, directed by an armed overseer, deliberately smashing all coarse or undecorated pottery. Market values had to be maintained. Lucien himself became an 'Etruscomaniac', declaring that the Vulci vases demonstrated 'that not only the fine arts, and the imagination which produces them, but also the sciences . . . belonged to Italy, when Greece was still barbarous'. In-house oracular pronouncements about this or that vase were provided by a priest with whom Lucien studied astronomy. However, he also invited a German scholar, Eduard Gerhard, to examine and record the vases before their sale and dispersal.

184 Bucchero vases at the time of finding in modern excavation, Vulci.

Gerhard was a sane influence. Furthermore, by forming a club of enthusiasts around the Vulci finds, the 'Istituto di Corrispondenza Archeologica' in 1828, Gerhard created the basis for the German Archaeological Institute in Rome, which remains the world's most reliable centre for scholarship in Classical archaeology generally, and the library where leading Etruscologists do their work. In 1831, Gerhard began using the *Annali* of his institute to publish a regular 'Vulcian report' (*rapporto volcente*). This monitored not only the inscriptions and styles of painting evident on the vases, but also their iconography; as a result, the Hellenized sophistication of Etruscans as patrons became increasingly apparent.

One of those who witnessed the shotgun excavations at Vulci was a bushy-bearded Englishman called George Dennis. Dennis was twenty-eight when he made his first journey to Etruria in 1842. He had a letter from his mother which enjoined him especially 'to avoid

Catholic ladies', and one from his father warning of other local dangers such as heat, rain and miasma. But Dennis was neither a soft traveller, nor the usual pleasure-seeking, aristocratic Grand Tourist. He had realized the limitations of merely collating ancient literary sources about the Etruscans (as had been done most diligently by K. O. Müller in 1828, whose *Die Etrusker* was written without its author so much as even setting foot in Italy). And he was irked by the careless reportage evident from those purporting to write guide-books, such as Mrs Hamilton Gray, whose *Tour to the Sepulchres of Etruria in 1839* (1841) had enjoyed some literary success. So, in the company of the artist Samuel Ainsley and making scrupulous notes all the way, Dennis set about his self-appointed task of describing Etruria's remains.

He had no problem finding a publisher for the work in John Murray, who issued the first edition of *Cities and Cemeteries of Etruria* in 1848. In Dennis's own words, the twin-volume tome 'propounds no new theories on the origin, language, or arts of the Etruscans, but gives a plain unvarnished tale of extant local monuments'. Modern readers of the work may raise an eyebrow at this – there *are* disquisitions on origin, language and the arts, and 'plain' does no justice to the author's colourful confidences about flea-ridden beds, or comely girls, encountered *en route* – but the accuracy of description is valid enough. Of course Dennis was influenced by Romantic notions of the picturesque, and he likes to apostrophize the landscape as Arcadia, mixed with more than a hint of 'merrie England'. But he checked and revised his record as thoroughly as possible (a third edition of *Cities and Cemeteries of Etruria* appeared in 1883). It is doubtful whether any individual before or since has possessed such a close topographical knowledge of Etruscan sites as George Dennis.

D. H. LAWRENCE

'If we judge of art by the kind of life which it suggests to us, by its moral elevation or nobility of sentiment, all Etruscan art must be condemned.' This is the curious verdict of Roger Fry – curious, that is, coming from an evangelist for primitivism in modern art. But if Fry is the voice of Bloomsbury in this matter, then it is no surprise to find D. H. Lawrence giving the contrary response. Lawrence's own 'savage pilgrimage' away from Bloomsbury, academia, England and industrial society generally took him to aboriginal Australia, New Mexico and elsewhere; he ended with contentment, of a sort,

in Italy, and consolation not from any living tribe, but the messages he received from dead Etruscans.

Lawrence came to Etruscan art in the autumn of his short life. He was fragile and bruised by tuberculosis, and so his decision to make a tour of Etruscan sites in 1927 was a brave one. Malaria was a particular threat in the plains of the Maremma area around Grosseto which encompass Vulci, where, in the castle that is now the museum, Lawrence found only rustic squatters and charcoal burners. By the time of his expedition, he had already pursued some informal research which led him to declare, in a letter of 1926, that 'there really is next to nothing to be said, *scientifically*, about the Etruscans. Must take the imaginative line.' Lawrence finished *Lady Chatterley's Lover*, his novel of 'phallic tenderness' and only a friendly Florentine printer, Pino Orioli, would typeset it. Cursing his worldly enemies – in particular the censors back in Britain – Lawrence went, literally, underground. In the tombs of Tarquinia, he greeted the vivid simulacra of his lost natural soulmates.

'Reach me a gentian, give me a torch!/let me guide myself with the blue, forked torch of this flower/down the darker and darker stairs . . . even where Persephone goes.' The imagery of Lawrence's later poetry is packed with direct or subliminal reference to his experiences of descending into Etruscan tombs. Intimations of his own mortality dogged him in museums too, as is made plangently clear in the exquisite sequence 'The Ship of Death', written as he lay dying in the early months of 1930. Verses of this poem may uncannily echo, for all we know, the hymns chanted in the course of Etruscan funerary processions: 'Oh build your ship of death, your little ark/and furnish it with food, with little cakes, and wine/for the dark flight down oblivion.'

Published posthumously, Lawrence's *Etruscan Places* is still a valid gospel of engaged response to Etruscan art. As voiced by Mark Rampion in Aldous Huxley's *Point Counter Point* (1928), the Lawrentian faith in the Etruscans ('*They* were civilized . . . they knew how to live harmoniously and completely, with their whole being') is easily parodied, but in the context of that novel, it is a welcome relief from cynical interwar repartee. The caricature Lawrence himself draws of a young German archaeologist encountered at Tarquinia, who can only shrug and utter embittered pedantries in the face of revelling Etruscans, is a condemnation of a certain type of academic evaluation of Etruscan art. But – as we saw in the Introduction – Lawrence invests himself to a fault. As George

Orwell noted, 'When Lawrence prefers the Etruscans (*his* Etruscans) to ourselves it is difficult not to agree with him, and yet, after all, it is a species of defeatism, because that is not the direction in which the world is moving.'

'Museums, museums, museums, object-lessons rigged out to illustrate the unsound theories of archaeologists . . . Why must all experience be systematized? Why must even the vanished Etruscans be reduced to a system?' Lawrence's protest at the end of *Etruscan Places* was indeed an isolated and eccentric plea. Making a system out of the Etruscans is precisely the aim of the postwar academic discipline of Etruscology.

MODERN ITALY AND THE ETRUSCANS

The Villa Giulia in Rome, the outstanding museum of Etruscan art, was created in 1889. Thus a dilapidated Renaissance residence, then on the outskirts of Rome, was rescued and given a new and overtly 'national' function. Hitherto there had been distinguished collections, such as the Gregorian Museum within the Vatican (since 1837), but none had claimed the Etruscans as the self-defining property of the Italian state. Garibaldi's aim in the mid-nineteenth-century Risorgimento had been the restoration of the Roman Republic, and indeed, the original intention of the Villa Giulia was that it should mainly house early Latin and Faliscan relics. But the quantity of finds from Veii and Cerveteri made their presence felt, and not even the rise of pro-Roman Fascism in the 1920s could offset the popularity of, say, the Apollo of Veii and his companion statues.

An etching made of the Villa Giulia in 1775, showing how its expansive hemicycle (perhaps designed by Michelangelo) was then serving as a hayloft and cattle byre, reflects the insouciant way in which Etruscan sites themselves were treated for many centuries. There are an estimated half-million tombs in southern Etruria. Meandering visitors will notice how even today, in rustic Lazio, these tombs may double as wine cellars or chicken coops. The effect of centuries of familiarity with ruins can be quaint (and indeed preferable to the petrifying effect of the heritage park), but of course it means that the number of tombs subjected to scientific excavation and never previously disturbed is tiny. The Etruscans, then, are an archaeological culture wrecked several times over.

As the perception of Etruscan art as anti-Classical, even

185 The Villa Giulia in 1775, as recorded by Jean-François Janinet.

Expressionist, periodically endears it to modern viewers, so fluctuations of political mood in Italy modulate claims upon the Etruscan past. Broadly it is the case that Fascism favoured Rome over Etruria, but this was never a consistent dogma (the irony is that some of the key symbols adopted by the Fascists as quintessentially evocative of Caesarean Rome, such as the ceremonial *fasces* axe itself, are of Etruscan origin). However, the image of the Etruscans as sensuous

rather than efficient has been steadily propagated in modern Italy. At a banal level, but pardonably so, motifs from the Tarquinian tomb paintings are regularly deployed to sell olive oil and wine.

The academic entrenchment of Etruscology has proceeded regardless of fashion. The first International Etruscan Congress was held in 1927, and the specialist journal *Studi Etruschi* was launched the same year. The highly influential manual of Etruscan studies, *Etruscologia* by Massimo Pallottino (1909–95), first appeared in 1942; professorships in the subject began with Pallottino at Rome, followed eventually by the installation of his pupils in chairs at Naples, Florence, Perugia, Milan and Venice.

But such academic development has not been purchased at the cost of public alienation. The first 'big' exhibition of Etruscan art and artefacts took place at Milan in 1955, and subsequently toured various European cities. 1985 was deemed the 'Year of the Etruscans' in Italy, with a series of nine exhibitions, and a second International Congress. The momentum of exhibitions shows no sign yet of slowing.

The progress of research can look impressive when tomes and titles are stacked up. And the modern techniques of recovering material from the ground include some genuine innovations. For instance, the geophysical resistivity surveys at Tarquinia by C. M. Lerici from the 1960s onwards brought to light many new painted tombs without serious disturbance to their structure, by the simple expedient of drilling a hole through the roof and recording the frescos by means of a form of inverted periscope. But a thread of anarchy runs through the history of Etruscan archaeology, and it has not been cut by state control over excavation. Illicit probes are performed in some Etruscan areas almost as a matter of local vocation, and the forgery of vases, sculpture and metalwork is an art that has been practised for generations. One of the tomb robbers ('tombaroli') at Tarquinia, Luigi Perticarari, has estimated that he has emptied a total of some 4,000 graves during his semi-clandestine career. When a Greek vase can fetch millions of pounds or dollars on the art market, the incentives are clear enough. And among the victims of large-scale forgeries of Etruscan sculpture in modern times are institutions which really should have known better.

Above the academic busyness and the predatory greed, Platonic Etruria remains. 'Platonic Etruria' may here be taken as that shaggy, suggestive landscape which still eludes mass tourism, where traces of Etruscan habits and habitation belong as if by organic right. At once

enduring and evanescent, this landscape is the true allure and context of Etruscan art. George Dennis thought Etruria was Arcadia. And as those who revel in Arcadia are bound to place a skull upon their feasting table to remind them of life's brevity, so those who gaze at Etruscan art will often shiver with intimations of mortality. So much was entrusted to the grave. This is why, in the end, any art history of the Etruscans must tend to conjure elegy.

186 Luigi Perticarari emerging from a tomb at Tarquinia in 1986.

Chronology

Bibliography and Sources

List of Illustrations

Index

Timeline

Late Bronze Age
c. 1200–*c.* 1000 BC

Villanovan (Early Iron Age)
c. 1000–*c.* 750 BC

Orientalizing
c. 750–575 BC

Archaic
c. 575–490 BC

Classical
c. 490–300 BC

Roman Conquest (Hellenistic period)
c. 300–90 BC

Chronology

Late Bronze Age
c. 1200–*c.* 1000 BC
Small communities subsist on tufa plateaux. Iron comes into use *c.* 1000 BC. 'Art' is virtually non-existent, apart from some pottery which is scratched or impressed with basic patterns. Archaeologists speak of a 'Latial' or 'Appennine' culture in this period; however, it is presumed that some form of proto-Etruscan language was being spoken.

Villanovan (Early Iron Age)
c. 1000–*c.* 750 BC
Population grows; nucleated families in wattle-and-daub huts constitute the early basis of urban formation at sites such as Cerveteri, Veii and Tarquinia. Impasto pottery is used for hut-urns. Geometric-style painted vases and terracotta figurines appear in *c.* 800 BC, and the production of small-scale metal artefacts (fibulae, razors, horse-bits) increases. The Euboeans establish a trading post at Pithekoussai on Ischia in *c.* 775–750 BC.

Orientalizing
c. 750–575 BC
'Orientalizing' usually describes the influence of Near Eastern art upon Etruria, but this is also the period of Etruscan contact with early Greek colonies. Objects from Syria and the Levant (e.g. decorated ostrich eggs) are probably brought over by Phoenician traders. 'Oriental' motifs are copied in Etruscan painting and metalwork; granulation characterizes fine jewelry. The first inscriptions of Etruscan language (using the Euboean Greek alphabet) occur in *c.* 700 BC. Wheel-made pottery is an innovation of the early seventh century BC, and in *c.* 675 BC the production of bucchero ware begins. Wealthy burials at Vetulonia (the Pietrera Tomb), Tarquinia (the Tomb of the Warrior) and Cerveteri (the Regolini-Galassi Tomb) link up with similar graves dating from *c.* 670–630 along the Tyrrhenian coast as the characteristic 'princely' monuments of this period. Demaratus, a semi-legendary figure, is supposed to have arrived in Etruria from Corinth with his entourage of artists in 657 BC. Early painted tombs at Veii and Cerveteri date from *c.* 650 BC; 'Etrusco-Corinthian' vase painting begins in *c.* 630 BC.

Archaic
c. 575–490 BC
Expansion and political consolidation of Etruria occurs, as does the development of sea power (the Etruscan 'thalassocracy'): Etruscan colonies are planted across the Appennines and in Campania. Persia occupies Ionia in the mid- to late sixth century BC; the presence of 'Ionian-style' painting and sculpture in Etruria argues some migration of artists. Early Tarquinian painted tombs include the Tomb of the Bulls (*c.* 530–520 BC) and the Tomb of the Augurs (*c.* 510 BC). The importation of Athenian vases is

evident from 570 BC onwards and local schools of Greek and Etruscan vase painting are established in the second half of the sixth century (e.g. Caeretan hydriai at Cerveteri, and the Micali Painter at Vulci). The 'Tuscan order' in architecture was established by the late sixth century BC (Portonaccio Temple, Veii, *c.* 500 BC; Temple A, Pyrgi, *c.* 460 BC). Large-scale terracotta sculpture flourishes (e.g. Apollo of Veii, *c.* 510 BC), along with bronze-working (the production of incised mirrors begins in the mid-sixth century). Etruscan kings (the Tarquin dynasty) seem to have ruled Rome for most of the sixth century BC: the conventional date given for their expulsion is 509 BC. The Etruscan colony of Marzabotto, founded *c.* 500 BC, demonstrates regular urban planning.

Classical
c. 490–300 BC
The period begins with Etruscan–Carthaginian alliances against Rome, and ends with the virtual submission of most Etruscan cities to Rome (the first Etruscan city to fall to Rome was Veii, in 396 BC). Interior and transappennine Etruscan sites (notably Spina on the Adriatic coast) fared better. At Tarquinia, however, tomb painting flourished: including the Tomb of the Leopards (*c.* 475 BC), Tomb of the Triclinium (*c.* 470 BC), the Tomb of the Ship (*c.* 450 BC), the Tomb of the Blue Demons (*c.* 420 BC) and the Tombs of Orcus I and II (*c.* 400–350 BC). The François Tomb, Vulci (*c.* 350 BC) is thought to depict and allegorize Etruscan–Roman conflict. Relations with Greek colonies were also abrasive: in 384 BC Dionysius of Syracuse sacked the sanctuary of Pyrgi. But Etruscan artists produced 'Roman' works (e.g. the Capitoline She-Wolf, early fifth century BC), and Greek themes predominate in mirror scenes and temple decoration. Portraiture (in terracotta, stone and bronze) begins in the late fourth century BC.

Roman Conquest (Hellenistic period)
c. 300–90 BC
Chiusi yielded to Rome in 295 BC, Orvieto and Vulci in 280 BC and Cerveteri in 273 BC. Those northern Etruscan cities left autonomous supported Rome, when in 205 BC Scipio levied them for supplies to assist his war effort against Carthage. Tomb painting waned, but more funerary stone sculpture was produced, especially ash-urns at Perugia and Volterra. In 90 BC the rights of Roman citizenship were extended throughout Etruria. The bronze Orator from Pila near Perugia of *c.* 90 BC typifies the subsuming effect of Rome. The ethnic and cultural integrity of the term 'Etruscan' was thereafter ever more meaningless.

Bibliography and Sources

This has been selectively compiled with Anglophone readers in mind, but assumes that anyone seriously interested in the Etruscans will also follow Italian scholarship.

GENERAL

One comprehensive survey of Etruscan art and archaeology is unfortunately difficult to obtain: *Rasenna* (Milan 1986). See also L. Bonfante (ed.), *Etruscan Life and Afterlife* (Detroit and Warminster 1986) and M. Cristofani, *The Etruscans: A New Investigation* (London 1979). E. Macnamara, *The Etruscans* (London 1990) is a guide based on the Etruscan holdings of the British Museum. O. Brendel, *Etruscan Art* (Harmondsworth 1978) has been reissued with an updated bibliography by F. Serra Ridgway (Yale 1996). Two exhibition catalogues are durably valuable: *La civiltà degli Etruschi* (Milan 1985) and *Les Etrusques et l'Europe* (Paris 1992). The best overall account of Etruscan art is M. Cristofani, *L'arte degli Etruschi: produzione e consumo* (Turin 1978). A brave and sweeping effort at investing Etruscan art with presumed ideological significance is F.-H. Pairault Massa, *Iconologia e politica nell'Italia antica* (Milan 1992); see also M. Menichetti, *Archeologia del potere* (Milan 1994).

Archaeology On sites, see M. Torelli, *Etruria* (Rome 1982) in the Laterza guidebook series. F. Coarelli (ed.), *Etruscan Cities* (London 1975) is well illustrated and comprehensive. N. Spivey and S. Stoddart, *Etruscan Italy: an archaeological history* (London 1990) is a patchy attempt at synthesis.
Architecture A. Boëthius, *Etruscan and Early Roman Architecture* (revised edition, Harmondsworth 1978) and *Case e palazzi d'Etruria* (exh. cat., Milan 1985). On interiors,

see F. Prayon, *Frühetruskische Grab- und Hausarchitektur* (Heidelberg 1975).
Minor arts On mirrors, see N. T de Grummond, *A Guide to Etruscan Mirrors* (Tallahassee 1982); on furniture, see S. Steingräber, *Etruskische Möbel* (Rome 1979). Gems are covered by G. M. A. Richter, *The Engraved Gems of the Greeks and the Etruscans* (London 1968) and P. Zazoff, *Etruskische Skarabäen* (Mainz 1968); on goldwork, see M. Cristofani and M. Martelli (eds), *L'oro degli Etruschi* (Novara 1983) and G. Nestler and E. Formigli, *Granulazione etrusca* (Siena 1994).
Painting On vase painting, see J. D. Beazley, *Etruscan Vase Painting* (Oxford 1947) and M. Martelli (ed.), *La ceramica degli Etruschi* (Novara 1987). On tomb painting, see the entries under Tarquinia (Chapter Four) below.
Sculpture A. Andrén, *Architectural Terracottas from Etrusco-Italic Temples* (Lund 1940) is still useful for antefixes, though many have been discovered since. Bronzes are covered by E. Richardson, *Etruscan Votive Bronzes* (Mainz 1983); S. Haynes, *Etruscan Bronzes* (London 1985) and M. Cristofani (ed.), *I bronzi degli Etruschi* (Novara 1985). A general sketch of Etruscan sculpture is given by M. Torelli in P. Bruneau et al., *La Sculpture: le prestige de l'antiquité* (Geneva 1991).

INTRODUCTION
Etruria and the Limits of Demystification
For a summary of the debate on Etruscan origins, see M. Pallottino, *The Etruscans* (Harmondsworth 1975), pp. 64–81 and his *A History of Earliest Italy* (London 1991). A reliable introduction to the Etruscan language is to be found in L. Bonfante, *Etruscan* (London 1990); see also L. and G. Bonfante, *The Etruscan Language: An Introduction* (Manchester and New

203

York 1983). For Bernard Berenson's opinion of Etruscan art, see his *Aesthetics and History in the Visual Arts* (New York 1948), pp. 170–2. (For D. H. Lawrence's writings, see the entry under Chapter Six below.) On the Giglio find, see M. Bound, *The Giglio Wreck* (Athens 1991) and M. Cristofani, 'Novità sul commercio etrusco arcaico: dal relitto del Giglio al contratto di Pech Maho', in J. Swaddling *et al.* (eds), *Italy in Europe: Economic Relations 700 BC–AD 50* (London 1995), pp. 131–7. On the gift exchange system, see M. Cristofani, 'Il "dono" nell'Etruria arcaica', in *Parola del Passato* 30 (1975), pp. 132 ff. On Daedalus in Etruria, see M. A. Rizzo and M. Martelli, 'Un incunabulo del mito greco in Etruria', in *Annuario della scuola archeologica di Atene* L–LI (1988–9), pp. 7–56.

CHAPTER ONE
The Emergence of Etruscan Culture
Older books on Etruscan prehistory are misleading, especially with regard to the confusion between 'Villanovan' and 'Early Etruscan' nomenclature; this warning applies, for instance, to H. Hencken, *Tarquinia and Etruscan Origins* (London 1968). For an archaeological survey, see G. Bartoloni, *La cultura villanoviana* (Rome 1989); for Bologna and environs, see M. Forte and P. von Eles, *La pianura bolognese nel villanoviano* (Florence 1994). A. M. Bietti Sestieri, *The Iron Age Community of Osteria dell'Osa* (Cambridge 1992) is an approachable account of one excavation which also does much to synthesize an overall picture. On hut-urns, see G. Bartoloni *et al.*, *Le urne a capanna rinvenute in Italia* (Rome 1987). On bucchero, see T. Rasmussen, *Bucchero Pottery from Southern Etruria* (Cambridge 1979); M. Wadsworth, 'A Potter's Experience with the Method of Firing Bucchero', in *Opuscula Romana* 14 (1983), pp. 65–8 and M. Bonghi Jovino (ed.), *Produzione artigianale ed esportazione nel mondo antico: il bucchero etrusco* (Milan 1993).

CHAPTER TWO
Etruria and the Orient
The best compendium of Phoenician material relating to Etruria is H. G. Niemeyer (ed.), *Phönizier in Westen* (Mainz 1982). For a discussion of gift exchange models, see M. E. Aubet, *The Phoenicians and the West* (Cambridge 1993). Scholarly polemic may be savoured in D. J. Gill, 'Silver anchors and cargoes of oil: some observations on Phoenician trade in the Western Mediterranean', in *Papers of the British School at Rome* 56 (1988), pp. 1–12 and M. Martelli, 'I Fenici e la questione orientalizzante in Italia', in *Atti del II Congresso Internazionale di Studi Fenici e Punici* 3 (1991), pp. 1049–72. On Orientalizing, see W. Llewelyn Brown, *The Etruscan Lion* (Oxford 1960); I. Strøm, *Problems Concerning the Origin and Early Development of the Etruscan Orientalizing Style* (Odense 1971) and A. Rathje, 'Oriental Imports in Etruria', in D. and F. Ridgway (eds), *Italy Before the Romans* (London and New York 1979), pp. 145–83. On the Tomb of the Statues near Ceri, see G. Colonna and F. W. von Hase, 'Alle origini della statuaria etrusca: la Tomba delle Statue presso Ceri', in *Studi Etruschi* 52 (1984), pp. 13 ff. On the origins of tomb painting, see A. Naso, *Architetture dipinte* (Rome 1996). Greek activity in this period (particularly at Pithekoussai) is succinctly charted in D. Ridgway, *The First Western Greeks* (Cambridge 1992).

CHAPTER THREE
Etruria Hellenized
On the Greek colonies, see G. Pugliese Carratelli, *The Western Greeks* (London 1996). For details of the excavation of Gravisca, see the reports by M. Torelli in *Parola del Passato* 32 (1977) and 37 (1982). A study by D. Ridgway of the Demaratus myth is in preparation. On Etrusco-Corinthian painting, see L. Cerchiai, *Le officine etrusco-corinzie di Pontecagnano* (Naples 1990) and J. G. Szilágyi, *La ceramica etrusco-corinzia figurata I* (Florence 1994). J. M.

Hemelrijk, *Caeretan Hydriae* (Mainz 1984) is a detailed catalogue of those thirty-odd vases.

The Etruscan Cities as Centres of Art

Acquarossa C. E. Östenberg, *Case etrusche di Acquarossa* (Rome 1975); *Architettura etrusca nel Viterbese* (exh. cat., Rome 1986). Swedish archaeological activity in the 'regal' period is memorably evoked in A. Boëthius *et al.*, *Etruscan Culture, Land and People* (New York and Malmö 1962).

Castel d'Asso Finds here are due for publication in the series entitled *Necropoli rupestri dell'Etruria Meridionale*, the first volume of which is G. Colonna and E. Colonna di Paolo, *Norchia* (Rome 1978).

Cerveteri An overview exists in G. Proietti, *Cerveteri* (Rome 1986). On the painted plaques, see F. Roncalli, *Le lastre dipinti di Cerveteri* (Florence 1965). The city excavations are published as they progress, beginning with M. Cristofani and G. Nardi, *Caere I: il parco archeologico* (Rome 1988). On the Tomb of the Reliefs, see H. Blanck and G. Proietti, *La Tomba dei Relievi di Cerveteri* (Rome 1986).

Chiusi M. Cristofani, *Città e campagna nell'Etruria settentrionale* (Florence 1976); G. Maetzke (ed.), *La civiltà di Chiusi e del suo territorio* (Florence 1993). On the reliefs, see J.-R. Jannot, *Les Reliefs archaïques de Chiusi* (Rome 1984).

Marzabotto G. Sassatelli, *La città etrusca di Marzabotto* (Casalecchio di Reno 1989) is a brief guide; more commentary is to be found in G. A. Mansuelli, *Studi sulla città antica: l'Emilia-Romagna* (Rome 1983).

Murlo K. M. Phillips, *In the Hills of Tuscany* (Philadelphia 1993); R. D. de Puma and J. P. Small (eds), *Murlo and the Etruscans* (Wisconsin 1994).

Norchia G. Colonna and E. Colonna di Paolo, *Norchia* (Rome 1978).

Pyrgi Excavation reports are still appearing in *Notizie degli Scavi* (see especially the 1970 Supplement); the temple imagery is discussed in the Tübingen Conference proceedings, *Die Göttin von Pyrgi* (Florence 1981) and by F. Coarelli in *Il Foro Boario* (Rome 1988), pp. 328–63.

Talamone *Talamone: il mito dei Sette a Tebe* (exh. cat., Florence 1982).

Tarquinia For tomb painting, see the illustrated catalogue of tombs (plus those from other Etruscan sites) in S. Steingräber *et al.*, *Etruscan Painting* (New York 1986). New photographs and new finds feature in M. A. Rizzo (ed.), *Pittura etrusca al Museo di Villa Giulia* (Rome 1989). For earlier bibliography, see E. P. Markussen, *Painted Tombs in Etruria: A Bibliography* (Odense 1979).

On funerary games, see J. G. Szilágyi, 'Impletac modis saturae', in *Prospettiva* 24 (1981), pp. 2–23. On 'drinks cabinets', see L. B. Van der Meer, 'Kylikeia in Etruscan tomb painting', in H. A. Brijder (ed.), *Ancient Greek and Related Pottery* (Amsterdam 1984), pp. 298–304. On the Dionysiac cult in Etruria, see M. Cristofani and M. Martelli, 'Fufluns Pachies: sugli aspetti del culto di Bacco in Etruria', in *Studi Etruschi* 46 (1978), pp. 119 ff.; see also G. Colonna, 'Riflessioni sul dionisismo in Etruria', in *Dionysos, mito e mistero* (Bologna 1991), pp. 117 ff. For East Greek and other stylistic connections, see M. Cristofani, 'Storia dell'arte e acculturazione: le pitture tombali arcaiche di Tarquinia', in *Prospettiva* 7 (1976), pp. 2–10 and Å. Åkerström, 'Etruscan Tomb Painting: an Art of Many Faces', in *Opuscula Romana* 13.1 (1981), pp. 7–33. Essays in iconographic interpretation: B. d'Agostino, 'Image and Society in Archaic Etruria', in *Journal of Roman Studies* 89 (1989), pp. 1–10; also 'Le sirene, il tuffatore e le porte dell'Ade', in *Annali dell'Istituto Orientale di Napoli* 4 (1982), pp. 43–50; L. Cerchiai, 'Sulle tombe del Tuffatore e della Caccia e Pesca: proposta di lettura iconologica', in *Dialoghi di Archeologia* (1987), pp. 113–23; G. Walberg, 'The Tomb of the Baron Reconsidered', in *Studi Etruschi* 56 (1988), pp. 51–9. On the mock painted

doorways, see R. A. Staccioli, 'Le finte porte dipinte nelle tombe arcaiche etrusche', in *Quaderni dell'Istituto di Archeologia della libera università abruzzese* (1980), pp. 1–18.

Volterra The urns in the Guarnacci Museum are fully catalogued. For references and discussion, see G. Cateni and F. Fiaschi, *Le urne di Volterra e l'artigianato artistico degli Etruschi* and *Artigianato artistico* (exh. cat., Milan 1985). Some further studies of Etruscan urns of the fourth century BC onwards: R. Brilliant, *Visual Narratives* (Cornell 1984), pp. 21–52; F.-H. Massa-Pairault, *Recherches sur l'art et l'artisanat étrusco-italiques à l'époque hellénistique* (Paris and Rome 1985) and J. P. Small, *Studies Related to the Theban Cycle on Late Etruscan Urns* (Rome 1981).

Vulci On stone statuary, see (though outdated) A. Hus, *Recherches sur la statuaire en pierre étrusque archaïque* (Paris 1961). On the Micali Painter, see N. J. Spivey, *The Micali Painter and his Followers* (Oxford 1987) and M. A. Rizzo (ed.), *Un artista etrusco e il suo mondo: il pittore di Micali* (Rome 1988).

CHAPTER FIVE
From Etruscan Rome to Roman Etruria

No successful synthesis of the literary and archaeological evidence for early Rome and the Etruscan involvement in Rome has yet been achieved: the best attempt in English is T. J. Cornell, *The Beginnings of Rome* (London 1995). T. P. Wiseman, *Remus: The Making of a Roman Myth* (Cambridge 1995) exposes the dangers of credibility in myth as 'history'. On the archaeological evidence for the 'Great Rome of the Tarquins', see M. Cristofani (ed.), *La grande Roma dei Tarquinii* (Rome 1990). On the François Tomb at Vulci, see F. Buranelli

(ed.), *La Tomba François di Vulci* (Rome 1987). For a narrative of the conquest process, see W. V. Harris, *Rome in Etruria and Umbria* (Oxford 1971), and *La romanizzazione dell'Etruria: il territorio di Vulci* (exh. cat., Milan 1985). On sarcophagi of the conquest period, see M. Cataldi, *I sarcofagi etruschi delle famiglie Partunu, Camna e Pulena* (Rome 1988); M. Moretti and A. M. Sgubini Moretti, *I Curunas di Tuscania* (Rome 1983); M. D. Gentili, *I sarcofagi etruschi in terracotta di età recente* (Rome 1994) and M. Sannibale, *Le urne cinerarie di età ellenistica* (Rome 1994: a catalogue of the Vatican collection).

CHAPTER SIX
The Etruscan Legacy

On 'Imaginary Etruscans', see M. Vickers, 'Imaginary Etruscans: changing perceptions of Etruria since the fifteenth century' in *Hephaistos* 7/8 (1985–6), pp. 153–68. On Renaissance claims, see G. Cipriani, *Il mito etrusco nel rinascimento fiorentino* (Florence 1980). On seventeenth- and eighteenth-century Etruscan enthusiasms, see M. Cristofani, *La scoperta degli Etruschi* (Rome 1983) and J. Heurgon, *La Découverte des Etrusques au début du XIXe siècle* (Paris 1973). On George Dennis, see D. E. Rhodes, *Dennis of Etruria* (London 1973). For Roger Fry on Etruscan art, see his *Last Lectures*, Kenneth Clark (ed.), (Cambridge 1939), pp. 210–11. For D. H. Lawrence, *Etruscan Places*, see S. de Filippis (ed.), *The Works of D. H. Lawrence, Sketches of Etruscan Places and Other Italian Essays* (Cambridge 1992). On the Villa Giulia, see G. Proietti *et al.*, *Il Museo Nazionale Etrusco di Villa Giulia* (Rome 1980). On tomb-robbing as a profession, see L. Perticarari and A. M. Giuntani, *I segreti di un tombarolo* (Milan 1986).

List of Illustrations

In photographic credits, the following institutional abbreviations are used: DAI = Deutsches Archäologisches Institut, Rome; MCA = Museum of Classical Archaeology, Cambridge; SAEM = Soprintendenza archeologica per l'Etruria meridionale; SAES = Soprintendenza archeologica per l'Etruria settentrionale. The following abbreviations for measurements are used: D = diameter, H = height, L = length, W = width.

27. Etruscan gold fibula, seventh century BC. L 15 (6). Museo Archeologico, Florence.

28. Miniature ivory sphinx from Murlo, late seventh century BC. L 2 (¾). Museo Nazionale, Murlo. Photo DAI.

29. Etruscan bronze cauldron with lion-head *protomes* from the Regolini-Galassi Tomb, Cerveteri, *c.* 650 BC. Musei Vaticani.

30. Gilded silver bowl from the Regolini-Galassi Tomb, Cerveteri, *c.* 650 BC. D 18 (7) H 3 (1⅛). Musei Vaticani.

31. Bronze figure of a woman holding a horned bird from the Tomb of Isis, Vulci, mid-sixth century BC. H 34 (13⅜). Copyright British Museum.

32. Gold disc fibula from the Regolini-Galassi Tomb, Cerveteri, *c.* 650 BC. L 32 (12⅝). Musei Vaticani. Photo Scala.

33–34. Gold bracelet from the Regolini-Galassi Tomb, Cerveteri, *c.* 650 BC. D 10 (4). Musei Vaticani. Photo DAI.

35. Gold pectoral from the Regolini-Galassi Tomb, Cerveteri, *c.* 650 BC. H 42 (16½). Musei Vaticani.

36–37. Head and torso of a female figure from the Pietrera Tomb, Vetulonia, *c.* 640 BC. Limestone, head: H 27 (10⅝), torso: H 63 (24⅞). Museo Archeologico, Florence.

38. Relief showing two warriors from Tarquinia, early sixth century BC. Museo Nazionale, Tarquinia. Photo SAEM.

39. Krater signed by Aristonothos from Cerveteri, mid-seventh century BC. H 36.3 (14¼). Musei Capitolini, Rome. Photo RCS Libri & Grandi Opere SpA, Milan.

40. Jug attributed to the Swallow Painter, early sixth century BC. University Museum of Christchurch, Canterbury. Photo courtesy R. M. Cook.

41. Architectural terracotta plaque from Veii, sixth century BC. Museo Nazionale di Villa Giulia, Rome. Photo RCS Libri & Grandi Opere SpA, Milan.

42. Bronze *lituus* from Cerveteri, early sixth century BC. L 36.5 (14⅜). Museo Nazionale di Villa Giulia, Rome. Photo SAEM.

43. Reconstruction of a Tuscan order temple according to Vitruvius, by Gottfried Semper, 1878. After G. Semper, *Die Textile Kunst*, Munich 1878, plate 12.

44. Reconstruction of the Portonaccio Temple, Veii; original constructed *c.* 500 BC. Museo delle Antichità Etrusche e Italiche, Rome. Photo DAI.

45. Apollo of Veii, *c.* 510 BC. Terracotta. H 180 (70⅞). Museo Nazionale di Villa Giulia, Rome. Photo RCS Libri & Grandi Opere SpA, Milan.

46. Figure of Leto from the Portonaccio Temple, Veii, *c.* 500 BC. Terracotta. H 170 (66⅞). Museo Nazionale di Villa Giulia, Rome. Photo DAI.

47. Detail of Apollo of Veii, *c.* 510 BC. Photo Bildarchiv Marburg.

48. Head of Hermes from the Portonaccio Temple, Veii, *c.* 500 BC. Terracotta. H 37 (14⅝). Museo Nazionale di Villa Giulia, Rome. Photo Leonard von Matt.

49. Detail of 'Etrusco-Ionic' black figure amphora from Chiusi, late sixth century BC. Museo Etrusco, Chiusi. Photo MCA.

50. Detail of Etrusco-Corinthian jug, perhaps from Cerveteri, early sixth century BC. Museo Nazionale di Villa Giulia, Rome. Photo MCA.

51. The Tragliatella *oinochoe*, late seventh century BC. H 24 (9½). Musei Capitolini, Rome. Photo Archivio Fotografico dei Musei Comunali.

52. Detail of plate 51. Drawing by Stephen Ashley.

53–54. Details of Caeretan hydria, late sixth century BC. H whole vase 42.3 (16⅝). Courtesy, Boston Museum of Fine Arts. Photos by L. H. Hildyard.

55. Caeretan hydria, late sixth century BC. H 42.3 (16⅝). Musée du Louvre, Paris. Photo MCA.

56–57. Details from the main chamber of the Tomb of the Bulls, Tarquinia, *c.* 530–520 BC. Photo MCA.

58. Detail from the main chamber of the Tomb of the Bulls, Tarquinia, *c.* 530–520 BC. Photo MCA.

59. Cheekpiece from a bronze helmet found in the Tomb of the Warrior, Vulci, sixth century BC. H 15 (5⅞). Museo Nazionale di Villa Giulia, Rome. Photo SAEM.

60. Incised bronze mirror, late fifth century BC. Museo Nazionale di Villa Giulia, Rome. Photo DAI.

61. Incised bronze mirror, fifth–fourth century BC. Museo Nazionale di Villa Giulia, Rome. Photo DAI.

62. Relief bronze mirror, fifth century BC. Musei Vaticani. Photo MCA.

63. Tombs along the Via degli Inferi, in the Banditaccia necropolis, Cerveteri. Photo by Nigel Spivey.

64. Terracotta antefix from the Vigna Parrocchiale site at Cerveteri, late sixth century BC, at the time of excavation. Photo by Nigel Spivey.

65. White on red *pithos*, mid-seventh century BC. Terracotta. H 90 (35⅜). George Ortiz Collection.

66. White on red *krater*, mid-seventh century BC. Terracotta. D 58.6 (23) H 43.7 (17¼). George Ortiz Collection.

67. Etruscan inscription on the foot of an Athenian red figure cup, early fifth century BC. Terracotta. D 46.6 (18⅜) H 19 (7½). J. Paul Getty Museum, Malibu, CA.

68–69. Polychrome terracotta slabs recovered from the Vigna Parrocchiale site at Cerveteri, late sixth–early fifth century BC. Photos by Marcello Bellisario.

70–71. Parts of painted terracotta slabs from Cerveteri, mid-sixth century BC. Gorgon: H 94.3 (37⅛). Museo Nazionale di Villa Giulia, Rome. Soldiers: H 73 (28¾). Museo Nazionale, Cerveteri. Photos SAEM.

72–74. 'Boccanera' plaques from the Banditaccia necropolis, Cerveteri, mid-sixth century BC. Terracotta. H 102 (40⅛). Copyright British Museum.

75–76. Sarcophagus of the Married Couple from the Banditaccia necropolis, Cerveteri, late sixth century BC. Terracotta. L 191 (75¼). Museo Nazionale di Villa Giulia, Rome. Photos Scala.

77. Small-scale sarcophagus of a couple from Cerveteri, mid-sixth century BC. Terracotta. H 60 (23⅝). Museo Nazionale di Villa Giulia, Rome. Photo SAEM.

78. The Girl from Monte Abatone from the Monte Abatone necropolis, Cerveteri, mid-sixth century BC. Terracotta. H 64 (25¼) L 63 (24¾). Museo Nazionale, Cerveteri. Photo SAEM.

79. Recumbent youth on the lid of a cinerary urn from Cerveteri, late sixth century BC. Terracotta. L 90 (35⅜). Museo Nazionale, Cerveteri.

80. Travertine sarcophagus from Cerveteri, late fifth century BC. L 202 (79½). Musei Vaticani. Photo MCA.

81. Interior view of the Tomb of the Reliefs, Cerveteri, mid-fourth century BC. Photo Scala.

82. Samuel Ainsley, engraving of Castel d'Asso, November 1842. H 29.3 (11½) W 44.4 (17½). Copyright British Museum.

83. Terracotta pedimental decoration from Temple A, Pyrgi, *c.* 460 BC. H 126 (49⅝). Museo Nazionale di Villa Giulia, Rome. Photo DAI.

84–85. Terracotta pedimental decoration from Talamone, mid-second century BC. Museo Archeologico, Florence. Photos DAI.

86. Detail from the Tomb of the Triclinium, Tarquinia, *c.* 470 BC. Photo Scala.

87. Detail from the Tomb of the Lionesses, Tarquinia, *c.* 520–510 BC. Photo Scala.

88. Detail from the Tomb of the Baron, Tarquinia, *c.* 510 BC. Photo Scala.

89. Detail from the Tomb of the Blue Demons, Tarquinia, *c.* 420 BC. Photo O. Louis Mazzatenta/National Geographic Image Collection.

90. Detail from the Tomb of the Augurs, Tarquinia, *c.* 510 BC. Photo Scala.

91. Detail from the Tomb of the Hunter, Tarquinia, *c.* 500 BC. Photo DAI.

92. Detail from the Tomb of the Augurs, Tarquinia, *c.* 510 BC. Photo DAI.

93. Etruscan black figure *kalpis*, late sixth century BC. H 52.1 (20½). The Toledo Museum of Art, Ohio.

94. Detail from the second chamber of the Tomb of Hunting and Fishing, Tarquinia, *c.* 510–500 BC. Photo Scala.

95. Detail from the Tomb of the Augurs, Tarquinia, *c.* 510 BC. Photo Scala.

96. Detail from the Tomb of the Black Sow, Tarquinia, mid-fifth century BC. Photo DAI.

97. Detail from the Tomb of the Cockerel, Tarquinia, *c.* 400 BC. Photo DAI.

98. Detail from the first chamber of the Tomb of Hunting and Fishing, Tarquinia, *c.* 510–500 BC. Photo DAI.

99. Detail from the Tomb of the Mouse, Tarquinia, early fifth century BC. Photo DAI.

100. Detail from the Tomb of the Lionesses, Tarquinia, *c.* 520–510 BC. Photo DAI.

101. Central scene of the tympanum of the second chamber of the Tomb of Hunting and Fishing, Tarquinia, *c.* 510–500 BC. Photo DAI.

102. *Nenfro* sphinx from Ischia di Castro, mid-sixth century BC. Ischia Museum. Photo DAI.

103. *Nenfro* sphinx from Vulci, mid-sixth century BC. Museo Nazionale di Villa Giulia, Rome. Photo SAEM.

104. *Nenfro* statue of a boy on a hippocamp from Vulci, *c.* 520 BC. H 76 (29⅞) L 80 (31½). Museo Nazionale di Villa Giulia, Rome. Photo SAEM.

105. *Nenfro* figure of a youth on horseback from Vulci, mid-sixth century BC. H 69.2 (27¼) L 111.3 (43⅞). George Ortiz Collection.

106–107. *Nenfro* centaur from Vulci, *c.* 550 BC. H 79 (31⅛) L 85 (33½). Museo Nazionale di Villa Giulia,

Rome. Photo SAEM.

108. Detail of black figure amphora belonging to the 'Ivy Leaf' group from Vulci, late sixth century BC. Staatliche Museen zu Berlin Preussischer Kulturbesitz.

109. Hydria by the Micali Painter, *c.* 500 BC. Nationalmuseet, Copenhagen.

110. Amphora by the Micali Painter from Vulci, late sixth century BC. Nationalmuseet, Copenhagen.

111. Detail of hydria by the Micali Painter from Vulci, *c.* 510 BC. H 41 (16⅛). Copyright British Museum.

112. Amphora by the Micali Painter, late sixth century BC. Private collection, Geneva.

113. Applied red figure amphora belonging to the Praxias Group, *c.* 470 BC. Fitzwilliam Museum, Cambridge.

114. Part of the necropolis of Crocefisso del Tufo, Orvieto, late sixth–early fifth century BC. Photo by Nigel Spivey.

115. Terracotta bearded divinity from the San Leonardo Temple, Orvieto, late fifth century BC. Museo dell'Opera del Duomo, Florence.

116. Detail from the Golini Tomb I, Orvieto, fourth century BC. Photo DAI.

117–118. Bronze statue, the Mars of Todi, from Orvieto, early fourth century BC. H 142 (55⅞). Musei Vaticani. Photo MCA.

119. 'Canopic' urn from Chiusi, mid-sixth century BC. Terracotta. Copyright British Museum.

120. 'Canopic' urn from Chiusi, early sixth century BC. Terracotta. H 18.5 (7¼). Museo Etrusco, Chiusi. Photo Leonard von Matt.

121–122. Details of relief from Chiusi, late sixth century BC. Photo DAI.

123. Relief from Chiusi, late sixth century BC. Staatliche Museen zu Berlin Preussischer Kulturbesitz. Photo DAI.

124–125. Clusine reliefs on two sides of a carved sarcophagus, early–mid-fifth century BC. H 45 (17¾). Copyright British Museum.

126. Akroterial enthroned figure from Murlo, sixth century BC. H 170 (66⅞) Museo Nazionale, Murlo. Photo DAI.

127. Akroterial terracotta sphinx from Murlo, sixth century BC. H 70 (27⅝). Museo Nazionale, Murlo. Photo DAI.

128. Cinerary urn from Volterra, second century BC. Copyright British Museum.

129. The Inghirami Tomb from Volterra, late third–early first century BC, as recreated in the garden of Florence Archaeological Museum. Photo Scala.

130. Cinerary urn from Volterra, second century BC. H 73 (28¾) L 50 (19⅝). Museo Etrusco Guarnacci, Volterra. Photo Leonard von Matt.

131. 'Evening Shadow', votive bronze from Volterra, third–second century BC. H 57.5 (22⅝). Museo Etrusco Guarnacci, Volterra.

132. Gabled tomb at Populonia, early fifth century BC.

133. View of Marzabotto, showing restored house foundations.

134. Site-plan of Marzabotto.

135. Grave Q of the Forum cemetery, Rome, showing eighth-century BC pottery. Photo Department of Antiquities, Forum and Palatine, Rome.

136. Detail of funerary relief from Bologna, late fourth century BC. Sandstone. H 23.5 (9¼). Museo Civico, Bologna.

137. Akroterial terracotta head of Athena from the Sant'Omobono sanctuary, Rome, late sixth century BC. Height of original statue 140 (55⅛). Communal Antiquarium, Rome. Photo SPQR.

138. Detail from the François Tomb, Vulci, *c.* 350 BC. Photo Scala.

139–140. Details from the François Tomb, Vulci *c.* 350 BC. Photo DAI, Scala.

141. Gemstone showing suicide of Ajax, *c.* 500 BC. H 1.4 (⅝) W 1.2 (½). Copyright British Museum.

142. Gemstone showing seated Achilles, *c.* 500 BC. H 1.4 (⅝) W 1.1 (⅜). Copyright British Museum.

143. Detail of polychrome sarcophagus from Torre San Severo, Orvieto, *c.* 300 BC. Museo Etrusco Faina, Orvieto. Photo DAI.

144. Detail from the François Tomb, Vulci, *c.* 350 BC. Photo DAI.

145. Warrior from painted marble sarcophagus from Tarquinia, mid-fourth century BC. H 50 (19⅝) L 194 (76⅜). Museo Archeologico, Florence. Photo DAI.

146. Incised bronze mirror, fourth century BC. D 15.9 (6¼). Copyright British Museum.

147. Detail of sarcophagus from Chiusi, early second century BC. Copyright British Museum.

148. Charun carved in *nenfro* from the Greppe Sant'Angelo grave complex at Cerveteri, late fourth century BC. H 134 (52¾). Museo Nazionale, Cerveteri.

149. Relief vase of the Malacena Group, late fourth century BC. H 23 (9). Staatliche Museen zu Berlin Preussischer Kulturbesitz.

150. Detail from the Pulcella Tomb, Tarquinia, *c.* 400 BC. Photo DAI.

151. Detail from the Tomb of the Aninas, Tarquinia, *c.* 240 BC. Photo DAI.

152. Red figure drinking cup, fourth century BC. H 38.4 (15⅛). Courtesy Boston Museum of Fine Arts.

153. Detail from the Tomb of the Charuns, Tarquinia, *c.* 300 BC. Photo DAI.

154. Detail from the Orcus Tomb II, Tarquinia, *c.* 400–350 BC. Photo DAI.

155. Detail from the Orcus Tomb I, Tarquinia, *c.* 400–350 BC. Photo Scala.

156. Detail from the Bruschi Tomb, Tarquinia, third century BC. Photo DAI.

157. Etruscan bronze head, late fourth century BC. Musei Capitolini, Rome.

158. Detail from the Golini Tomb I, Orvieto, fourth century BC. Photo DAI.

159. Interior view of the Tomb of the Shields, Tarquinia, c. 350 BC. Photo Museo Nazionale di Villa Giulia, Rome.

160. Detail from the Giglioli Tomb, Tarquinia, late fourth century BC. Photo DAI.

161. Detail of *nenfro* sarcophagus of Laris Pulena, early second century BC. H 153 (60¼) W 199 (78⅜). Museo Nazionale, Tarquinia.

162–163. Details of male stone sarcophagus from Tuscania, second century BC. Photo DAI.

164. Detail of terracotta female sarcophagus from the Tomb of the Treptie family, Tuscania, mid-second century BC. Photo DAI.

165. Detail of couple on terracotta sarcophagus from Volterra, early first century BC. H 38 (15) L 70.4 (27¼). Museo Etrusco Guarnacci, Volterra. Photo DAI.

166. Stone sarcophagus from Tarquinia, late second century BC. Photo DAI.

167–169. Sarcophagus of Seianti Thanunia Tlesnasa from Chiusi, mid-second century BC. H 122 (48) L 183 (72). Copyright British Museum.

170–171. The Orator ('Aule Meteli') from Pila near Perugia, c. 90 BC. Bronze. H 179 (70½). Museo Archeologico, Florence. Photos DAI.

172. Bronze statuette of Apollo, c. 350 BC. H 27 (10⅝). Bibilothèque Nationale, Paris. Photo DAI.

173. Bronze statuette of Tinia from Furbara, c. 350 BC. H 12.3 (4⅞). Museo Nazionale di Villa Giulia, Rome. Photo SAEM.

174. Votive terracotta heads from Vulci, second century BC. Museo Nazionale, Vulci. Photo SAEM.

175. Votive model of intestines from Tarquinia, third–second century BC. Terracotta L 28.5 (11¼). Museo Nazionale, Tarquinia. Photo SAEM.

176–177. Marble statue of mother and child from Volterra, third century BC. Photos DAI.

178. Terracotta model temple, from the north gate of Vulci, late second century BC. H 22 (8⅝) L 32.6 (12⅞). Museo Nazionale di Villa Giulia, Rome. Photo SAEM.

179. Terracotta statuette of enthroned Dionysos, from the north gate of Vulci, late second century BC. H 21 (8¼). Museo Nazionale di Villa Giulia, Rome. Photo SAEM.

180. The bronze Chimera from Arezzo, late fifth century BC. H 78.5 (31) L 129 (50¼). Museo Archeologico, Florence.

181. Robert Adam's design for the 'Etruscan Room' at 20 Portman Square, London, 1771. Pen and coloured washes. H 32 (12⅝) W 42 (16½). © The Trustees of Sir John Soane's Museum, London.

182. Vases from the Querciola Tomb, Tarquinia, nineteenth-century drawing. Photo DAI.

183. Bronze relief, probably a chariot panel from Castel San Mariano, mid-sixth century BC. L 59.5 (23½). Staatliche Antikensammlungen, Munich.

184. Bucchero vases at the time of finding in modern excavation, Vulci. Photo SAEM.

185. Jean-François Janinet, engraving of the Villa Giulia, 1775. The Bowes Museum, Barnard Castle, Co. Durham.

186. Luigi Perticarari emerging from a tomb at Tarquinia in 1986. © Times Newspapers Limited. All Rights Reserved. Photo by Graham Wood.

Index

Numbers in *italic* refer to illustrations